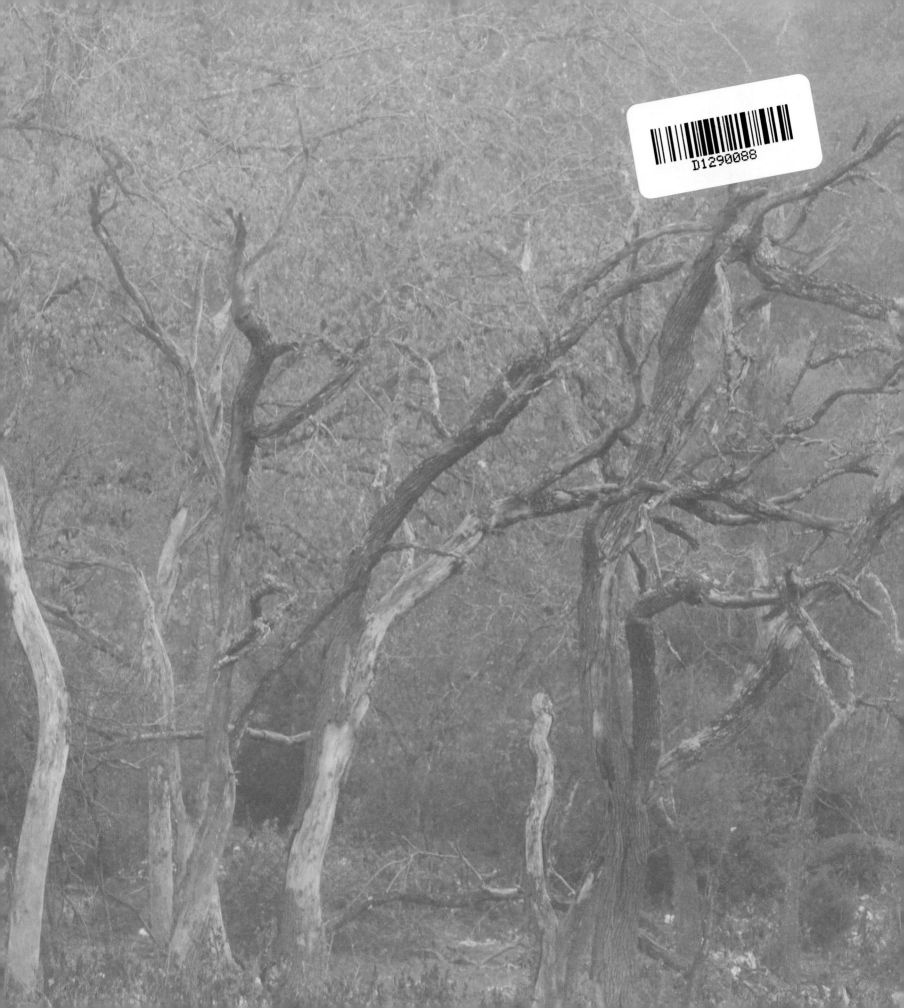

Fog at Hillingdon

David K. Langford is a friend
whose photography documents memorable scenes
of Texas ranchlands. I hope that you enjoy this book
and that you have a wonderful holiday season.

—CHARLES B. ALBRIGHT

Buena Suerte Ranch
Beefmasters
Lavaca County

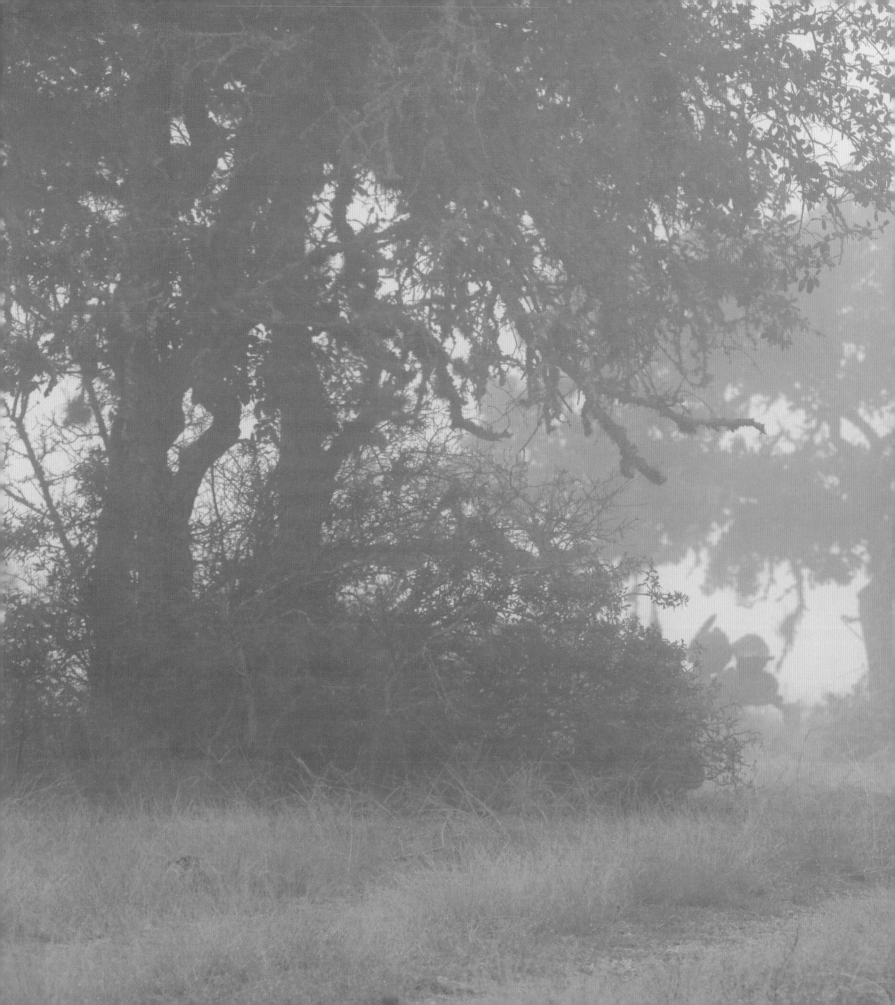

Fog
AT HILLINGDON

David K. Langford

Introduction by Rick Bass

Foreword by Andrew Sansom
Quotations selected by Myrna Langford

TEXAS A&M UNIVERSITY PRESS College Station

This paper meets the requirements of
ANSI/NISO Z39.48–1992 (Permanence of Paper).
Binding materials have been chosen for durability.
Manufactured in China by Everbest Printing Co.
through FCI Print Group

LIBRARY OF CONGRESS CATALOGING-IN-PUBLICATION DATA
Langford, David K., 1942– photographer.
[Photographs. Selections]
Fog at Hillingdon / David K. Langford ; introduction by Rick Bass ; foreword by
Andrew Sansom ; quotations selected by Myrna Langford.—First edition.
pages cm—(Kathie and Ed Cox Jr. books on conservation leadership)
Includes bibliographical references.
ISBN 978-1-62349-332-5 (cloth : alk. paper)—ISBN 978-1-62349-345-5 (e-book)
1. Landscape photography—Texas—Hillingdon Ranch. 2. Nature photography—
Texas—Hillingdon Ranch. 3. Fog—Texas—Hillingdon Ranch—Pictorial works.
4. Langford, David K., 1942—Homes and haunts—Pictorial works. I. Bass, Rick,
1958– writer of introduction. II. Title. III. Series: Kathie and Ed Cox Jr.
books on conservation leadership.
TR660.5.L387 2015
778.9'3609764—dc23
2015013756

Kathie and Ed Cox Jr. Books on Conservation Leadership
SPONSORED BY

THE MEADOWS CENTER
FOR WATER AND THE ENVIRONMENT
TEXAS STATE UNIVERSITY

A list of other titles in this series may be found at the back of the book.

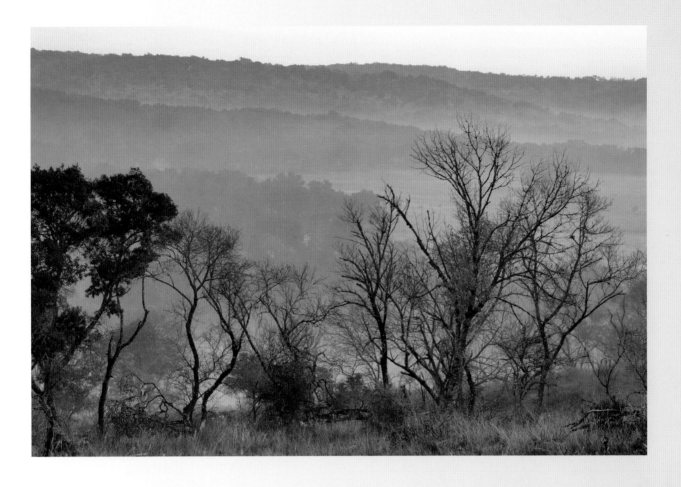

For all who appreciate the mystery and magic of fog.

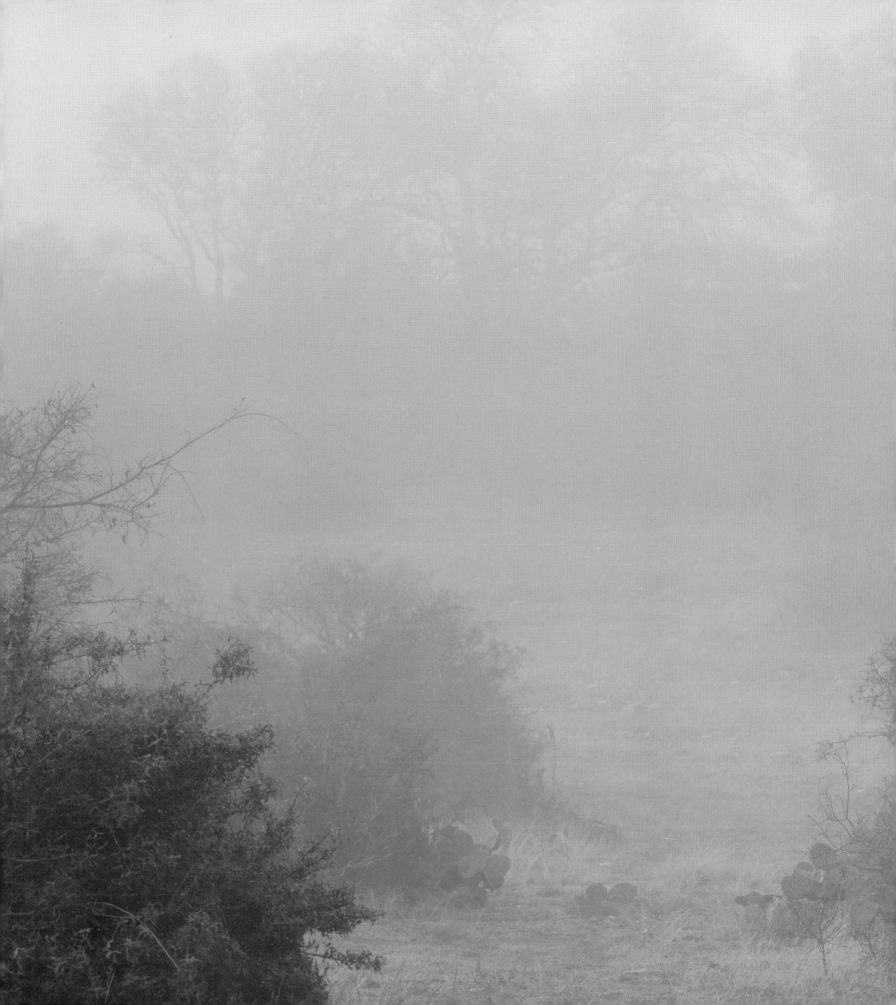

Contents

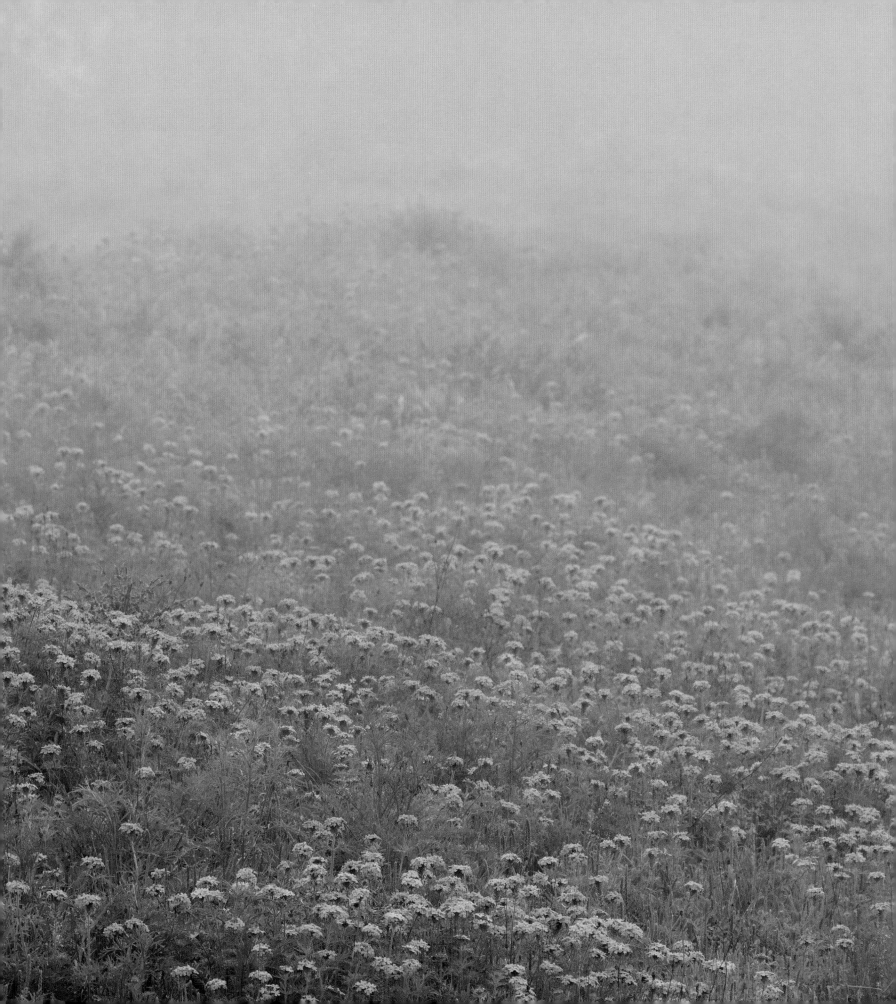

Foreword

ANDREW SANSOM

I have the almost indescribable privilege of working each day in a space that was once the honeymoon suite of the famous old Aquarena Springs hotel in San Marcos, Texas. From the windows on two sides of the room is the stunning view of Spring Lake, the headwaters of the San Marcos River.

For me, that view is most sensational on cold winter days when a ribbon of fog rises out of the crystal-clear spring waters of the lake and winds its way downstream from the source of the river lying just below my office. Mimicking the meanders of the river itself, the snaking line of fog forms because the water temperature, a constant spring-fed seventy degrees, is warmer than the air. The resulting mystical imagery outside my window is a striking testament to why few phenomena in nature have inspired as much poetry and prose as fog.

Most of it has been moody. Through the ages, in most literary references to fog, whether verse or narrative, fog becomes a metaphor for confusion or murk, clouding the mind and the vision from understanding and direction.

Although many have tried over the years, few photographers have captured the mysterious beauty of this remarkable hydrologic occurrence as eloquently as David Langford has in the mists of his family's beloved Hillingdon Ranch. In this, Langford's second volume of Hillingdon images, the old ranch becomes even more alluring as the photographer interprets its cultural and natural beauty in the shroud of exquisite Texas Hill Country fog.

On these pages, Langford is remarkably able to capture both the mood and the uniqueness of this lovely, enigmatic, natural phenomenon—catching the three-dimensional shadows cast in fog as images of trees or buildings or hills or animals are projected on a continuum of droplets.

And so, as I look out my window on a frigid day in January, my mind and my soul are

drawn to the enchantment and elegance of the serpentine river of fog below me. My soul is moved by the solemnity and grace of the scene, and my mind is certain that through the fog there is clarity.

Here, from my dear friend and colleague, David K. Langford, we are able to experience both.

—Andrew Sansom
General Editor, Kathie and Ed Cox Jr. Books on Conservation Leadership

Preface

Fog, as we learned in earth science in elementary school, is formed when water vapor condenses into tiny water droplets in the air. Essentially, it is a cloud close to the ground.

While the cause of fog is no mystery, fog still manages to be mysterious. Artists, novelists, and filmmakers have long used its shroud to create a sense of foreboding. Sherlock Holmes would not be the same character if he was sleuthing on a sunny beach.

There is a reason that Carl Sandburg wrote, "Fog comes on little cat feet." It is quiet, really quiet—so quiet that your thoughts seem to be amplified. Fog even seems to quieten the clanging, banging chaos of cities.

People often talk about fog muting colors. I do not agree. While fog does indeed soften the edges and obliterate some sight lines, its neutrality causes many colors to pop. The wide spectrum of visible colors stands out in stark contrast to the neutral gray all around.

Fog is unpredictable. Despite advances in technology, no one ever knows for sure when it will come. Once it is here, no one knows how long it will stay. In the Texas Hill Country, it is rare for fog to last more than a few minutes before or after dawn. Although there are days when some early sunlight peeks through fog's veil for an hour or so, sometimes it blocks out the sun for the entire day.

Fog and mist are the same things, except for visibility. If the visibility is less than one thousand yards, it is fog. If the visibility is between one thousand yards and two thousand yards, it is mist. Mist is inconvenient. Fog can be dangerous, causing newscasters to hurl warnings and motorists, hopefully, to slow down and proceed with caution.

Fog's cloak of invisibility has changed history. In August 1776 (just seven weeks after the signing of our Declaration of Independence) at the Battle of Long Island, Gen. William Howe came close to stopping the American Revolution almost before it began. British forces had the upper hand, and were readying to annihilate the American troops, when a

dense fog settled over the area during the night of August 29, allowing Gen. George Washington and his army to escape undiscovered. During the Civil War, Confederate soldiers were surprised to see Union troops, who had used the cover of fog, making their way up Lookout Mountain. During the Second World War, during the Battle of the Bulge, the Germans used dense fog and horrible weather to counterattack the Allied Forces. The fog was such an impediment to air support that the Allied Forces organized prayer efforts asking for clear skies.

In addition, fog has its own personality. I observed this as I was in the field. Sometimes fog hovers only over the hilltops, and the valleys and lowlands are virtually clear. At other times it is the complete opposite. Visibility can be near-zero at creek level, while the hills and ridges are bathed in full sun.

Some fog moves horizontally across the landscape. Then, there is the wispy fog that rises like smoke on the water. Sometimes fog freezes as it is suspended in the air, and clings to grasses, brush, and trees.

Despite its personality differences, I thought all fog was the same. I have since come to learn that there are actually six types, classified by the different ways they are formed. While I am not a meteorologist, I think I have images in this book that represent all six types.

Fog has fascinated me since I was a child. Fog's aura evokes many moods and all sorts of surprising personal feelings and reactions. Unlike almost anything else I've ever experienced, it can transform the familiar into something new. Thick fog disguises landmarks and can cause you to become disoriented, and maybe even lost, in a landscape that is as familiar as the contours of your own face.

As a photographer, I've always been drawn to the challenge of seeing the well-known from a new vantage point. This book of fog images focused on Hillingdon Ranch's surroundings gave me the opportunity to see my family's beloved home from a fresh, ever-changing, often fleeting perspective. Thank you for joining me on this journey of magical discovery.

Acknowledgments

Shannon Davies's mind is never still, but when the wheels speed up, projects are set in motion. This book got started before the last one was finished. As I submitted the complete set of photos for *Hillingdon Ranch: Four Seasons, Six Generations*, I commented, "I've got some other fog images that are really nice, but we already have enough for this book."

Without hesitation, Shannon, who is now the editor-in-chief at Texas A&M University Press, said, "Well, let's do a fog book. We'll need about 100 new images and 50–60 accompanying quotes."

Initially, she envisioned a book of fog images taken around the state. Knowing what I knew about the unpredictable, fleeting nature of fog and my own personal schedule, I countered with the suggestion that I shoot Texas Hill Country fog at Hillingdon Ranch. Working from a home base would allow me to get up early, look out the window, and go chase fog if it was hanging around. The alternative was traveling halfway across the state, twiddling my thumbs in a motel on the chance the forecasted fog might actually materialize. I am at a point in my career where that sort of gamble is not an option.

Fortunately, Shannon saw merit in my proposal and got behind it wholeheartedly. As a result, I not only got to work with the professional that is Shannon, but the entire, top-notch team at the Press. Although this book marks my second rodeo, I consider myself an amateur cowboy and am grateful to have had so many talented, experienced hands helping me hold the reins. All of the contributions, individually and collectively, are much apprekciated.

Lee Young at Adtech Photo Imaging in San Antonio, Texas, once again prepared every image to the specifications demanded by both the Press and, moreover, by me. Our relationship got its start 30 or so years ago when Lee began doing all of my film darkroom work. He continues helping me today with the ever-changing technology of this digital universe. I appreciate his help beyond measure.

This book would not have been possible without my extended family. In recent years,

my camera and I have become a fixture in Hillingdon's pastures. As the sun rises, ushering in prime shooting light, they have come to expect my old truck and me sitting on the top of the hill, behind a tree, or down in one of the valleys. In fact, the photographic record has become such a part of ranch life some of my family have started spotting opportunities for memorable pictures. I cannot tell you how many early morning phone calls and emails I received from my family alerting me to potential photos. I am thankful for their willingness to help me and to share our part of Texas with the world beyond our front gate.

Our part of Texas, nearly 13,000 acres located near Comfort in the heart of the Texas Hill Country, is special indeed. My great-grandparents, Annie Laura and Alfred Giles, founded the ranch in 1885, naming it after Alfred's ancestral home in England. Giles was a renowned architect in early Texas, but the family remembers him for instilling in his children a deep and abiding love of the outdoors in general, and Hillingdon Ranch in particular. The children grew up and did the same thing. History repeated itself.

Today, we are in our seventh generation of land stewardship. My cousin Robin Giles, his wife Carol, their son Grant, and Grant's wife Misty oversee the day-to-day operations. The land, under the capable and responsible management of the Gileses, not only produces cattle, sheep, and goats, but also wildlife and life's most precious resource, water. Our extended family has resisted the temptation to sell to the highest bidder, placing a higher value on ecological and agricultural productivity than on market price. I'm certain the land shapes us more than we shape it.

For a more complete history of the ranch and the story of our family's ongoing stewardship, I invite you to explore my first book, *Hillingdon Ranch: Four Seasons, Six Generations*. It captures a year in the life of a Hill Country ranch and a Hill Country family in photographs and text. It, too, is available through Texas A&M University Press.

I am especially grateful to Lorie Woodward Cantu, my longtime writing partner. Lorie helped me put together all the words in this book, except the quotes and the bibliography. There may be more books in my future, and if so, I will continue relying on her suggestions, advice, ideas, editing skills, and friendship.

It is hard to express what Rick Bass's contribution to this book means to me. I first made his acquaintance in the pages of *The Deer Pasture*, a fine collection of essays celebrating his family's experiences on a deer lease in the heart of the Texas Hill Country. Although he now

lives in Montana, we are spiritual neighbors. He understands life's ebb and flow, the flora and fauna, and the natural majesty that makes our Hill Country magical.

He is a writer of renown, but I have come to think of him as a fellow visual artist as well. His canvas is the blank page. His words are his brush strokes. The images he evokes are vivid, emotional, and memorable. In his hand, the pen is mightier than the bulldozer. His gifted use of language inspires the conservation of our wild places. I am honored to have his words introduce my photographs.

A special thank you goes to my friend of more than thirty years, Andy Sansom, executive director of The Meadows Center for Water and the Environment at Texas State University. In his role as the series editor, I am honored to have this book in the Kathie and Ed Cox Jr. Books on Conservation Leadership and for his kind words in the foreword. As one of our nation's leading conservationists, his ceaseless commitment advocating the stewardship of all natural resources, especially water, benefits every one of us, every day.

The quotations used in the book also provided me with a better understanding of their authors or speakers, some of whom are famous and some of whom are not. For instance, I did not know that Eleanor Roosevelt was a syndicated columnist whose work appeared six days a week from 1935–62. Identifying relevant quotes and researching their origins was an opportunity to dig below the surface and stretch my perceptions. Digging deep in order to reexamine what you think you know is a very good thing.

With that said, those quotes did not magically reveal themselves, nor did their original sources. As a university press, the Aggies hold all manuscripts, including photography books, to scholarly standards, meaning the bibliography has to be complete, correct, and verified. If I had known how involved the process was going to be, I am not sure that I would have undertaken it. I *am* sure that I would not have completed it without my wife, Myrna. Spending most of her career working in Trinity University's library, she used every bit of her experience searching out the proper attribution for these elusive references. Moreover, if that task was not difficult enough, the quotes also needed to relate to one of the images, and maintain the images' sequence as presented. Thank you, Myrna. This book, like so many other blessings in my life, would not have been possible without your love.

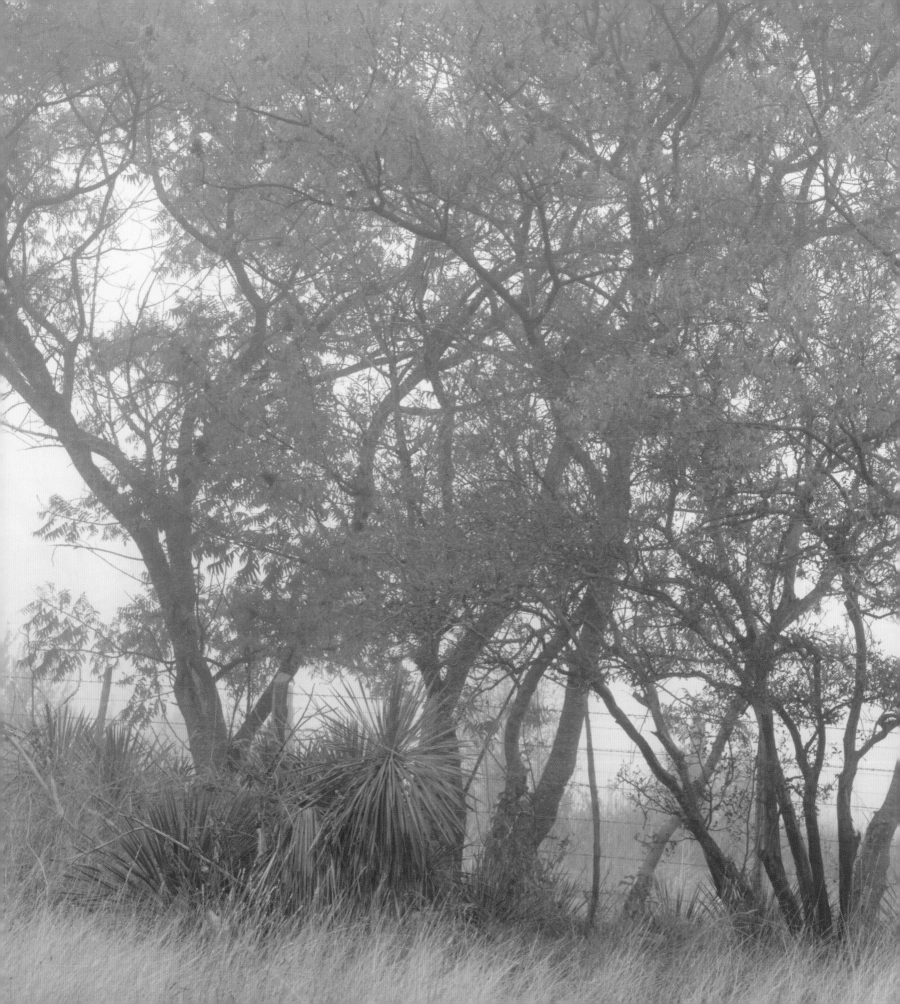

Notes on the Photography

I have spent a lot of my time behind the camera photographing wildlife and livestock. I did not think anything could be more challenging than a wily white-tailed buck or a cantankerous prize-winning bull, but then I set out to capture fog. Fog is fickle. There one minute and gone the next. Fog is unpredictable. Weather forecasts mean nothing. But to this photographer, fog alters landscapes, raising them to a different level of beauty. Being an eyewitness to this transition made all the early mornings and false starts completely worthwhile.

Almost every photograph in this book was taken using a Canon EOS 5D Mark III body with a Canon EF 28–300mm f/3.5–5.6L IS USM lens. Occasionally, to bring distant scenes closer, I used a Canon EOS 7D body with a Canon EF 100–400mm f4.5–5.6L IS USM. Three photographs were taken with a Sony a7R body and a Sony FE 70–200mm F4 GSS Full-frame E-mount Zoom Lens. For a couple of images, a 77mm Heliopan polarizing filter was used. Almost all ASA settings were at 200, with a very few at 400 or 800.

In my day-to-day photography, I seldom use a tripod because my subjects rarely stay still long enough to allow me to set one up. Fog is a different sort of animal. For most of the images in this book, I rolled down the driver's side window of my old 4×4 truck, put a bean bag over the door's window frame for padding, and used it as a brace. Holding steady was imperative. In most cases, I was shooting in a few predawn minutes, made even dimmer by the fog. To get the shots, I would turn off the auto focus and motion stabilizer, the things that create movement inside the camera. Then, I would set the self-timer for 10 seconds, meaning the shutter would not release until 10 seconds after I quit fiddling around with the camera. Ten seconds is a long time when you are trying to remain motionless.

Every bit of the equipment I used is readily available to all photographers. And while I have moved into the digital age, I have not become a Photoshop convert. None of these images has been enhanced beyond the capabilities of a traditional, film photography darkroom. For me, the beauty of photography lies in its ability to capture a moment in time just

as it was revealed to me. Any "tweaking" of the digital image file was done solely to replicate what I saw at the moment the shutter fired.

The use of light is what raises photography from mechanical button pushing to an art form. Unfortunately, most photography classes, except for the very rare and most advanced, focus on the mechanics. This setting. This speed. This exposure. This plugin. To understand and harness the nuances of light, you must seek out the masters. The works of photographers such as Galen Rowell and Bank Langmore have always inspired me, as have painters such as Rembrandt and Ken Carlson. Today, I still feel their influence with every image.

However, I began my career as most do, thinking what I really needed was to learn the mechanics of camera operation, so I took a couple of traditional courses. And while those were instructive and useful, a course taken in 1971 stands out as the most valuable. It established the photographic vision I still try to attain every day.

A lifelong friend, Carl Hensch, and I enrolled in a beginning photography course led by Jerry Klineberg, at the then-named Southwest Craft Center, in San Antonio, Texas. We had never heard of Jerry, but we did not know much about photography either, except the basics of operating our new cameras.

It was an eye-opening experience for both of us, especially for me. In that classroom, and on a few field trips, we did not talk much about camera operations, beyond the most elementary comments or tips. What Jerry did convey to us was how to think about light. To this day, my photography career has been influenced by how I learned to consider light and its defining impact on one's photographic vision. In this respect, I am indebted to Jerry Klineberg as much as I am to the historic photographers I continue to admire.

I would also like to thank those same friends I thanked in my previous book, *Hillingdon Ranch: Four Seasons, Six Generations*. Without the friendship and guidance of Bob Hipp, Bill West, Wyman Meinzer, and Eric Rindler, my photography career would not have turned out as it has.

Highest quality custom prints of the images in this book may be ordered from
www.westernphotographycompany.com

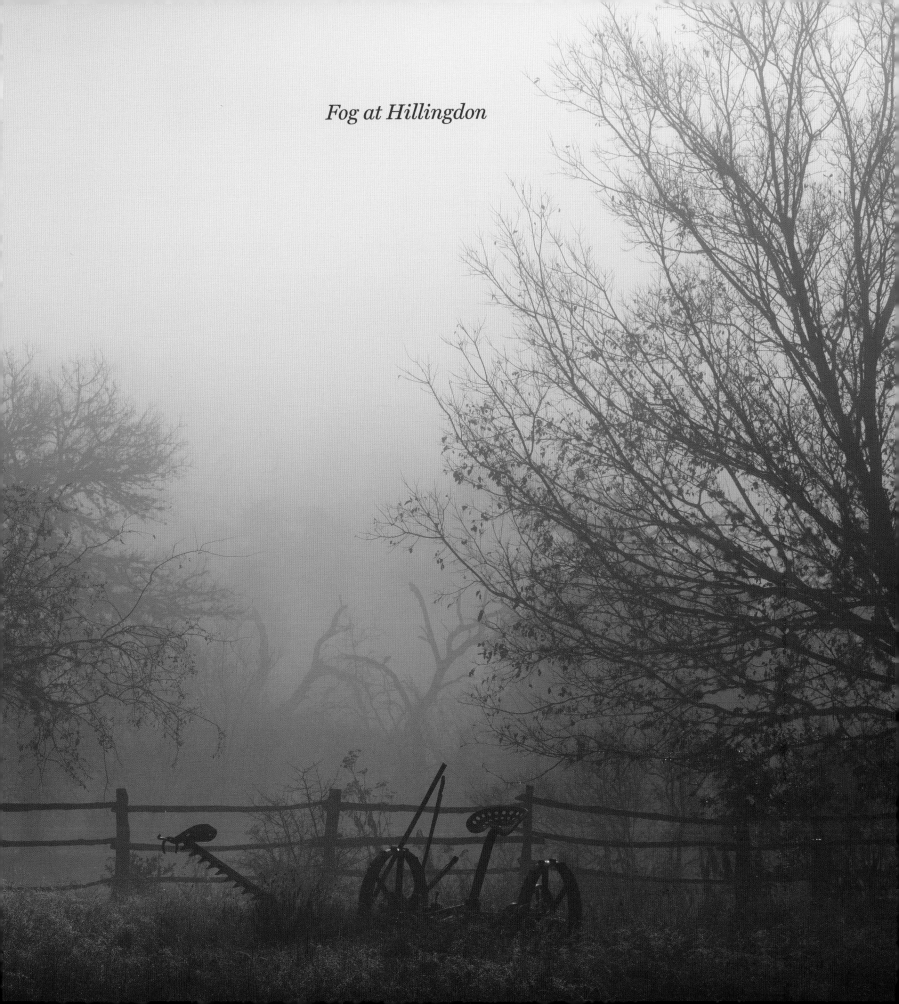

Fog at Hillingdon

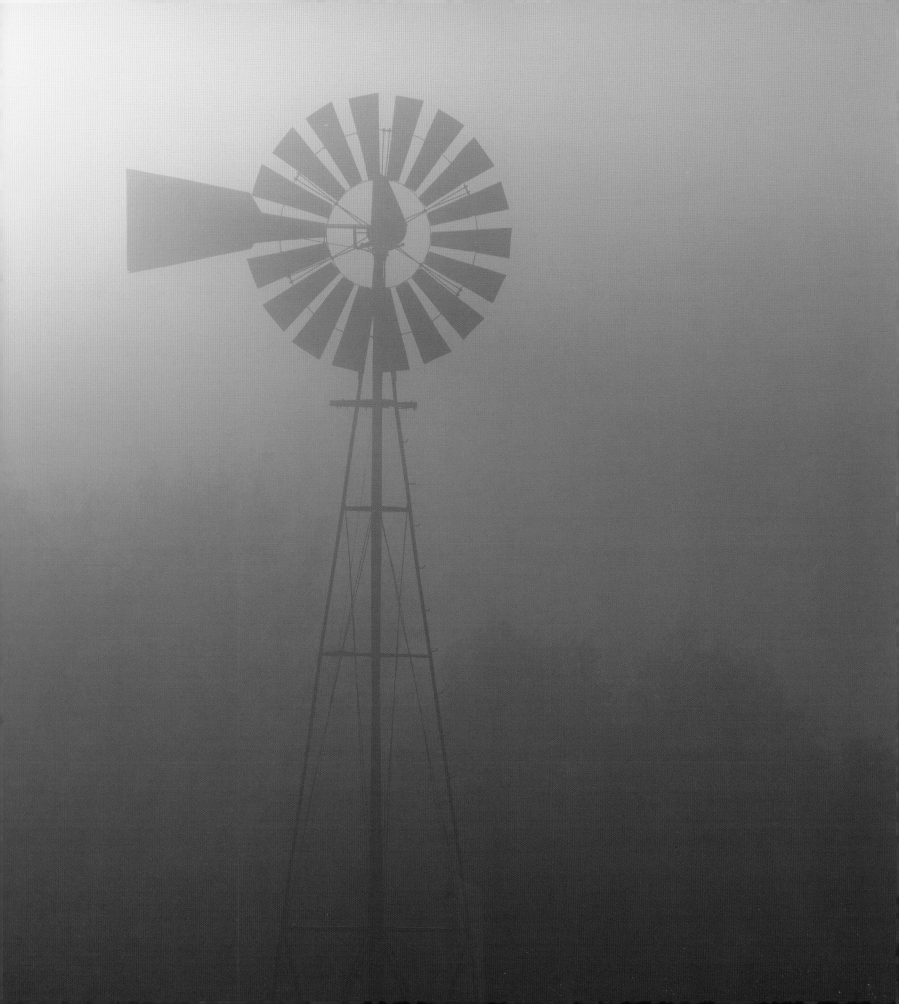

Introduction

RICK BASS

*Perhaps the way one feels about fog, upon awakening to
it, is—as is fitting and proper, appropriate to the great
blessing of life—that the day ahead is a present; that a
gift awaits, one which in due time will be revealed.*

The country of my heart, or the first country of my heart, lies little farther than a stone's throw from here; a hawk that in the morning kills a squirrel at Hillingdon could well by mid-afternoon be perched on the limb of an oak tree here, clutching a cottontail. I know this country in all its seasons and weathers, know its shapes and scents so well that it seems these pictures could have been taken from deep files in my mind that I barely remember, or do not remember at all. This is the best kind of art, I think: that which convinces the mind of another to enter another world.

Without question, the worst times I have been lost have always been in fog: in Texas, as well as up in the mountains of Montana. In such a condition, the mind struggles, and a thing like panic, but that we do not want to call panic, enters the mind and seeks to colonize. It slides in over the curved dome of the brain, flows down the canyons of the cerebellum, spreads an ever-widening blanket of erasure. Prior knowledge of a landscape wilts like fine grasses before the sweeping flames of an advancing wildfire.

One can try to reason, but in the absence of the familiar, the world is upside down, it is as if the nerve endings of the senses have been cauterized. Not only can instincts no longer be trusted, you can paradoxically almost count on them to be wrong, maybe even 180 degrees wrong.

In the Hill Country fog, as in other such fogs, a wayfarer in one's homeland known intimately might find a familiar tree, familiar granite boulder—the one that is the shape of a rhinoceros head, the one that is in the shape of a mythic sea creature, a Loch Ness monster, a camel, an elephant—and one can know then, in that moment of reality, and the specific senses reignited, where one is—but still missing is any knowledge yet of how to get to where one is going. There still remain plenty of directional challenges; a new center point has been established, the mind loosens its constriction, and yet: south soon becomes north again, or east becomes north, and south, west. Why does the world conspire to send us in circles?

I have found, in days following one fog-lost wandering or another, that my senses, even in the sharp light of day—especially then—are more keenly felt. Colors, sounds, shapes, and scents seem to come rushing in. The mind feels strangely more athletic, more capable.

Is this a product of the resiliency of relief, or something more profound, in which the synapses of nearly every cell that, just days previous, burned with such adrenalized intensity, are still opened so wide as to allow now in the milder environs an almost unbearable volume and clarity of data into the frail vessel that was a short time ago starving for *anything*?

I would not be surprised if the human mind requires, or at least desires and benefits from, these freshets. To be lost, to be found again. To sleep. To awaken. To sleep. To awaken. Perhaps it is in the presence of mystery that we strive hardest for knowledge. I like to imagine that such mental—and physical—gymnastics are occasionally healthy for us.

Is it possible that in fog, the wild becomes more domestic, and the domestic, more wild? A cow in fog is not a deer, nor is a deer in fog a cow, yet in the world of fog, the two might move closer.

The white-tailed bucks, more secure in the fog, move with greater confidence—are free to drift closer to the curiously mild freedom possessed by domestic animals, what we term "livestock," which live their lives, it must be assumed, without consideration of the slaughterhouse that awaits. And in the fog, conversely, do the domestic animals feel compelled to drift a bit closer back toward the rootstock of their wilder progenitors, the ones we first caught and corralled and began to sculpt and shape toward more bordered, bounded affinities?

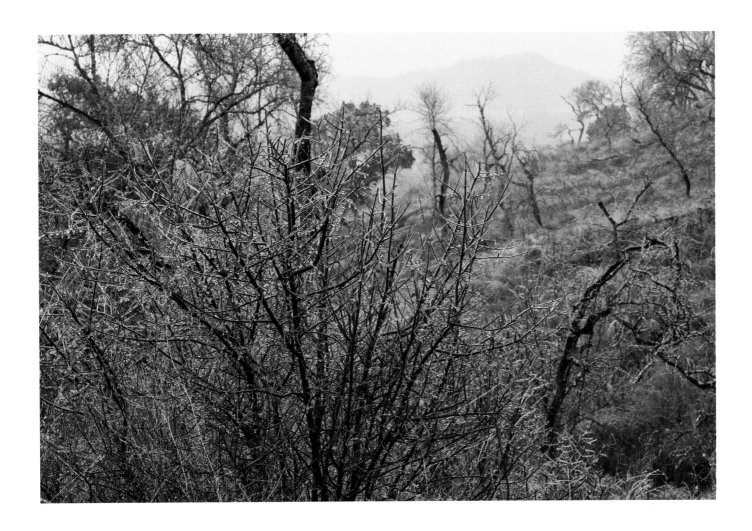

In his writing as well as his photography, Langford raises a fascinating question: while the tired old cliché of grayness and unseeingness comes quickly to mind in the archetypes of fog, Langford dissents, believing that in fog certain colors leap out with greater zest.

We have allowed other clichés to attach to our ideas of fog: "Thick as pea soup," and, "So thick you can cut it with a knife." I'm remembering even the famous, too-famous, Carl Sandburg poem, and how what was once original can, across time, become cliché: the fog coming on its little cat feet. But fog is not a cliché. Rather, it is an amalgam of day and night, contains the best and richest qualities of each. It looks like a cliché—static, trapped in the cage of hoary symbol—but always, it is changing, or is about to change; always, it contains a duality.

This, in addition to the softness, is one of the great powers of fog: it participates in both the immortal and the mortal. It attenuates the mythic land of sleep—perpetuates night, prolongs the arrival of dawn and the illumination of what we, so very much a visual species, think of as the "truer" world, one in which the physical laws of decay begin anew, that relentless clock ticking.

And yet fog also traffics in the mortal, for is not its very essence comprised of its contract with our vision? We do not so much hear or smell fog; we *see* it. And part of its allure surely is comprised of the equation between beauty and temporality, where the brevity is part and parcel of the beauty. For fog would surely not be as beloved were it always, always with us. And in the Hill Country, of course, the fog can be so very brief, the beauty *so* concentrated.

The greatest drama, of course, is in the fog's leave-taking. One can see the sun's rays breaking apart each diamond-globule of fog, the advancement of spectral prism bursting within and through each miniscule droplet. Does it matter if this perception is imagined or "real?" I think it is how our brains perceive it that matters.

As the sun awakens and bestirs the fog—dissipates it, opens it to full clean light—so too does it do the same to us. What a great squandering, to sleep in—to miss the dawn—in any country, but most of all here; to not have the brain and heart opened by the same light that cleaves the world on certain damp mornings, stretch open also our old routines and pathways of inattention, weariness, distraction, un-caringness?

Here is a conceit: that there exists a seam, translucent, evanescent, between the bottommost sheath of fog and the uppermost surface of the physical, durable world of stone, dirt, soil, and rock. This seam however might be like a brief-lived third world, neither past nor future, not known though not quite unknown. A border and borderlessness: the place where lines blur. As a species we are drawn to such places, and such ideas, and as a species we know to be cautious.

This is not just an abstraction. Such places exist in the mind. Thin seams and strata of possibility can be found in the world all around us. I'm thinking now of a certain species of violet that grows only in one canyon in northern Utah, only along a certain aspect of cliffs, where the plant is reliant upon the just-right breathing, the perfectly pulsed aspiration, of the smallest of cool-sinking end-of-day currents, and the slightly warmer uptick of gently warming currents each morning, and the moisture contents of each, bathing the violet in a narrowly held and utterly beautiful state of being.

To state the obvious: Fog follows the shape of the land with an attention to every topographic detail that, were we to anthropomorphize, we might characterize as loving. The fog *is* the land, carries moisture just slightly above the land—is a skyborne river, or a riverborne sky, an intermediary: always, a place-between.

Something the images cannot quite capture, but of which I am reminded, viewing them, is the scent of campfires and burning slash piles in foggy weather, the latter particularly poignant in a burning world as ranchers of grass and oak trees wage endless war against the encroachment of juniper, or cedar. We need the juniper, too, of course—a beautiful ecosystem has welcomed and woven the cedar into the old one with quite a bit of grace and elegance—but there remains always the question of water, and balance, and in the new droughts and new heat the cedar is finally dying, dying by the million-ton, and that which does not rot must burn. The oaks, somehow—and you see them in these pages, in all their fog-draped grandeur—keep surviving.

Something else that is not caught so sharply here are the acoustics of fog. The consciousness thinks, "Sounds are softer in the fog;" old words like "muffled" come easily to a sleeping or not-yet-wakeful mind. And yet that may not be exactly how sounds present themselves to us, in fog.

Perhaps because some certain percentage of water molecules, hanging suspended in the air, conduct sound waves in a different manner—as when, out on a lake, sounds can be heard so clearly, and from such distance—but it seems to me that on foggy mornings, sound penetrates more deeply—and gently—the pathways of hearing damaged by an era, a lifetime, of industrial white noise.

Who would not like the world to be coated in silver, now and again? As a child, particularly, I thrilled to the wild and ferocious grip of the beauty of the Hill Country—rough enough, already the arbiter of wild, in my life, at that point—encased in ice, luminous, mercury-slick. The woods becoming icy parabolas, branches bowed like hoops and horseshoes, creeks wrought with translucent lace, and, of course, the strange and unfamiliar cold that delivered such phantasmagoric sights.

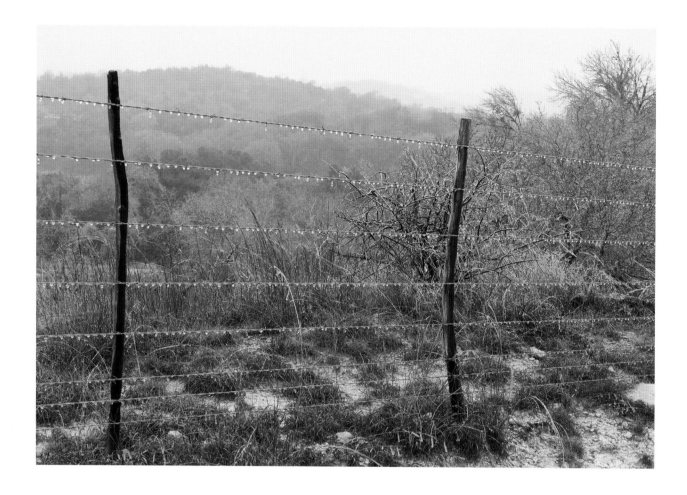

In my mind, December and January are the foggiest months. There can be fog in any season, but those cold-weather winter fogs are the ones I think of first: days and nights in which the familiar world is taken away, and can this not also be a definition for adventure? I am reminded of a Eudora Welty quote, "All serious daring starts from within."

In the new world of fog, you move more slowly, on foot, or, certainly, in a vehicle. Attempts to illuminate your way are futile, counterproductive. The world is reshaped by fog, is made small, so small, and again, in such contraction, the world of imagination can be kindled, can burn brighter, from that creative ignition Welty speaks of, the spark that must always be in us, and which may glow brightest when there is little else to be seen.

I keep thinking about Langford's assertion that color emerges most flamboyantly in fog—is not muted, as we might assume, but pops and burns. I am red-green colorblind, am drawn more to shapes and patterns, I think, than the mosaics and nuances of color, so

I could not agree or disagree. But for any number of reasons, I suspect he is correct, for in fog I feel this same incandescent crackling emotional response of occasional specificity—the fine detail amidst the vast overburden of fog's abstraction. Sharply, in fog, the mind lights up, not all at once, with swirl and speed, but one gripping and vibrant filament at a time.

One such instance I am thinking of occurred when I was very young, nine or ten. My father, grandfather, uncle, brothers, cousins, and I were up at our deer lease in the Hill Country on a New Year's Eve weekend, when there was an ice storm and thick fog, not the sweet little burn-off kind, not the evanescent hour's worth, but a real brute of a sock-in, and a night fog.

Back then, we got our water from the creek. I had gone down with a metal pail to break through the thin ice to gather some. As I crouched there, feeling in that fog and darkness the tug and gurgle of the big pail filling, I heard geese honking overhead. They had to have been flying above the fog, though perhaps too they found themselves somehow in it—and it seemed to me they were tired and trying to land, but could find nowhere to land as they circled above me, braying.

Did they know I was below? Was my flashlight a dim-glowing beacon, in all that fog? I could feel their agitation keenly. I looked up the hill toward the cabin, itself but a small glowing in the fog, and I realized that was what they were fixing on—the sole light, back then, for many miles.

They kept circling and circling, drawn to it, it seemed, which suggested they too might be disoriented. I had never experienced such a thing nor have I since. I have thought about it now and again in the long decades since, and always, my recollection is lodestar-the-same: that that foggy evening was like a catalyst and summons, an imprint, on the tiny spark of boy down at the bottom of, in the midst of, all that fog, drawing water from the icy creek.

The geese, their clarion call bespeaking wildness, and so very close—not two hundred feet above, I'd guess—seemed to be urging me to consider further and farther and wilder horizons, and more boisterous, even exuberant, imaginings—*all serious daring starts from within*—and I realized I could follow their sound, could take another ten or twenty or thirty steps, and be enveloped in the fog to the point where I could not see the cabin, lost. My little flashlight would do me no good.

And yet all of the other things I valued, and still value, and follow—the foursquare,

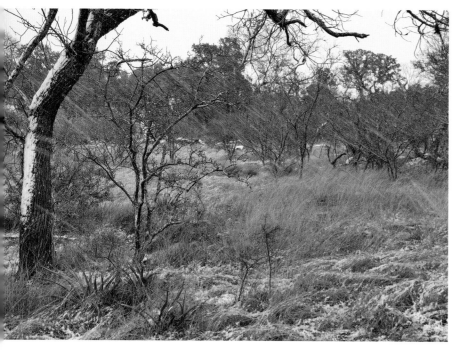
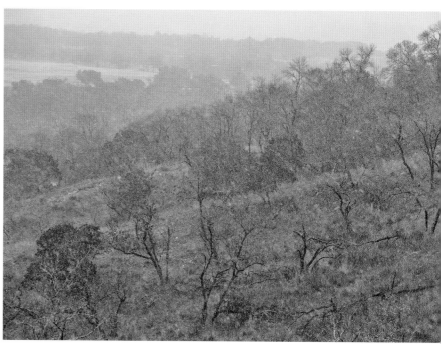
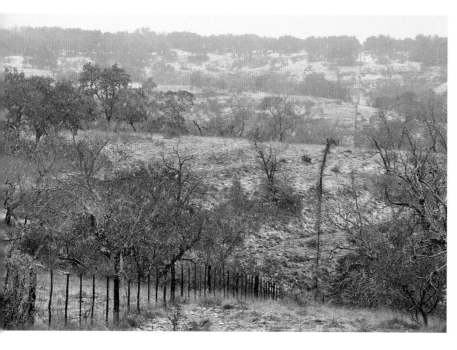
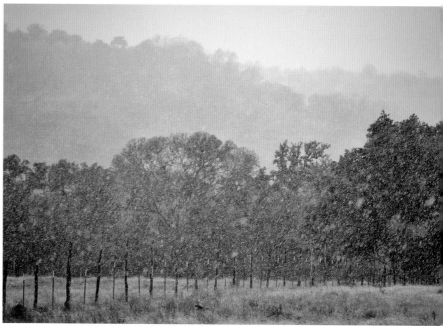

window-light blaze of hearth and home, not-too-close but not-too-far-away—the glow of it just at the outer reach of my fog-vision, and fixed—the sounds of the domino game seeming extraordinarily sharp, in the night like that, and in the fog, with no other distraction of the senses, and little else for the mind to attach to *but* that sound—created in me a tension between the pastoral and the deeply wild that remains to this day.

All from just one fog storm, from just one little passing-through band of winter-lost geese. Are our lives and paths comprised of drift and chance, or are they magnetic traversings of clockwork destiny and gear-work timing? No one knows. No one can say. Not in the middle of darkest night, nor in the center of brightest day.

Fog is mystery combined with moisture. In a warming world, our water—well, it's not ours; it's the world's water, needed by all, as all need each other—comes sometimes in torrents, sometimes as just the faintest web of dew or drifting curtains of fog, and other times not at all. Again, fog is the intermediary, the gauzed gateway between one world, bounty, and the other, paucity.

Would a viewer of these photographs know of Langford's stellar conservation efforts, his and his family's awards and stewardship in these matters? I have studied these photographs carefully and think perhaps not. There is the eye for beauty and the eye for detail, but these things do not always translate into an automatic concern and consideration for the future, nor the commitment required to shepherd these values—this beauty—safely forward and into and through a burning world. One cannot always know the heart of the artist, in looking at the art. But it should not be surprising that the eye of the man who waits for the fog, who rises early to meet it, and seeks to compose and order it in his mind—to observe the shape and movement of it—should, in being so attentive and connected to the land, understand the need to be active on its behalf, active against the forces that would carelessly or greedily fragment the natural beauty of the Hill Country, and the forces that seek to control selfishly rather than conserve and share with scientific wisdom and apportionment this most finite and dwindling and vital of resources: the rarity of water, within the beauty of the Hill Country.

"Perhaps," Langford writes, "a meaningful conversation can be started if we realize that

everyone's dreams, no matter what they are, will die without water." And: "The story we are telling is not new, but it is more urgent."

One cannot destroy fog, I don't think; as long as there are temperature differentials, and moisture, there will be fog. But the sweet wild country that it overlays, and the wild creatures that pass through it—that is a different matter. Congratulations and gratitude to Langford for being so generous a spirit as to take sustenance from the fog, and the land's beauty, and to then seek to pay back that gift with the awareness and activism of responsibility.

Maybe one should not be surprised to know this, to learn this, in viewing these photographs after all. What a lovely idea to consider, that the hearts of all men and women who stop and take time to look more carefully at a thing—to *really* look—might, in that gaze, resolve not to take a thing as their due or for granted, and view such a thing as not a right but a responsibility, and might then find themselves illuminated within, rising to protect that which they love, and find beautiful.

Photo Gallery

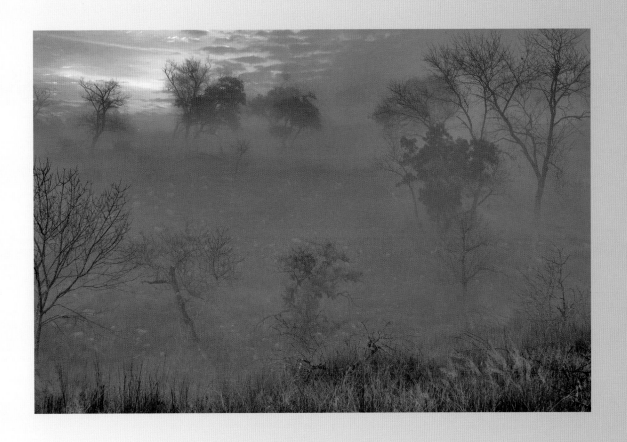

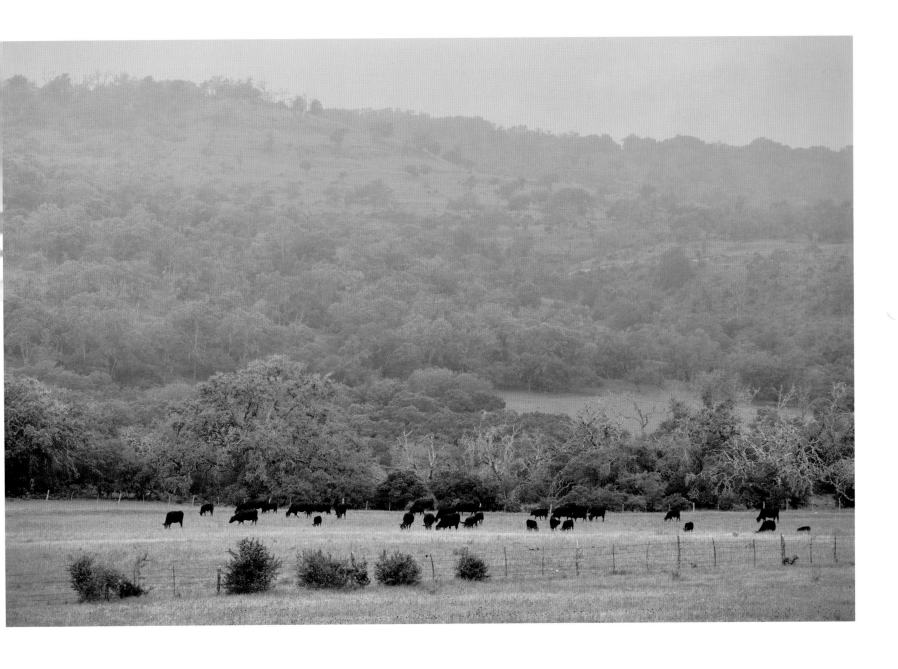

Mr. Giles's ranch, the Hillingdon, looks in the summer, when the imported Scottish cattle are grazing over it, like a bit out of the Lake country. Walnut, cherry, ash, and oak grow on this ranch, and the maidenhair-fern is everywhere, and the flowers are boundless in profusion and variety.

—Richard Harding Davis, 1899, *The West from a Car Window*

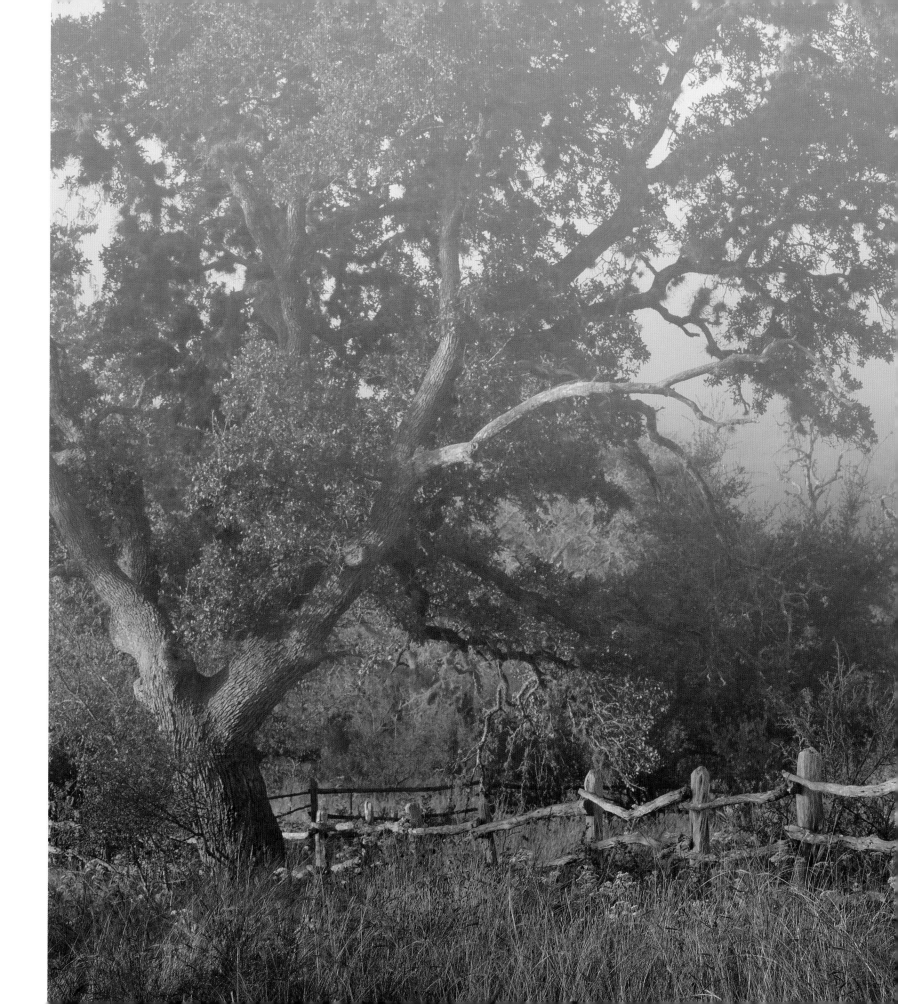

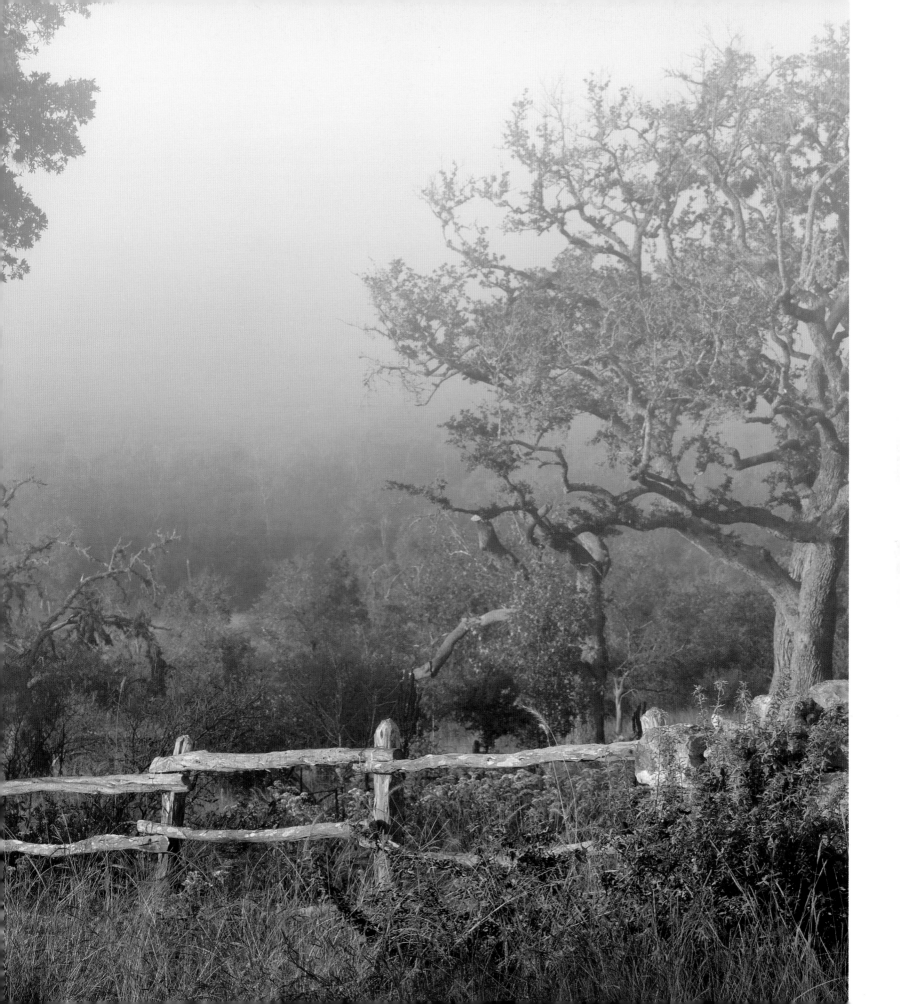

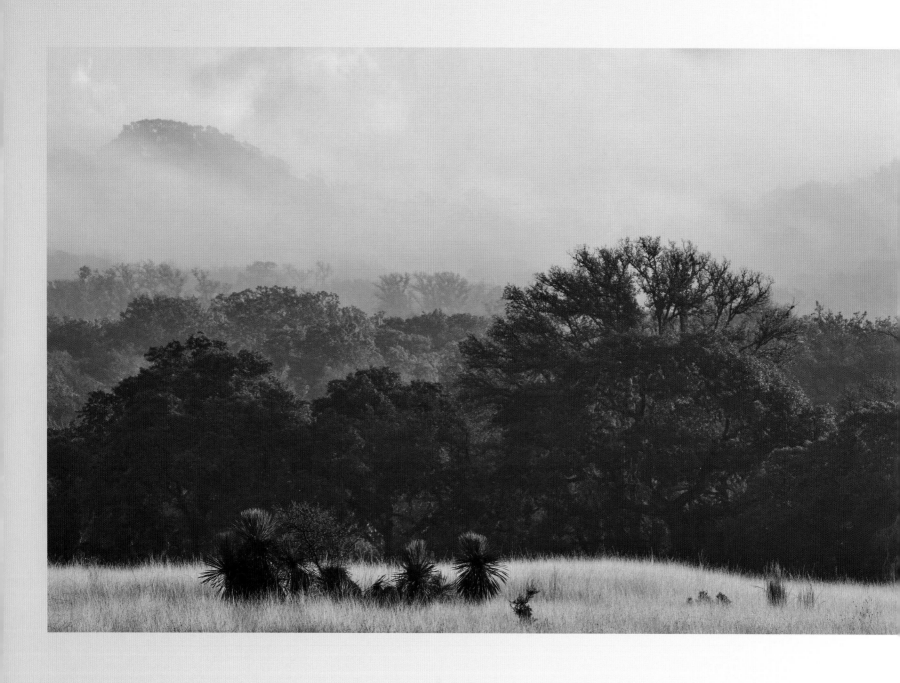

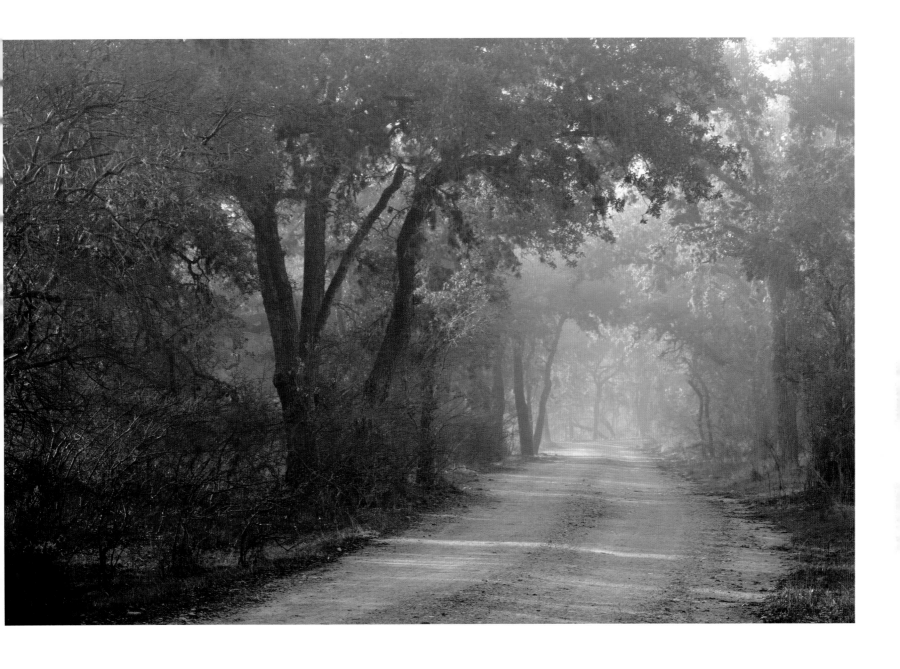

Mornings at the Ranch always begin a good day.

—Robin Laura Langford Russell, author's daughter

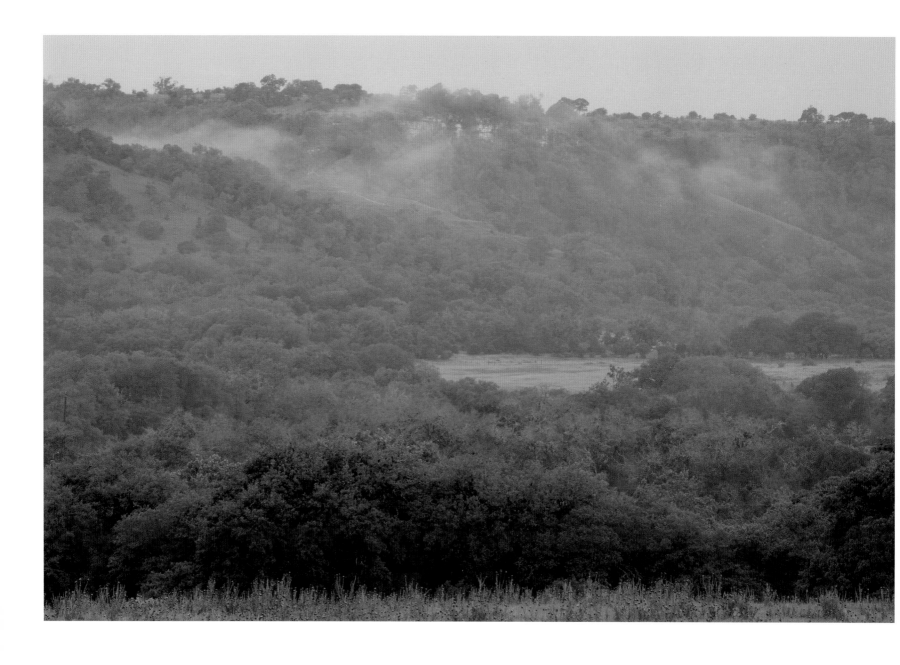

Here have I lived and here I would die, for of all places under the sun I know of none that contents me better. Nothing is required of me, I think, that cannot be done with joy. Stop here and be happy: where find a likelier place?

—David Grayson, *The Countryman's Year*

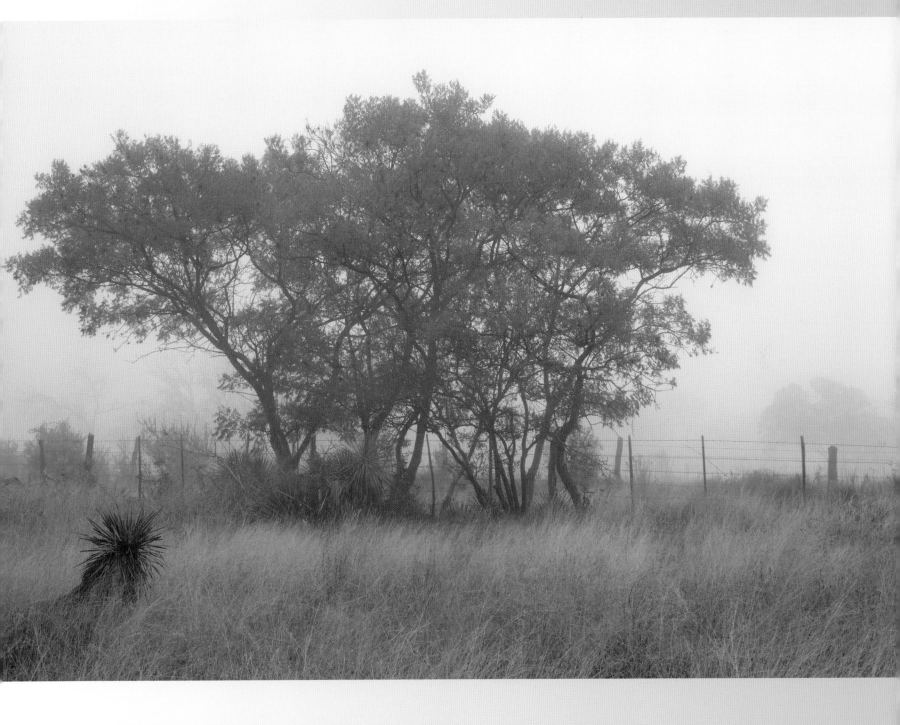

Conservation is a state of harmony between men and land.

 —Aldo Leopold, *A Sand County Almanac: And Sketches Here and There*

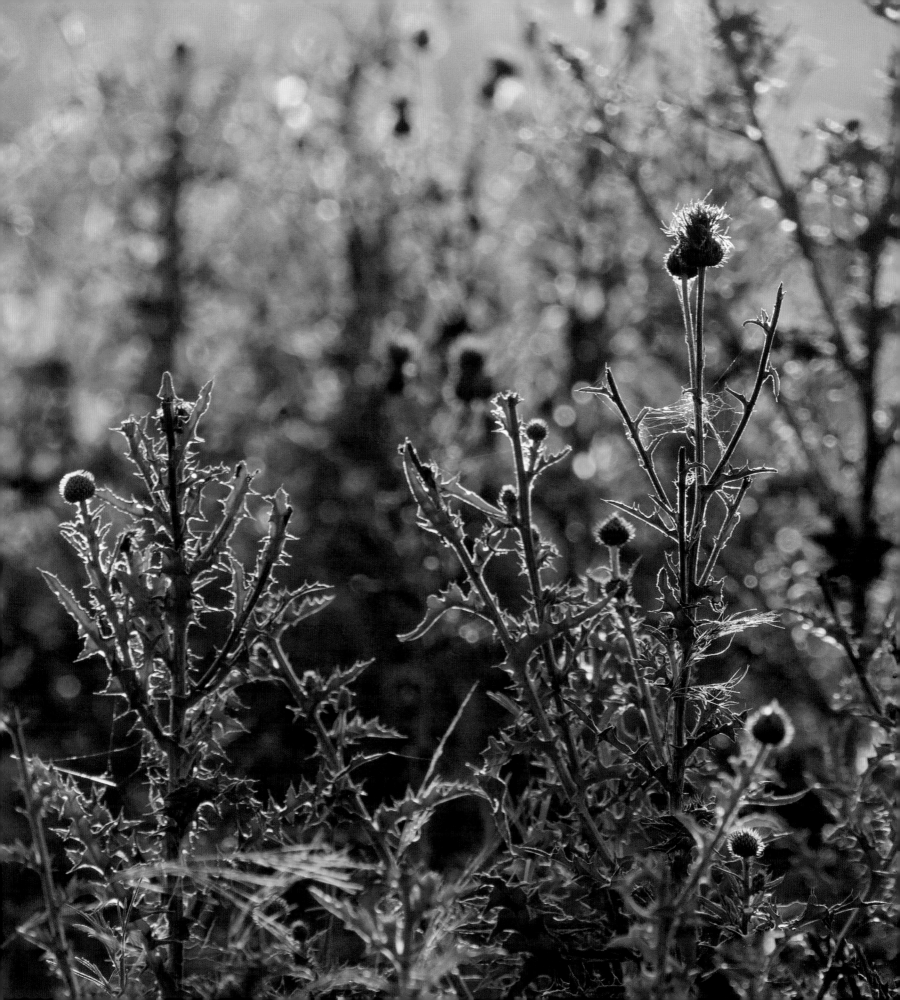

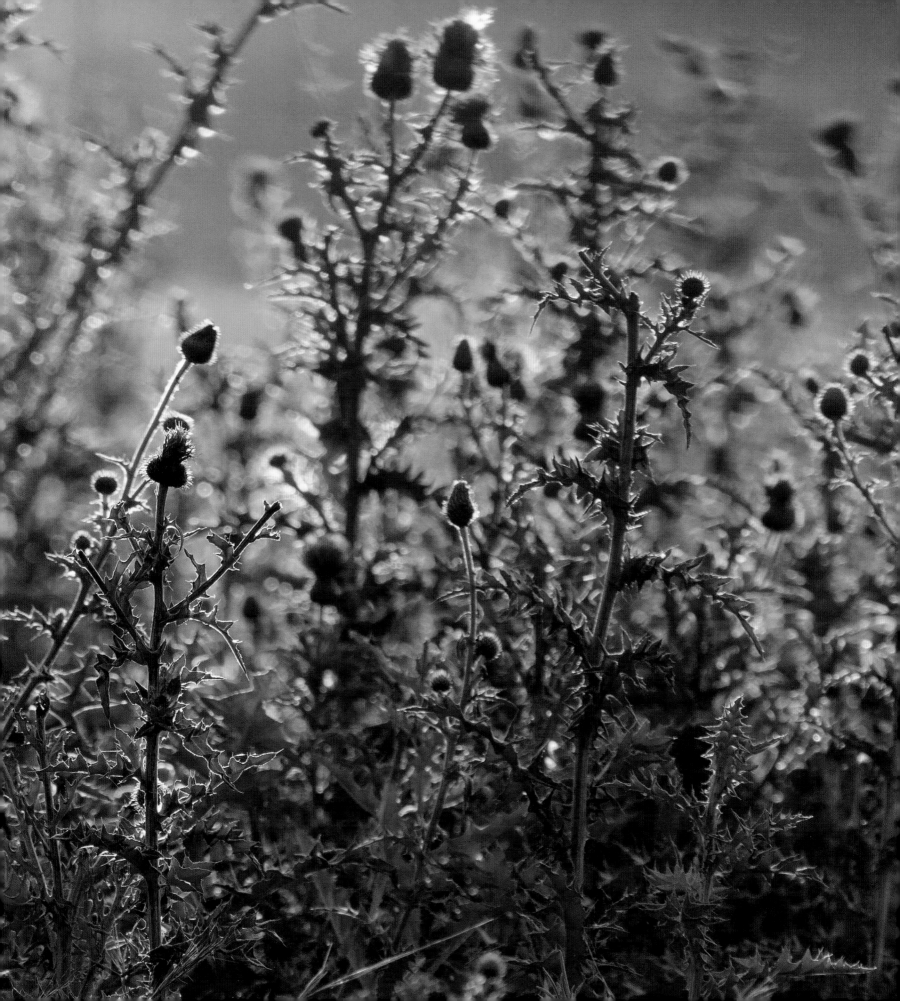

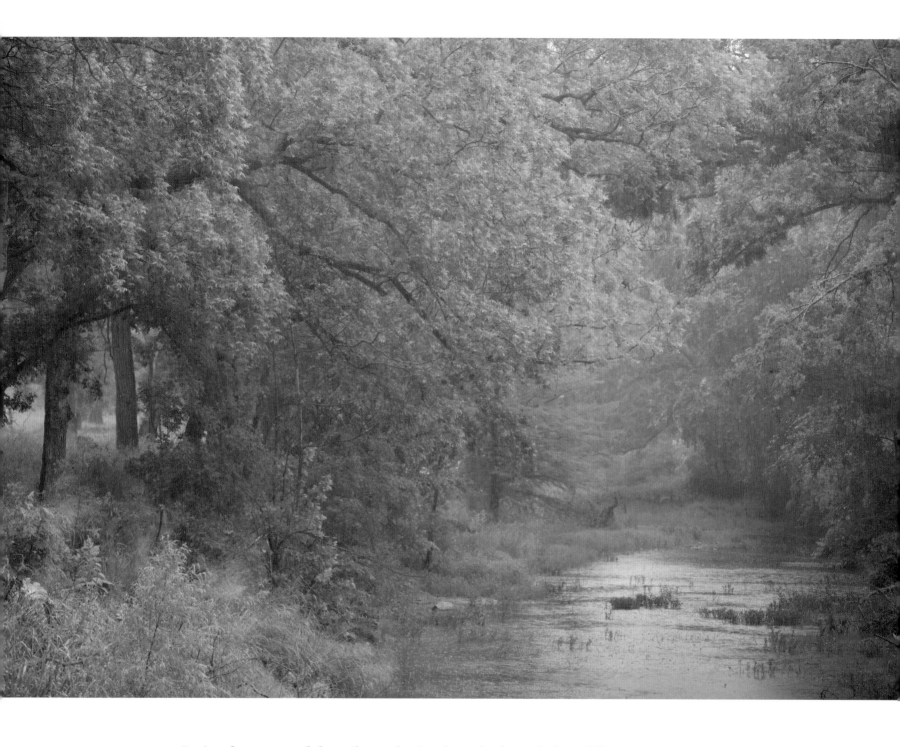

Saving the water and the soil must begin where the first raindrop falls.

—Lyndon Baines Johnson, 1948, Presentation to Lower Colorado River Authority

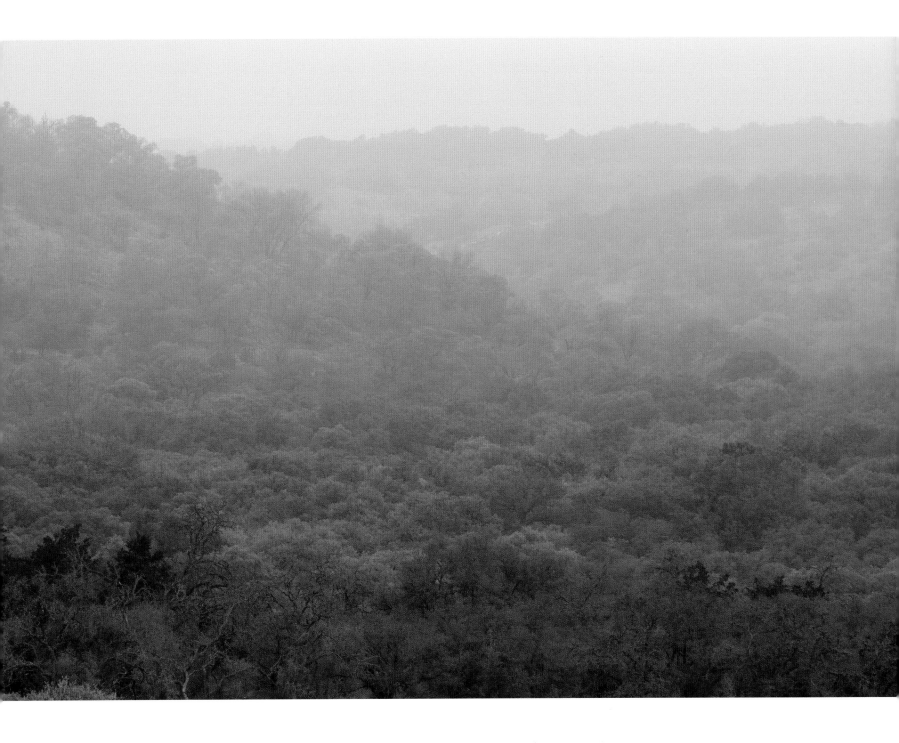

The fog, actually a vast cloud that lay on the hilltops and flowed and eddied down all the hollows, was a backdrop for the nearby trees. The fog had sharpened my eyes, given them focus.

—Hal Borland, *Hill Country Harvest*

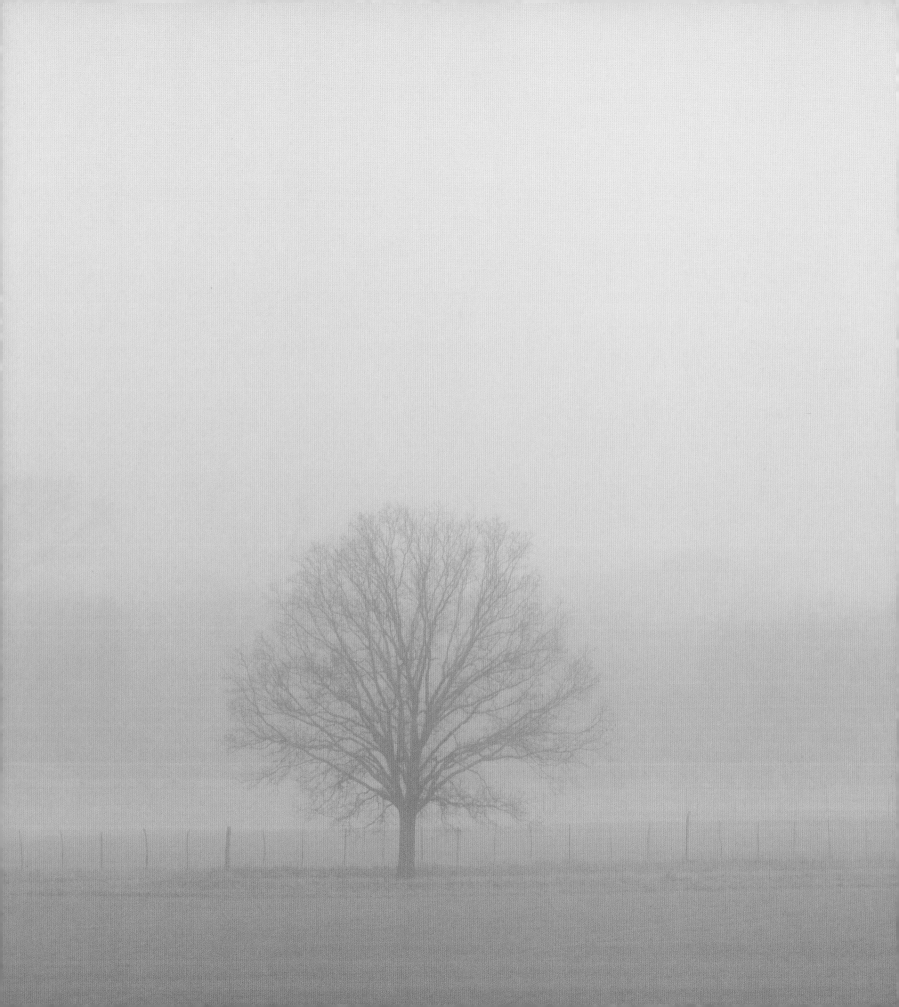

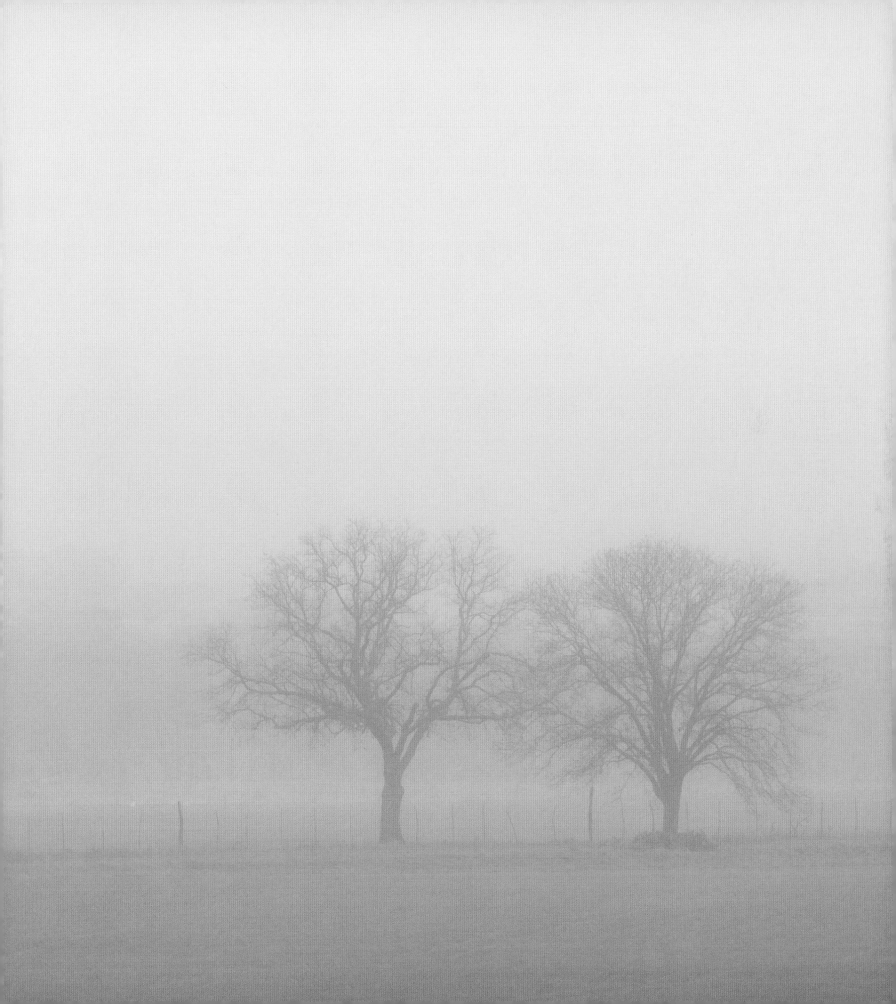

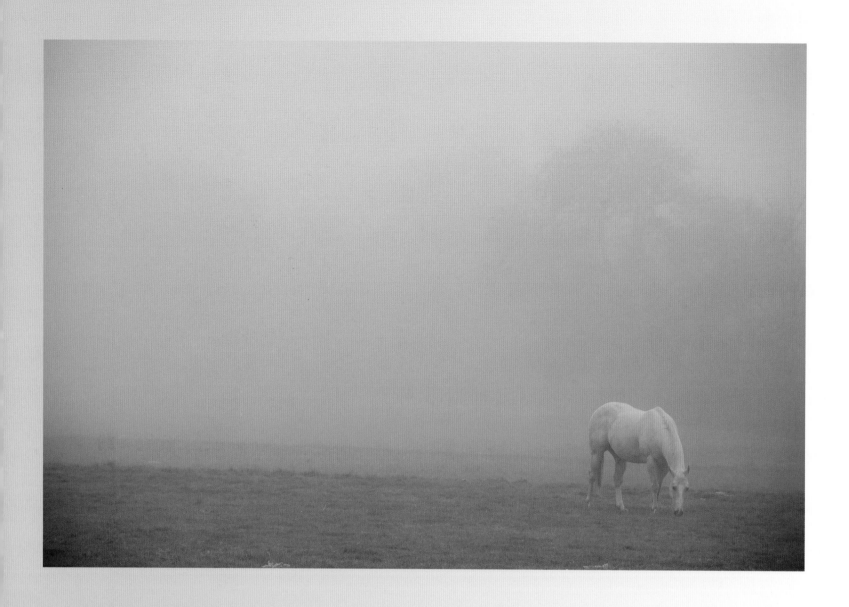

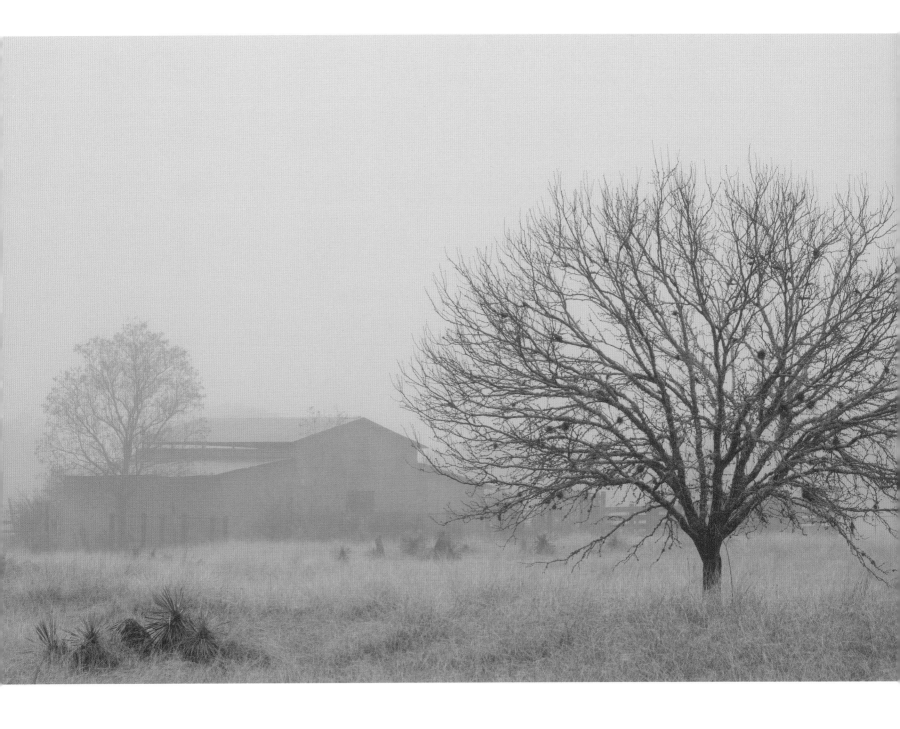

Till even the comforting barn grows far away.

—Robert Frost, "Storm Fear"

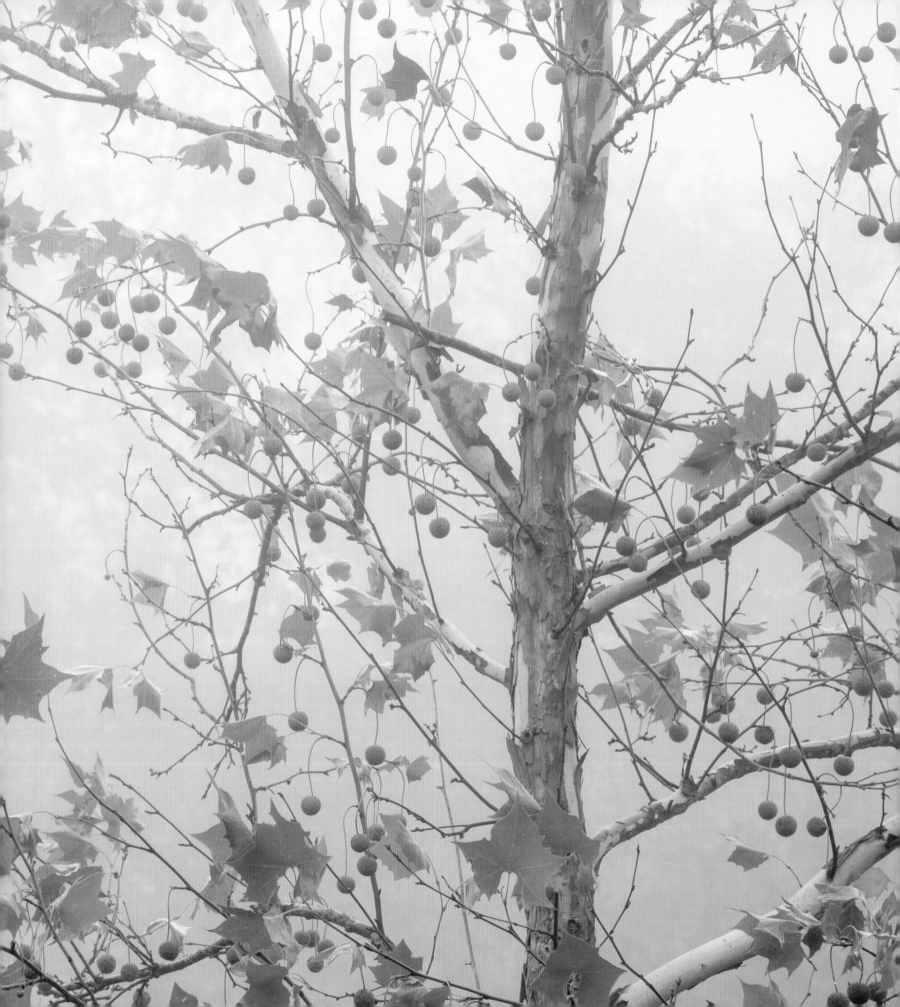

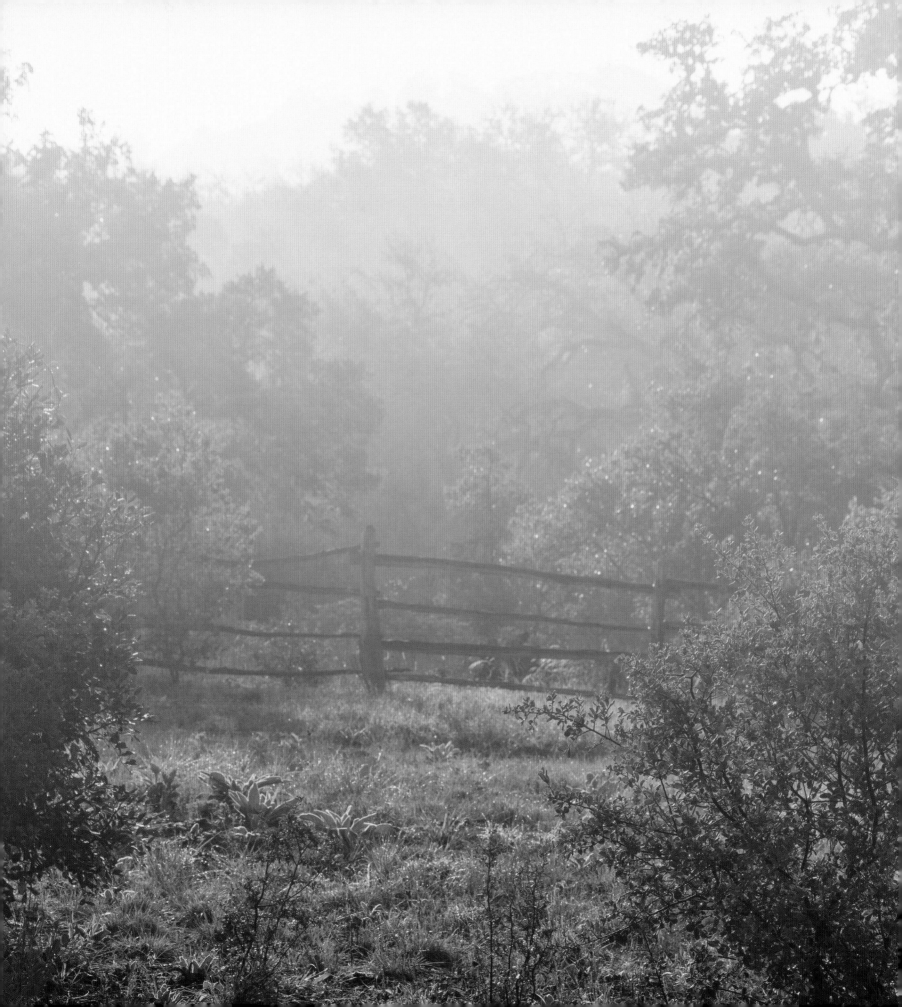

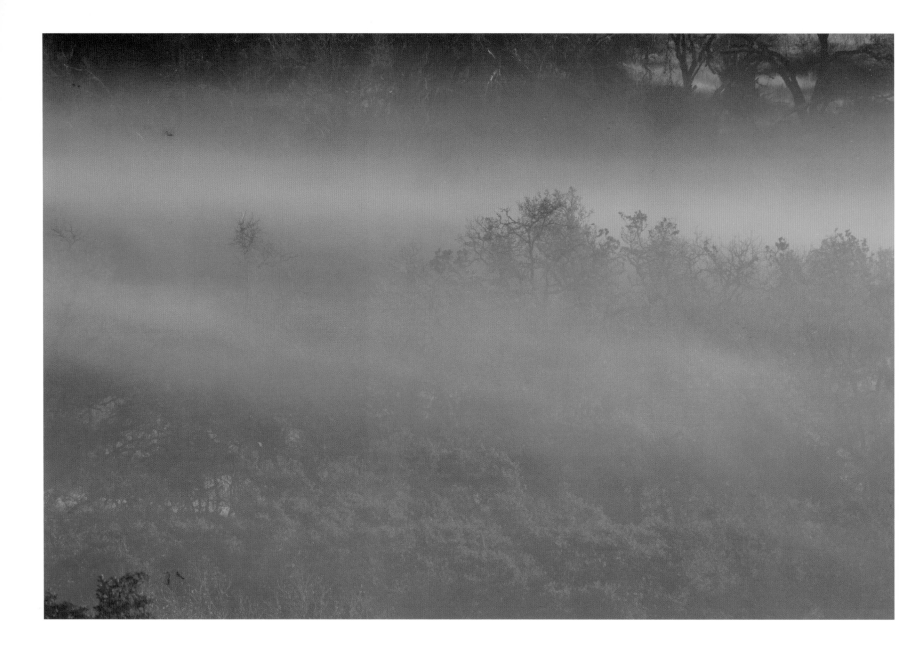

The real magician was light itself . . . mysterious and ever-changing light with its accompanying shadows rich and full of mystery.

—Edward Steichen, *A Life in Photography*

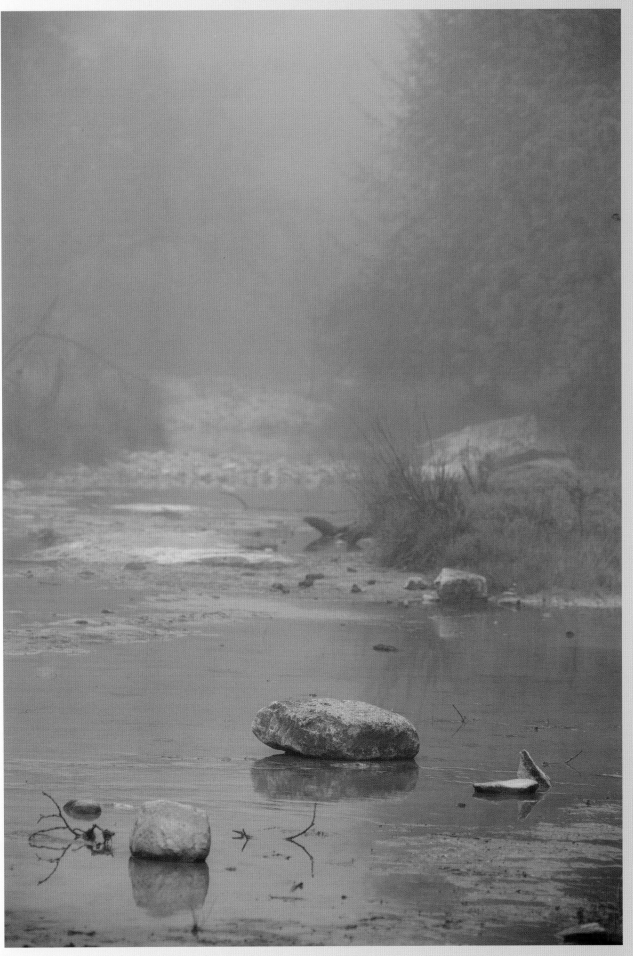

What happens on the land reflects in the creeks. . . . Riparian areas have been called "ribbons of gold" with their ecological value far surpassing the relatively small acreage they cover.

—Steve Nelle, "Cows and Creeks"

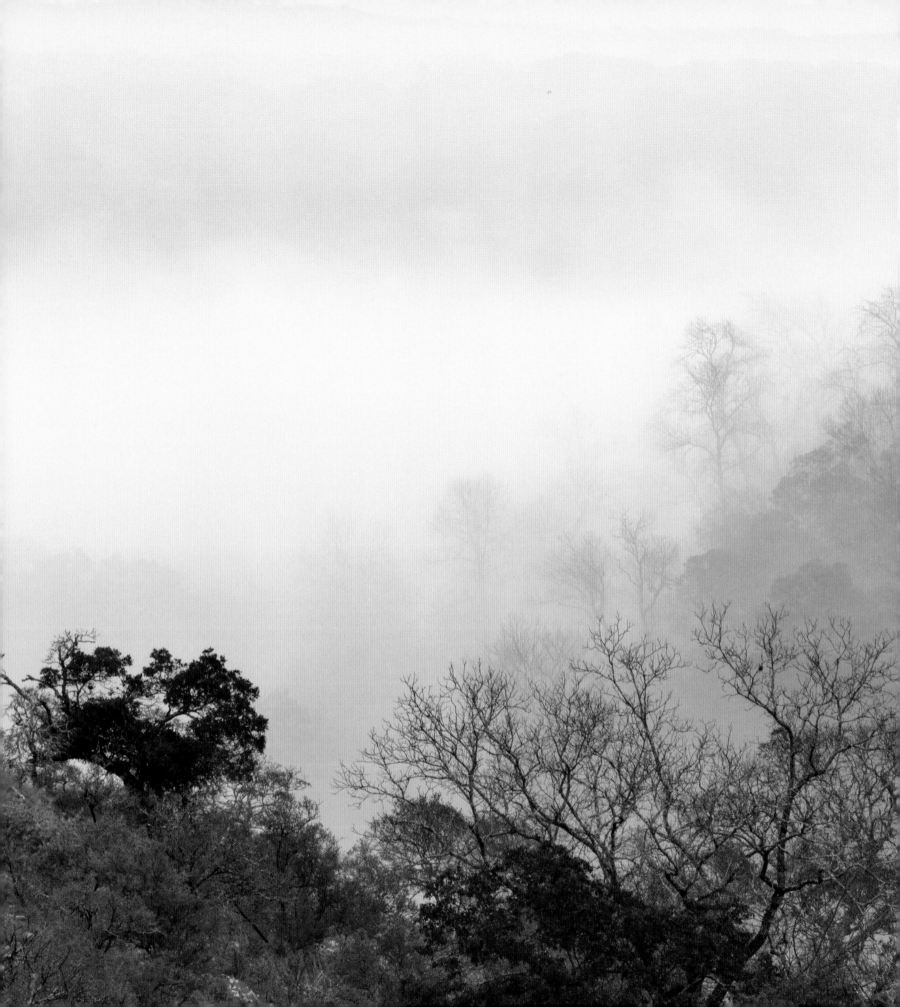

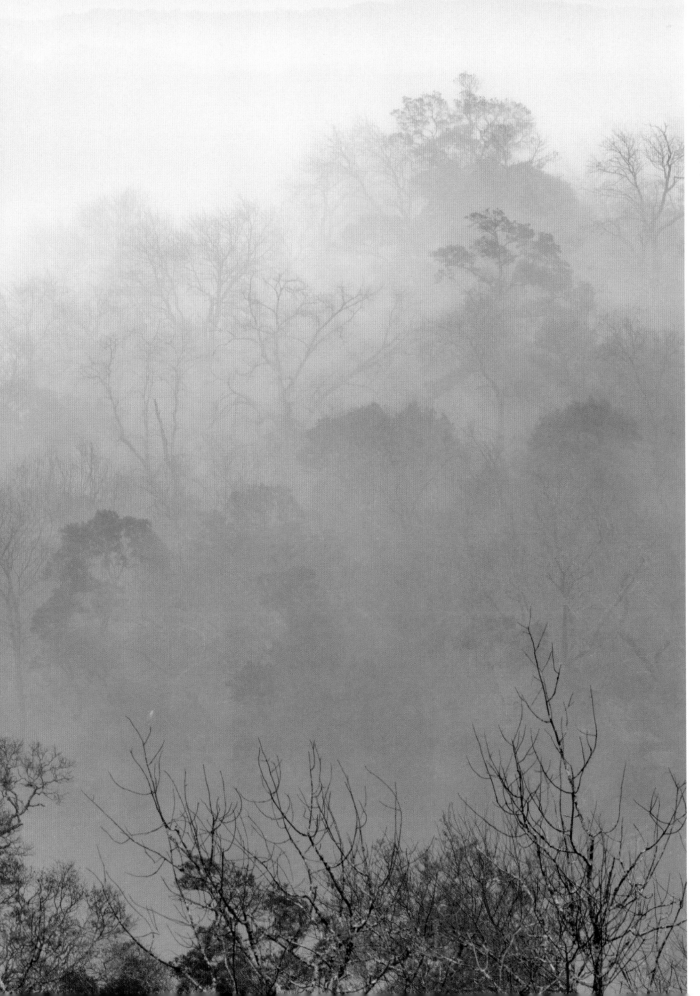

I've often wondered what power keeps drawing a human or animal back to the place where daylight was first blinked at.

—Will James,
Will James' Book of Cowboy Stories

33

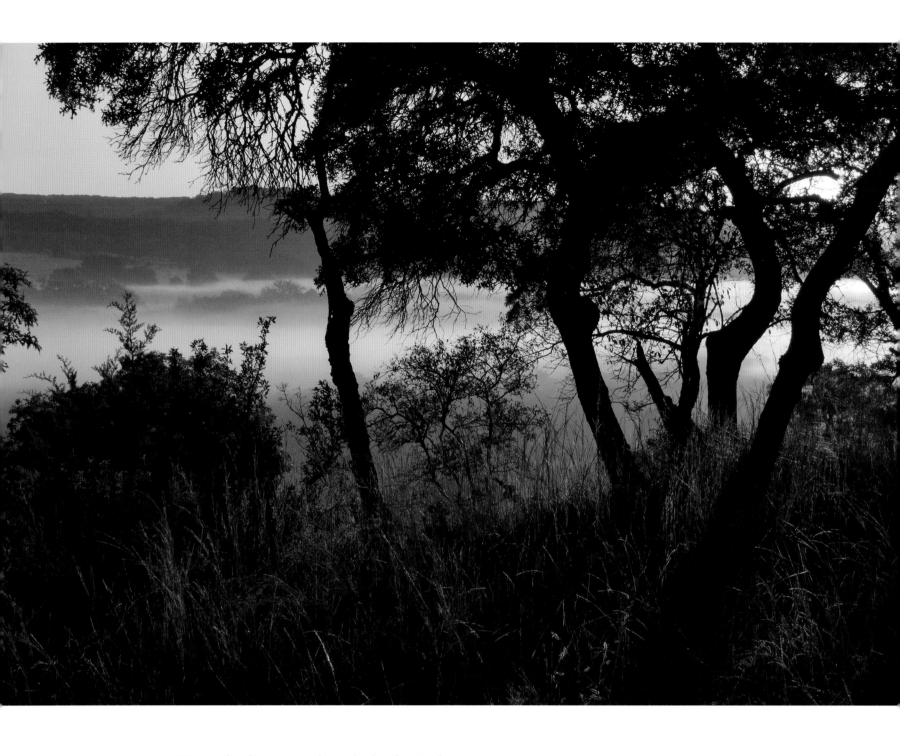

None of us lives apart from the land entirely.

—N. Scott Momaday, *Man Made of Words: Essays, Stories, Passages*

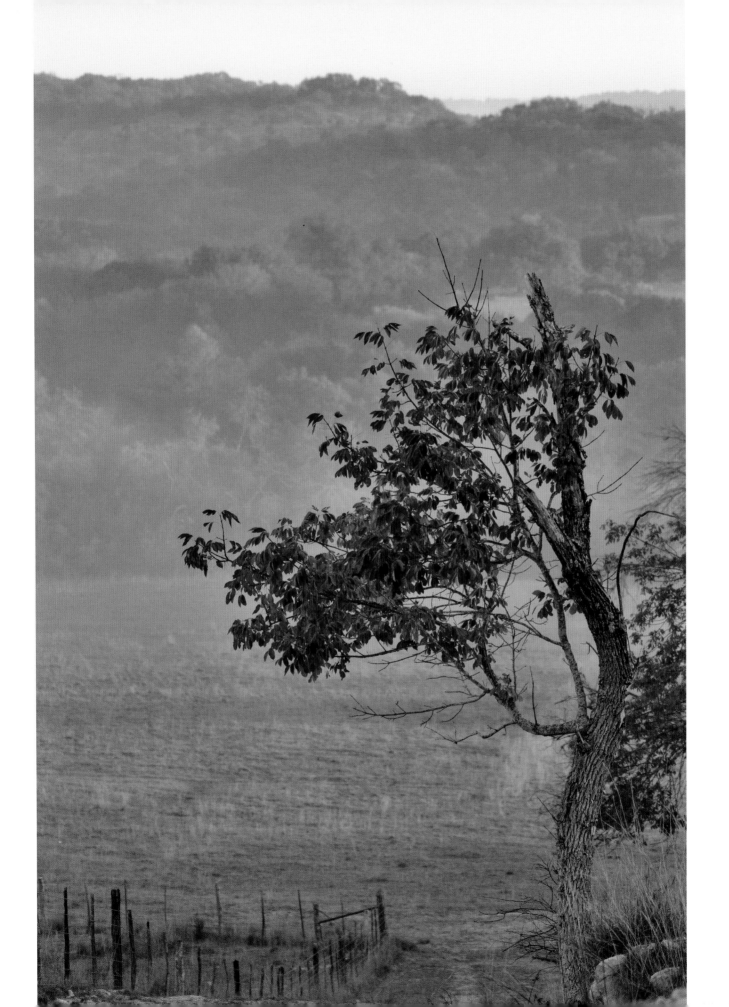

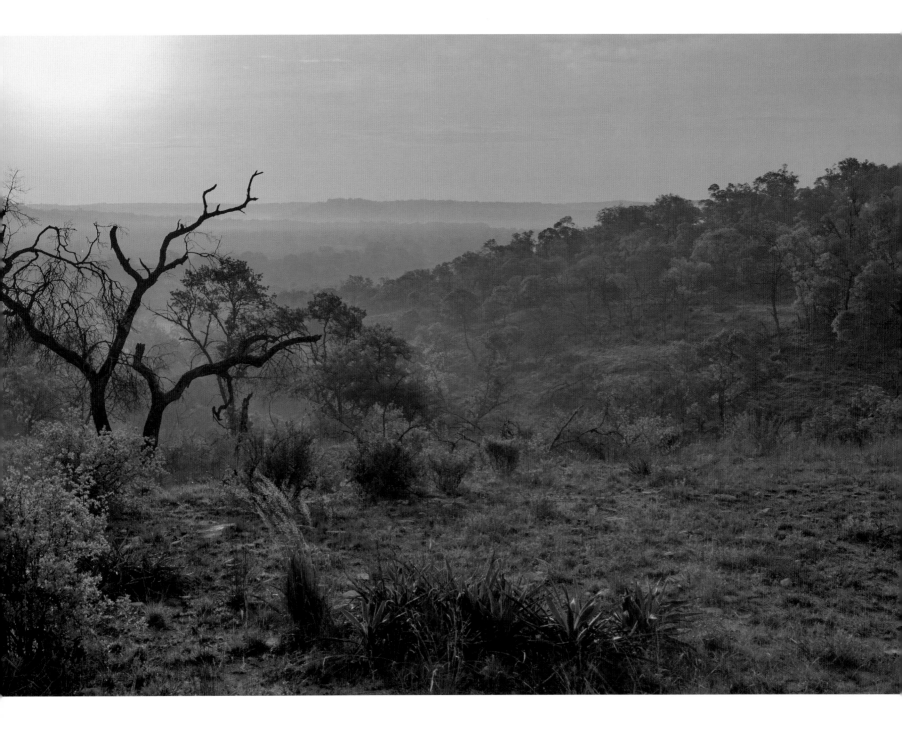

One touch of nature makes the whole world kin.

—William Shakespeare, *Troilus and Cressida*

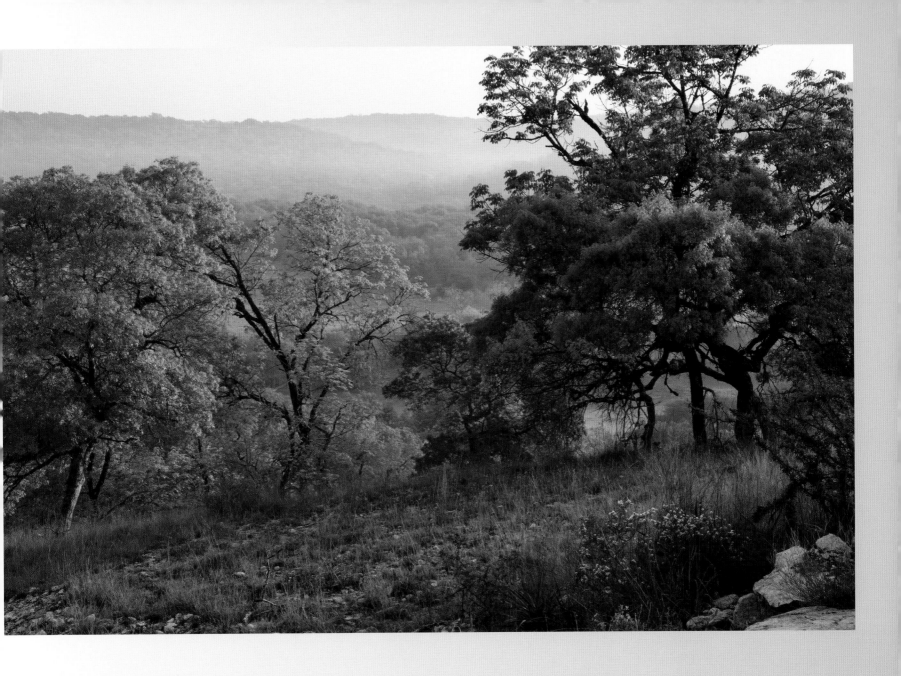

But by Easter the live oaks,
having shed the old,
having thrown in the face of the wind
their tasseled hope,
will float their leaved crowns
like a benediction
above the shadows of the year.

—Margie McCreless Roe, "Live Oak Spring"

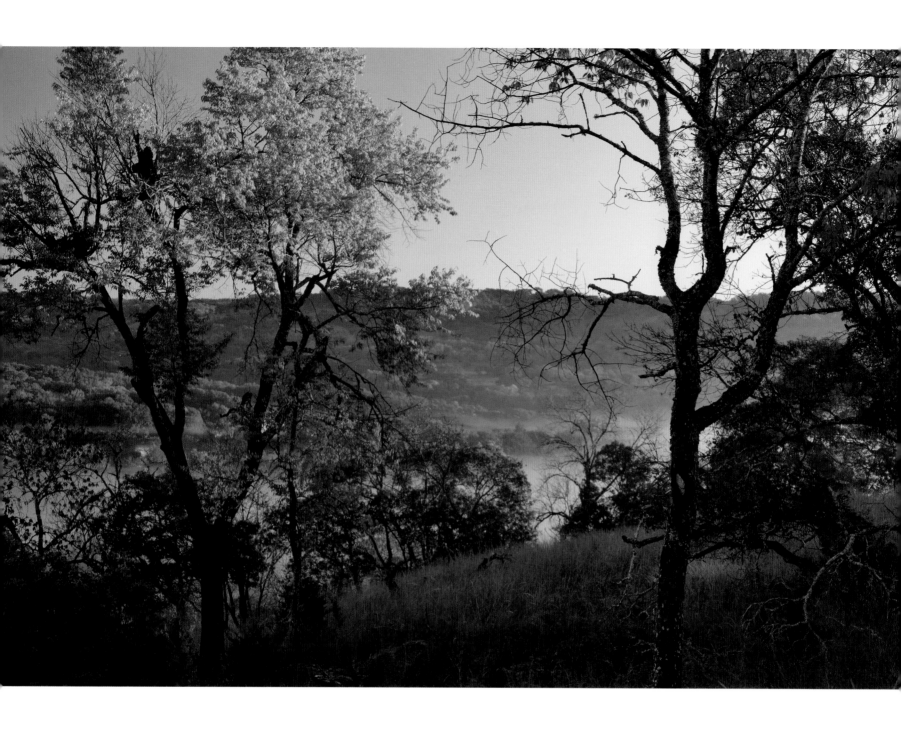

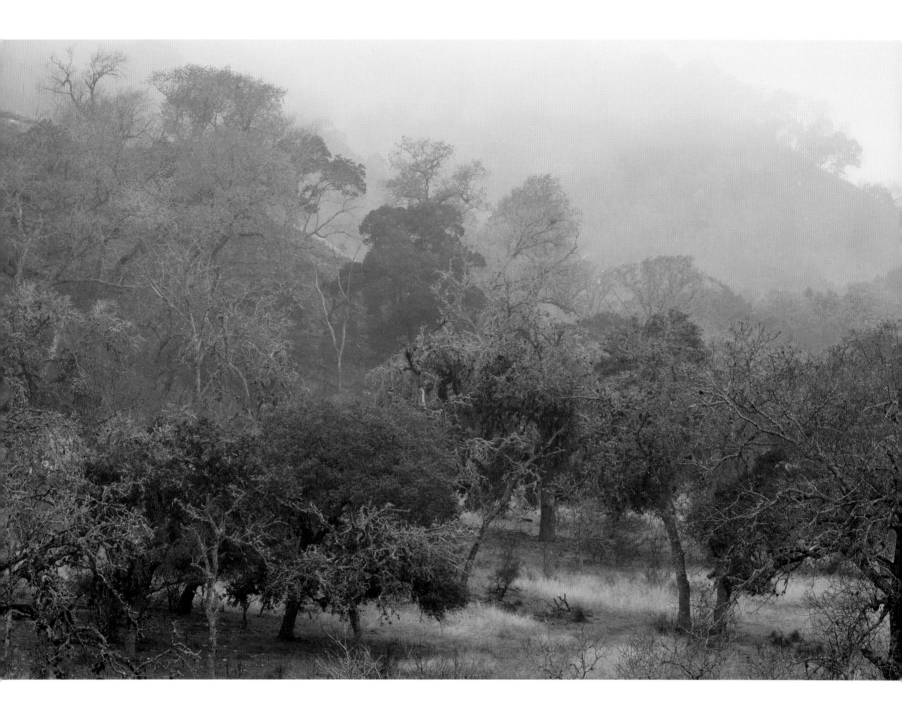

Yesterday morning it looked like three weeks rainy weather had set in, but the afternoons of both days turned out beautiful, and today was one of the grandest I have experienced here.

—Ida Kapp, 1850, "Letter"

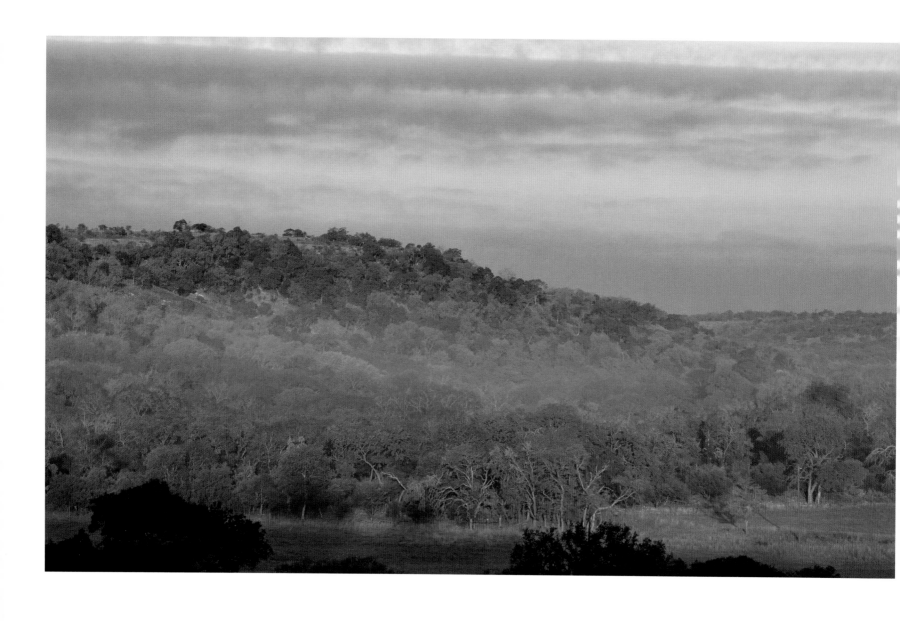

Laws change; people die; the land remains.

—Abraham Lincoln in Carl Sandburg, *Abraham Lincoln: The War Years*

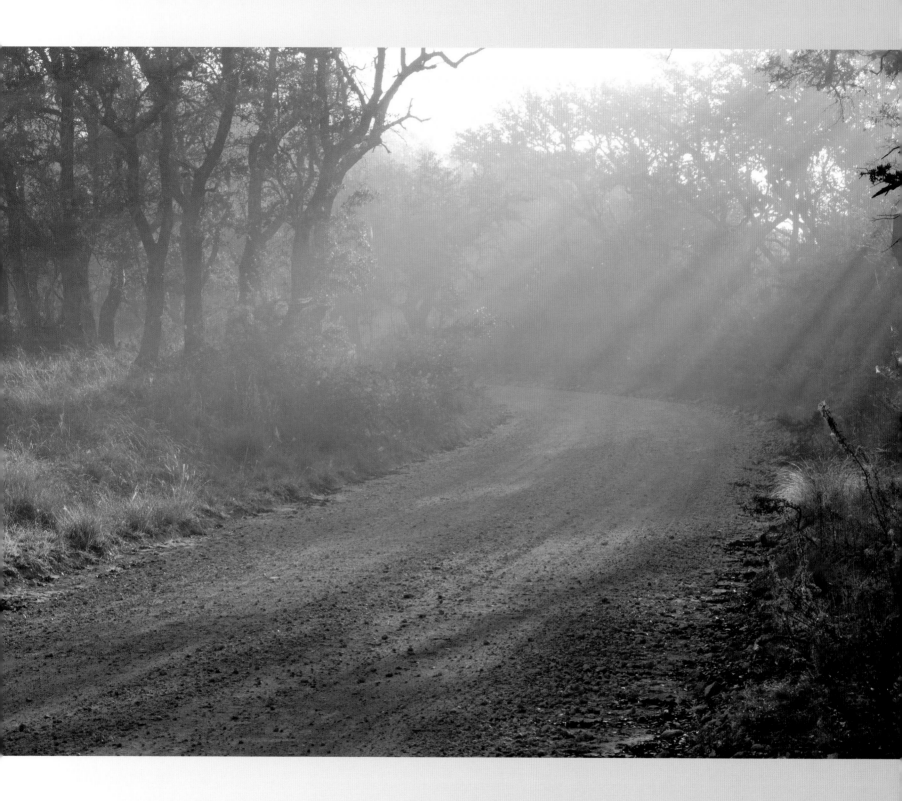

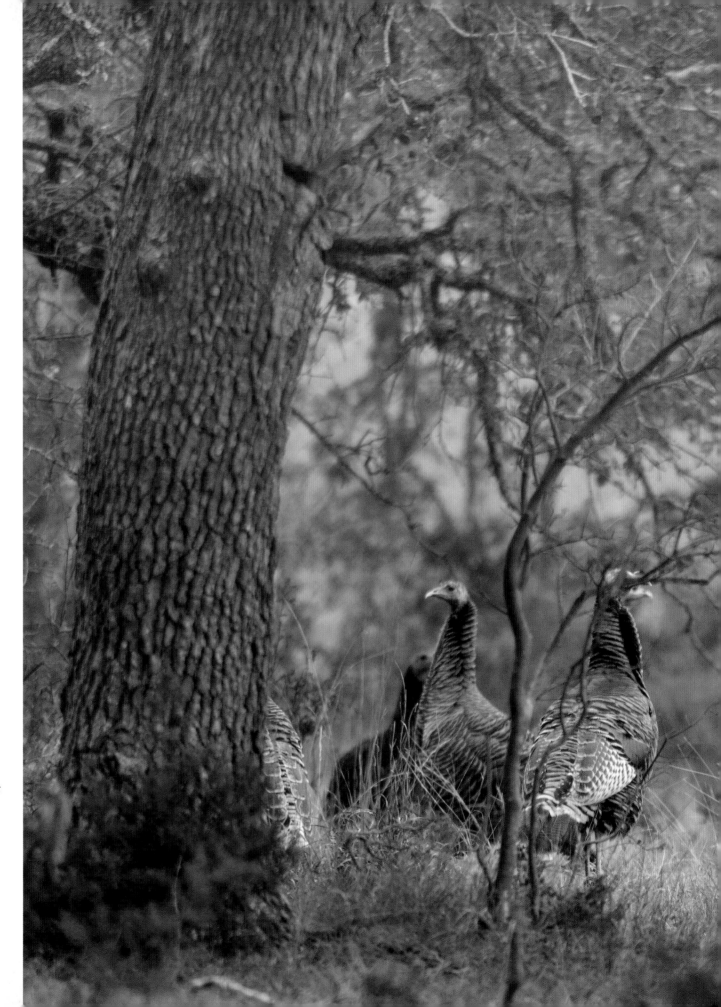

An ancient folk, intent on their work

—Margie McCreless Roe, "Wild Turkeys"

42

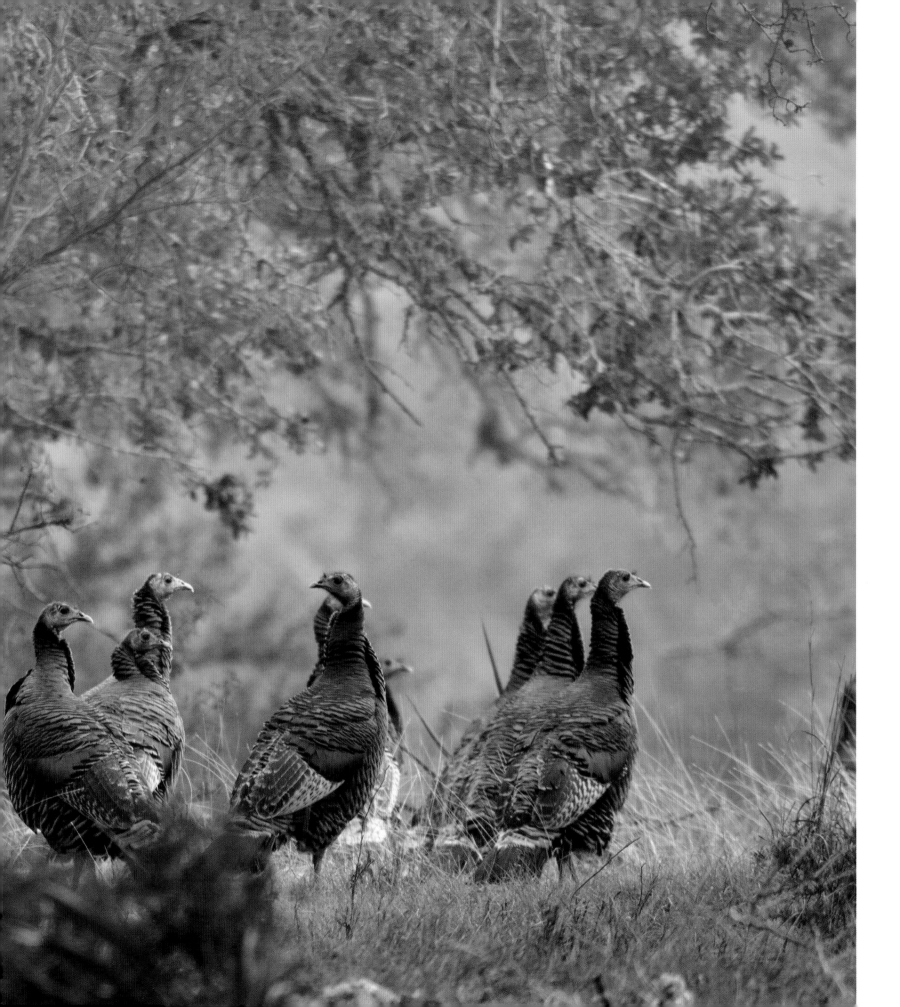

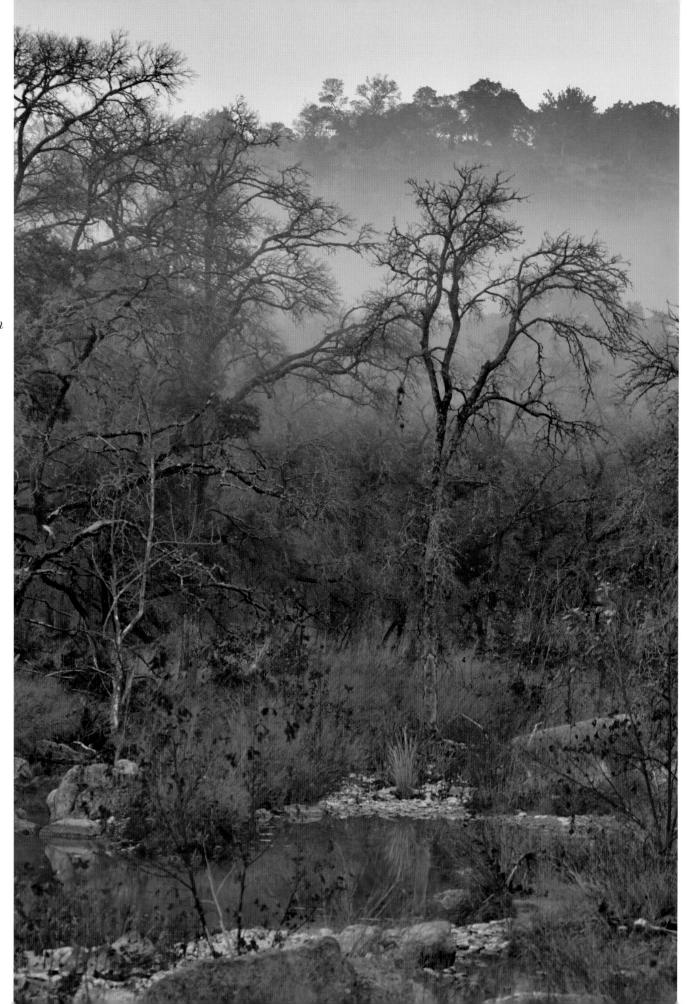

A ghost, if you will, holds the creek's place, moving slowly in darkness below the dry, sun-baked surface. . . . Dig, and the water will come to light.

—Barry Lopez, "Blind Creek" in *Home Ground: A Guide to the American Landscape*

There,
 there says the fog.
Where, where? You
 can't see a thing.

—Dean Young, "Son
of Fog"

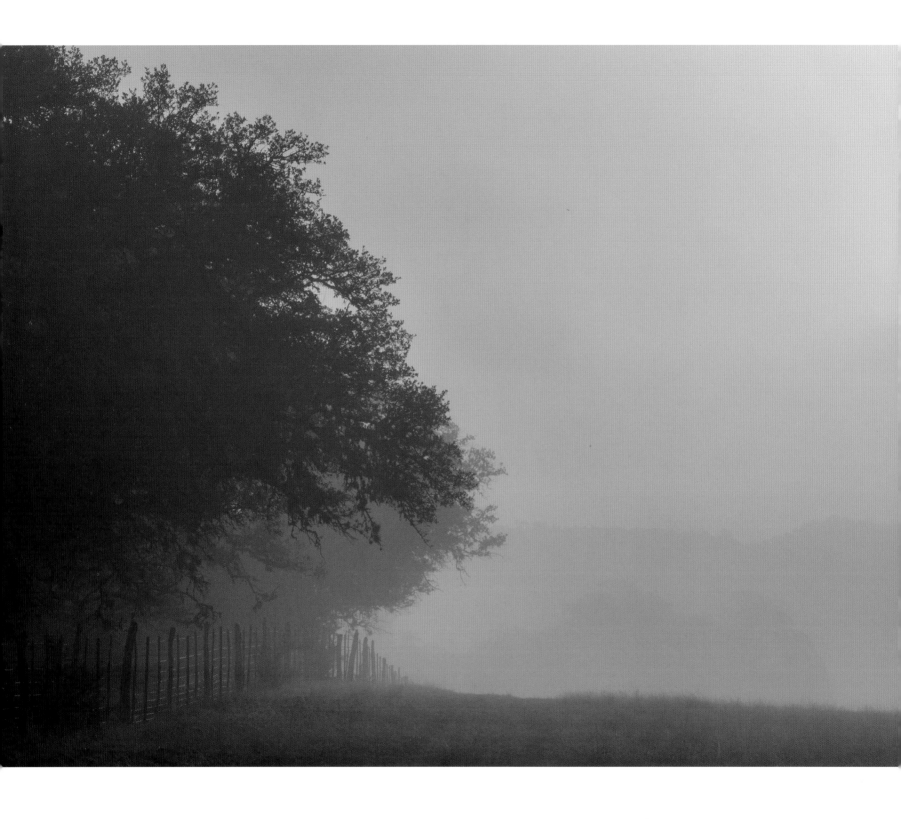

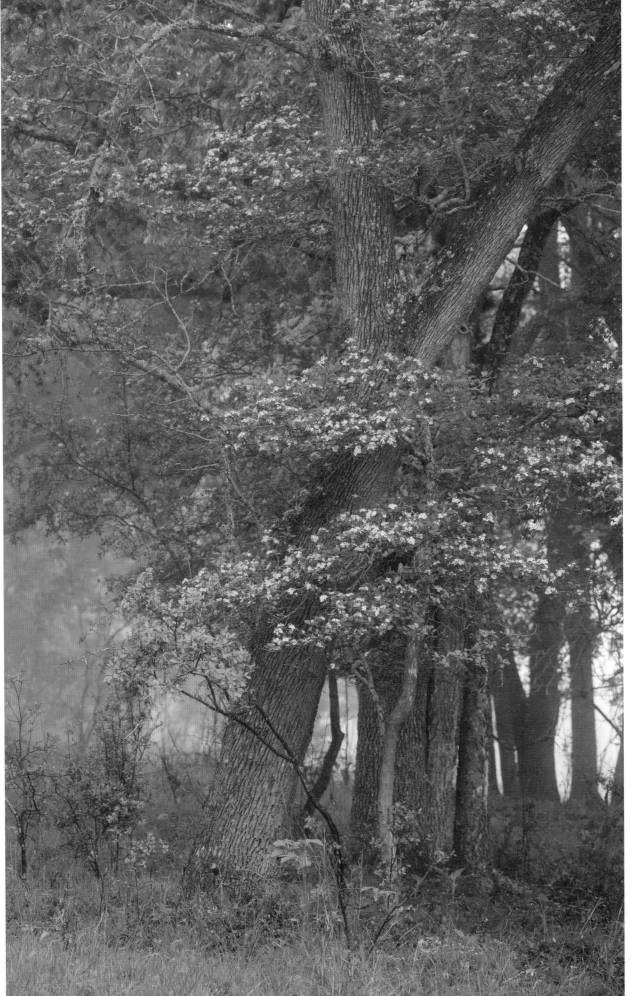

I come into the peace
 of wild things
who do not tax their
 lives with forethought
of grief. I come into
 the presence of still
 water.

. . . For a time
I rest in the grace of
 the world and am
 free.

—Wendell Berry, "The
Peace of Wild Things"

47

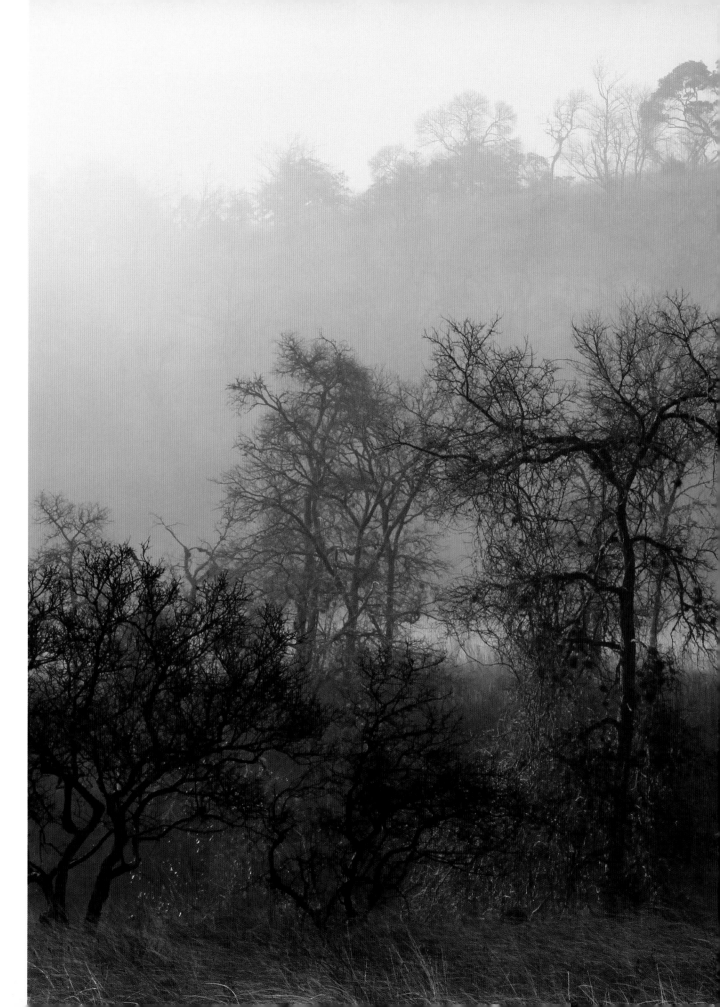

Edges of light
fascinate me. . . . I
search for perfect
light, then hunt
for something
earthbound to match
it with.

—Galen Rowell,
Mountain Light

48

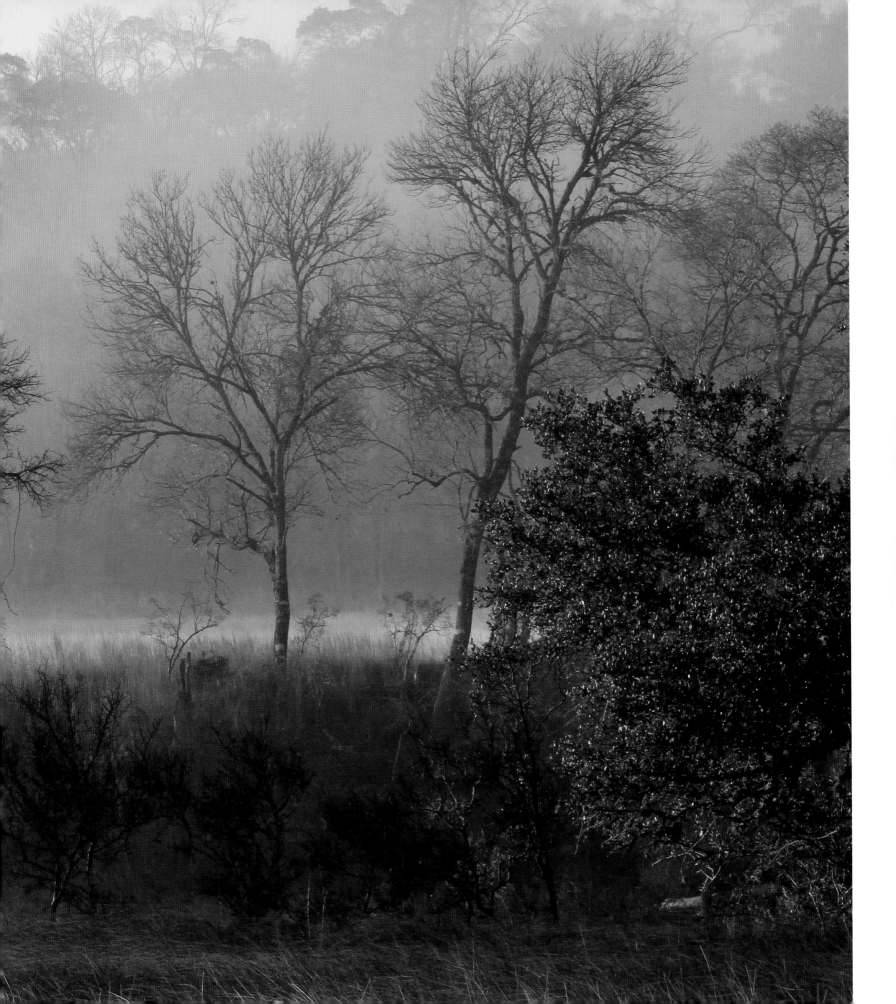

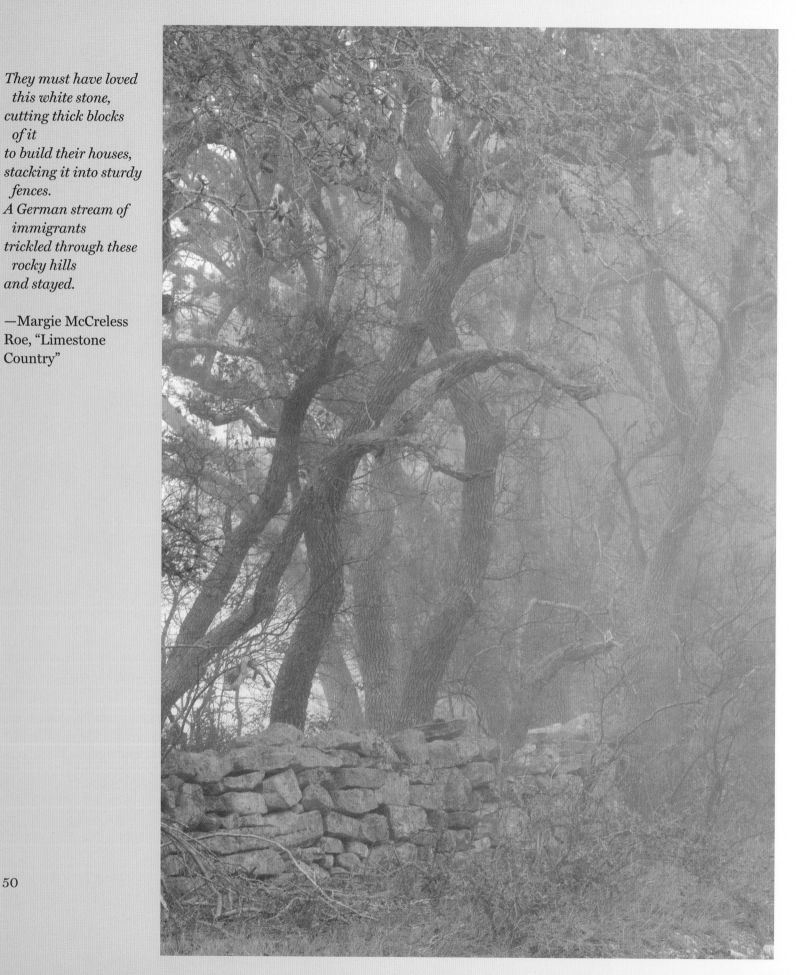

*They must have loved
this white stone,
cutting thick blocks
of it
to build their houses,
stacking it into sturdy
fences.
A German stream of
immigrants
trickled through these
rocky hills
and stayed.*

—Margie McCreless
Roe, "Limestone
Country"

50

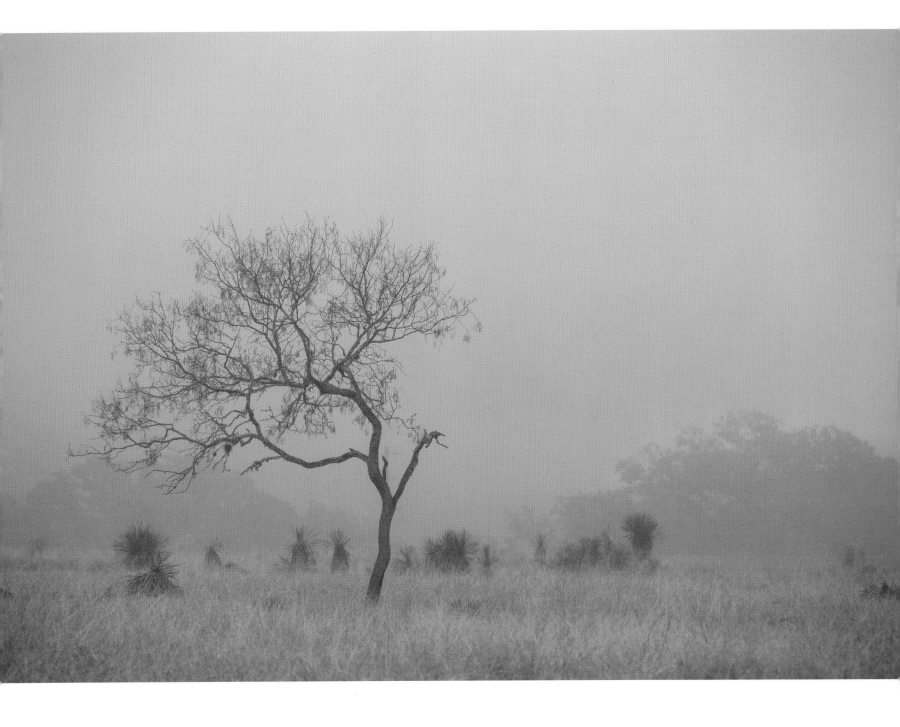

If a man is rich and strong anywhere, it must be on his native soil.

—Henry D. Thoreau, *Faith in a Seed:
The Dispersion of Seeds and Other Late Natural History Writings*

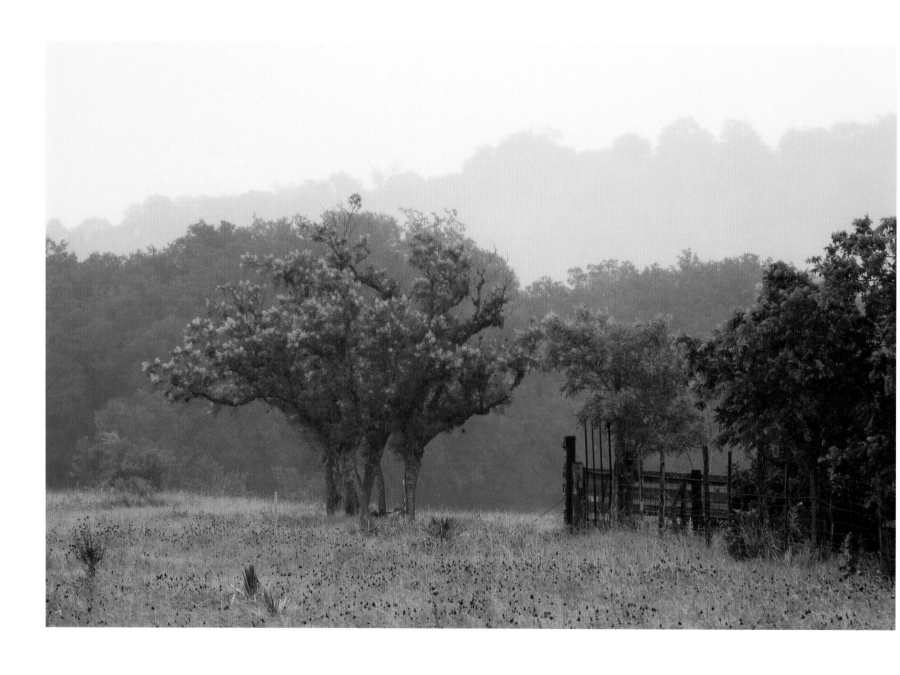

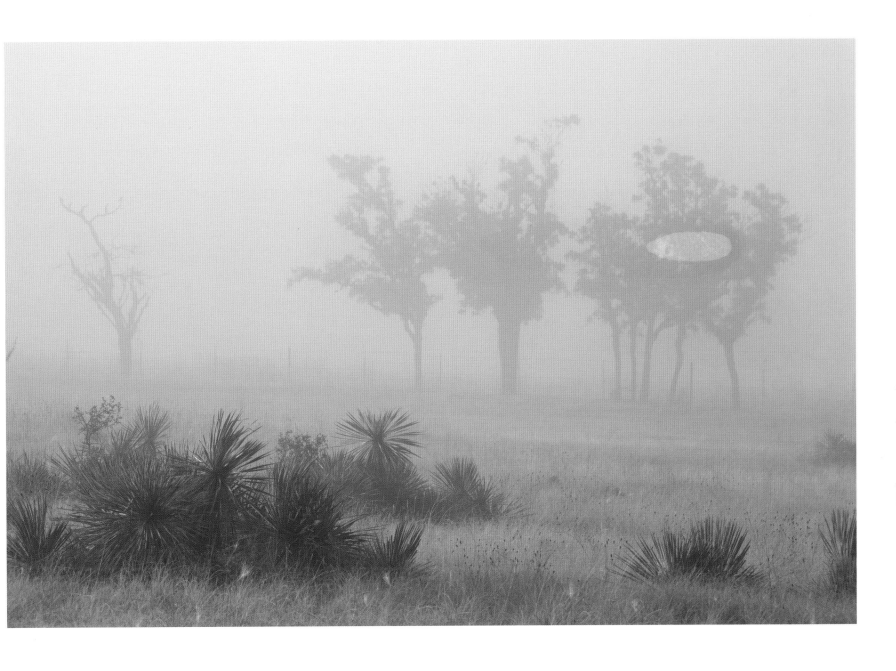

We seem to have lost our native wisdom about matters of the soul, and about those of nature, which I believe are essentially the same thing.

—Richard C. Bartlett, *Saving the Best of Texas: A Partnership Approach to Conservation*

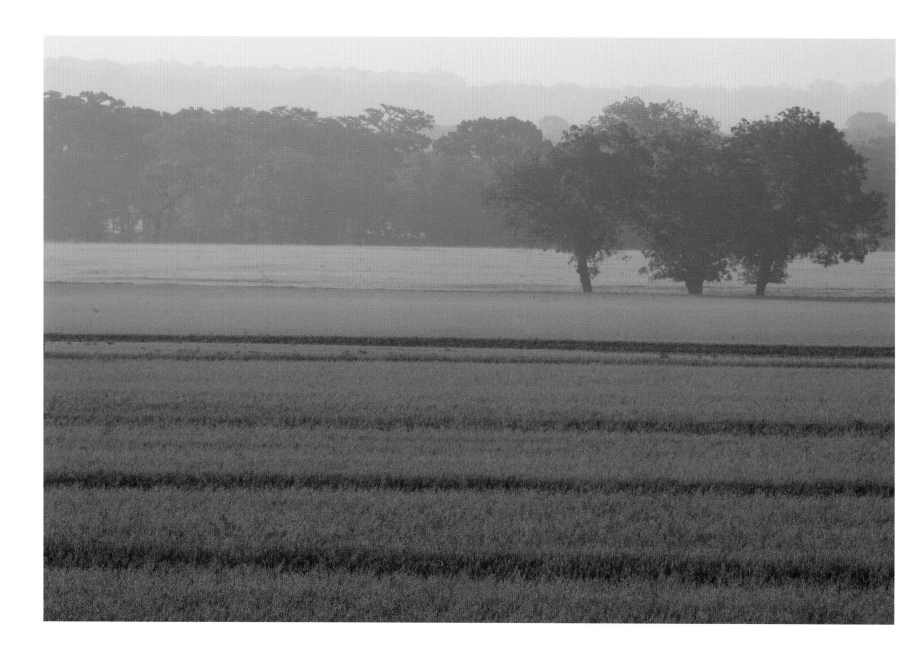

I had never managed to purge myself of the simple yeoman notion, contracted in childhood from kinsmen looking back to a rural past, that grass and crops and trees and livestock and wild things and water mattered somehow supremely, that you were not whole unless you had a stake in them, a daily knowledge of them.

—John Graves, *Hard Scrabble*

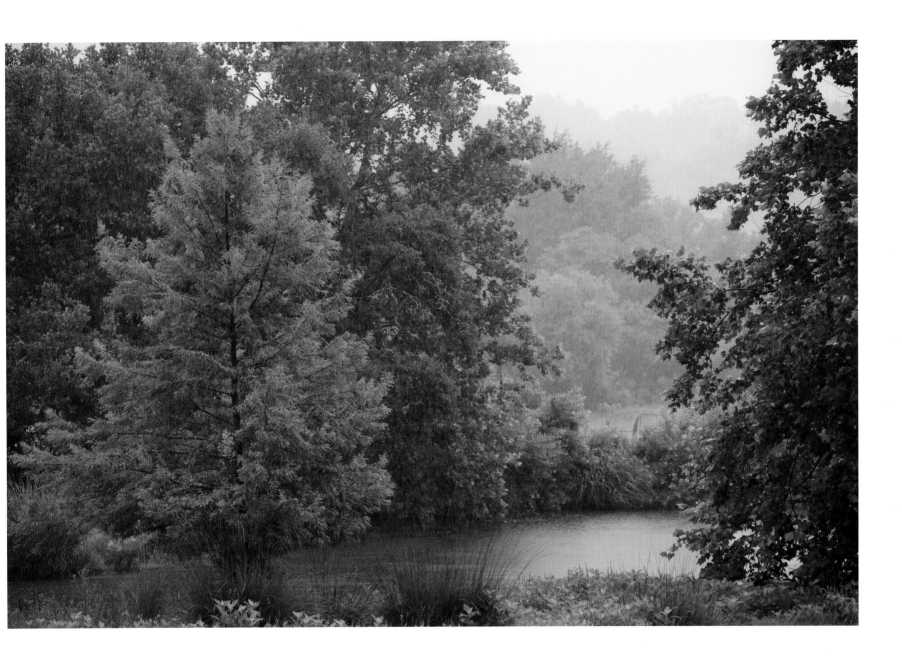

In large part, the creeks, streams, and rivers are what shape and define the landscape. And, for a kid with a love of nature, the creek beds definitely were the place to be.

—Myron J. Hess, "Hooked on Rivers"

These are noble creatures. Throughout the ages, we have revered and respected raptors, admiring their courage, strength and dignity.

—John Karger, master falconer, in "Last Chance Forever"

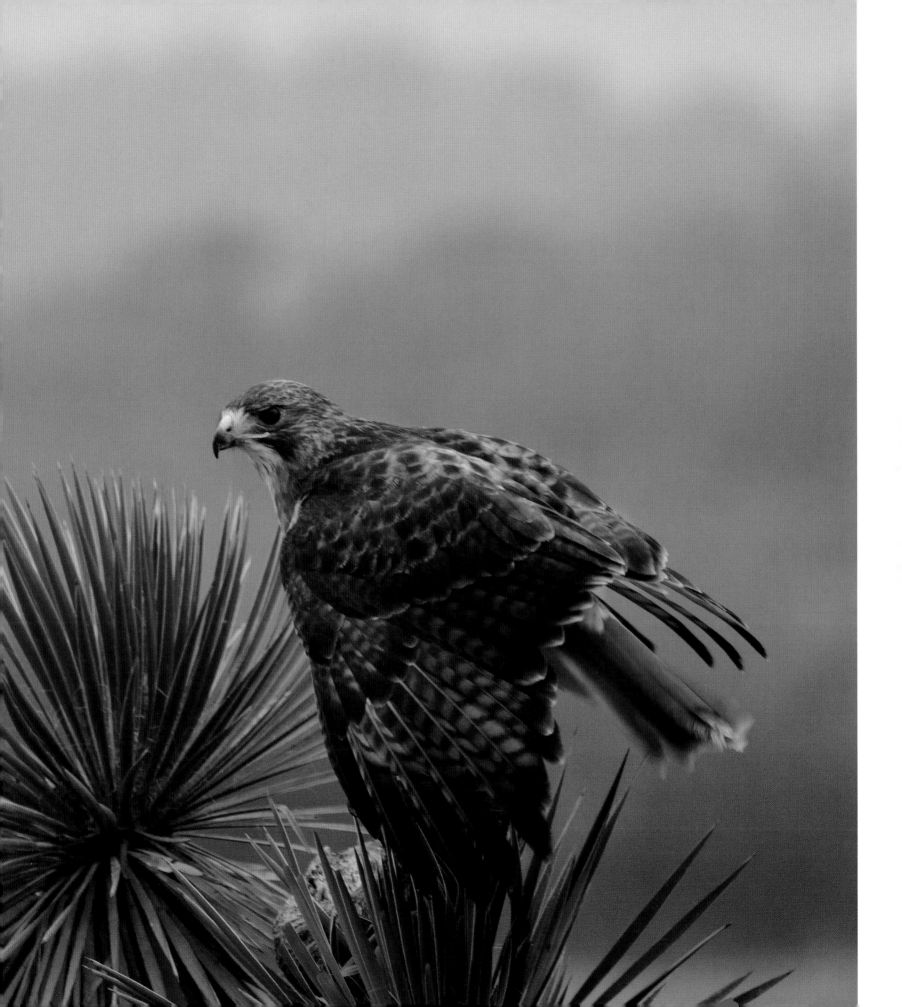

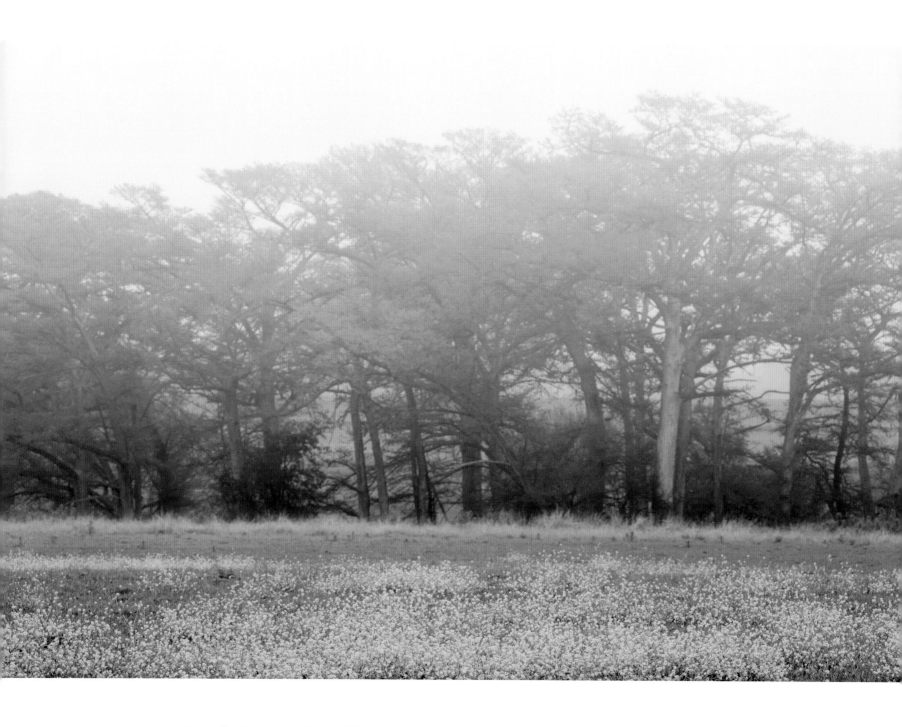

Come forth into the light of things,
Let Nature be your teacher.

—William Wordsworth, "The Tables Turned"

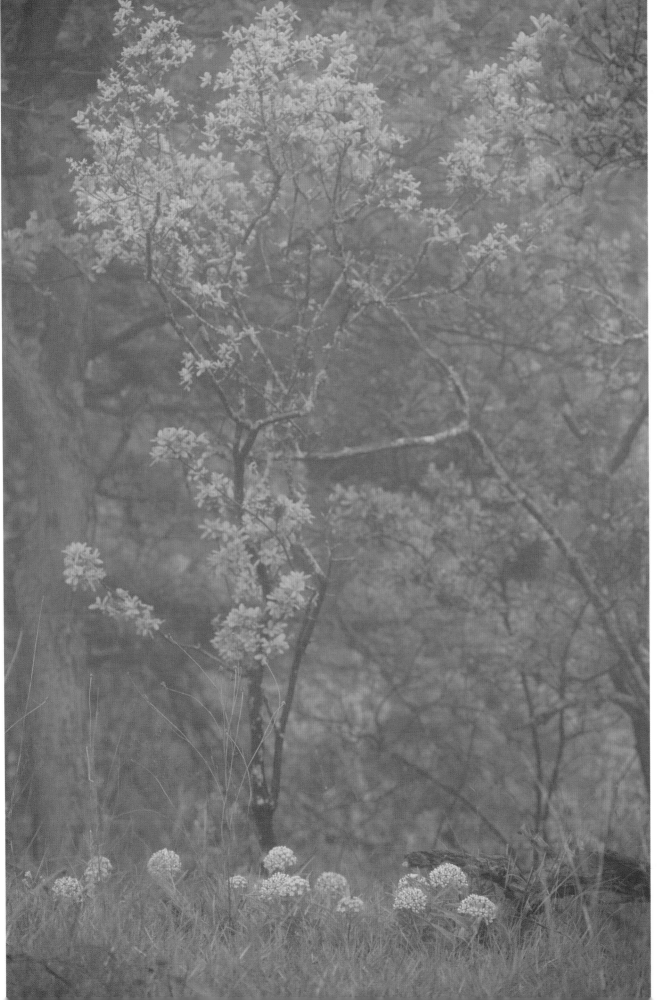

Monarchs lay their eggs on milkweed plants; hence monarch biology is tied closely to milkweed biology.

—Karen S. Oberhauser, "Overview of Monarch Breeding Biology"

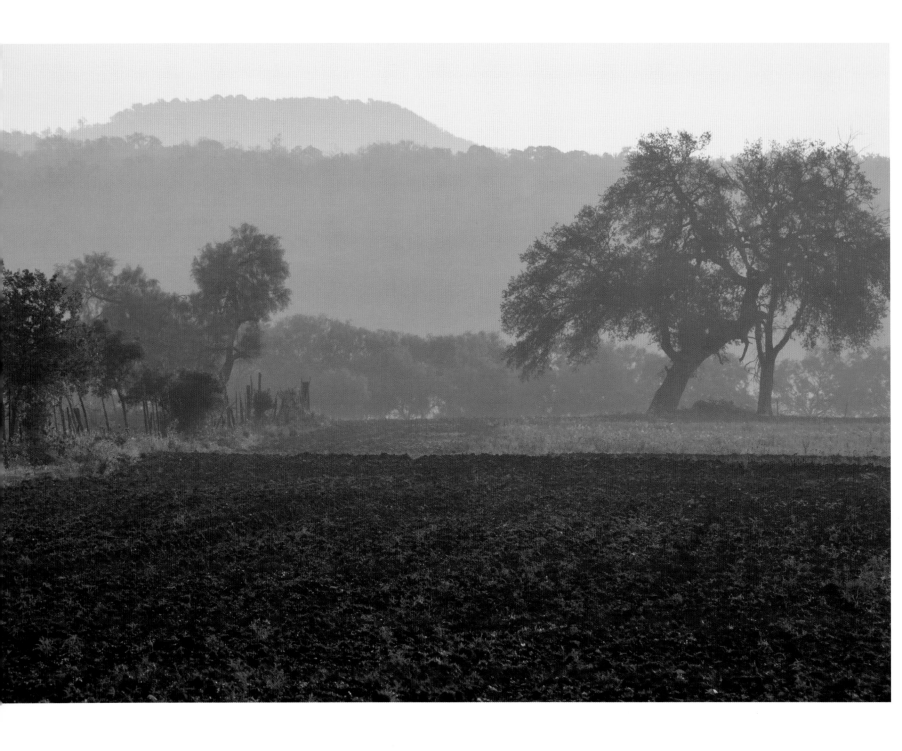

You know this soil. You know the feel of it, the smell, the growing warmth within it. It has been here for untold ages and it was green with life long before man came to stir it for his own purpose.

—Hal Borland, *An American Year*

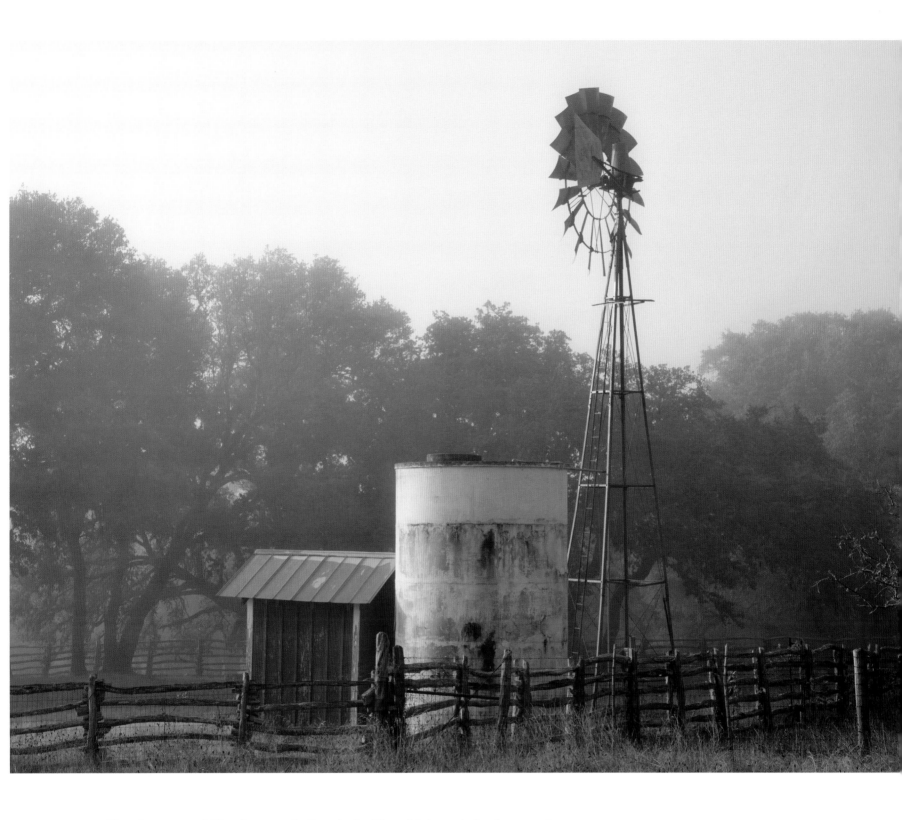

There's no sound like the sound of a windmill makin' music in the morning
As it reaches high to catch the early winds of dawn.
The harmony of nature flows down through the tower.

—Jim Chesnut, "The Music of a Windmill"

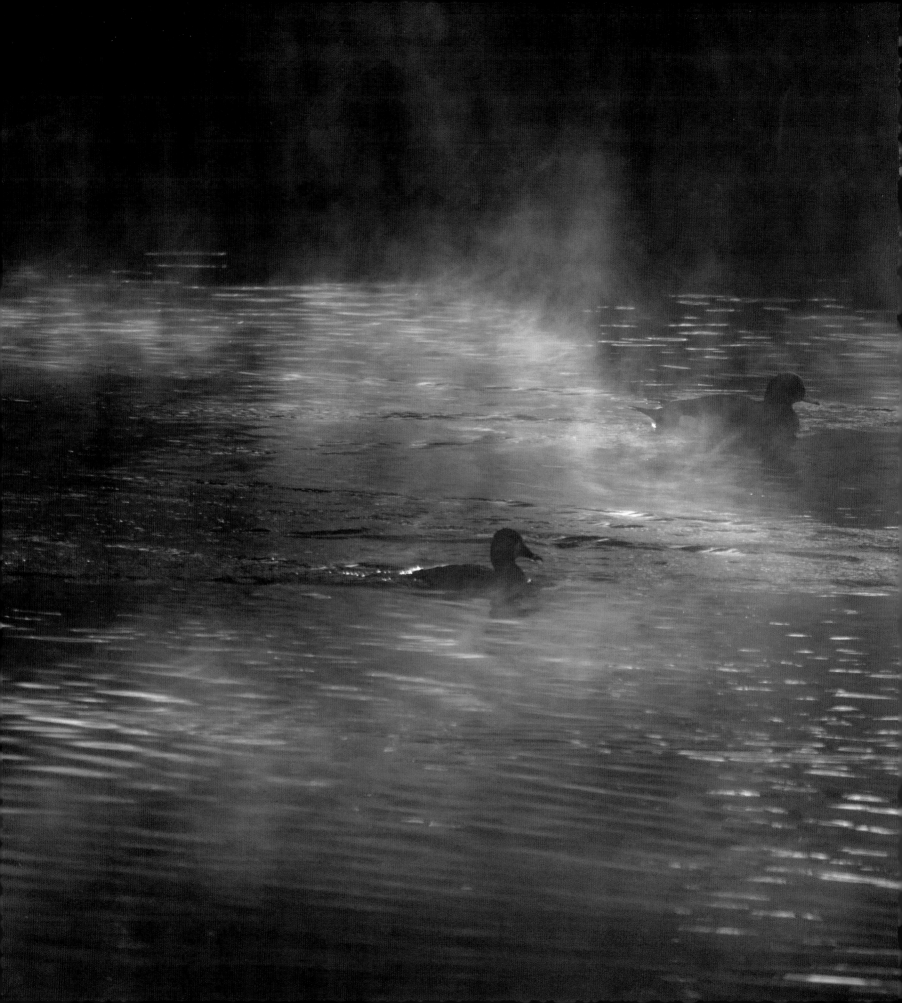

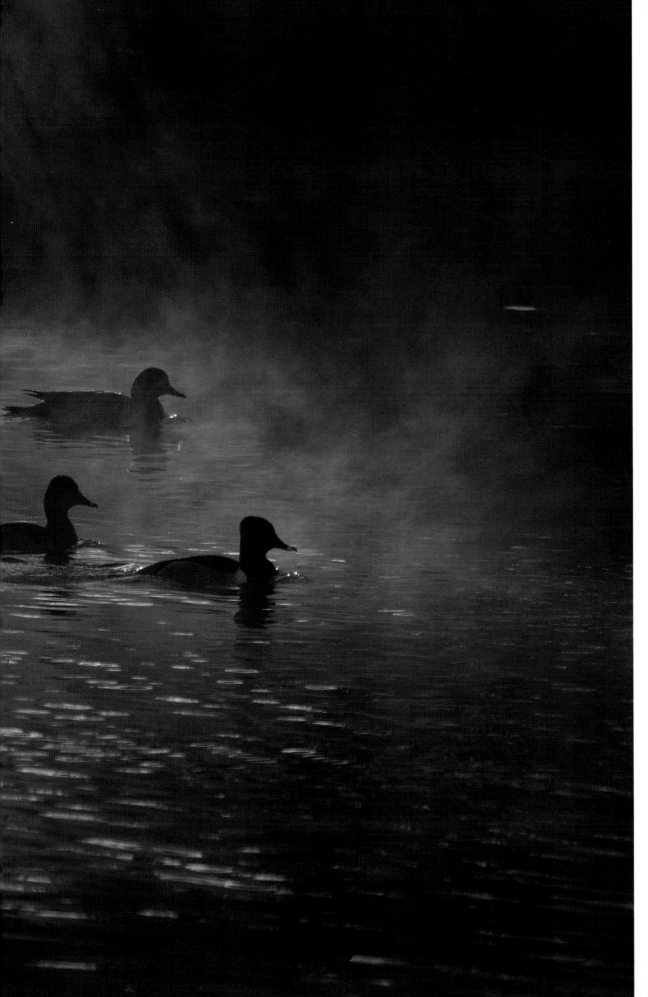

You are comfortable in this spot
so full of grace and being
that it sparkles like jewels
spilled on water.

—Tom Hennen,
"From a Country Overlooked"

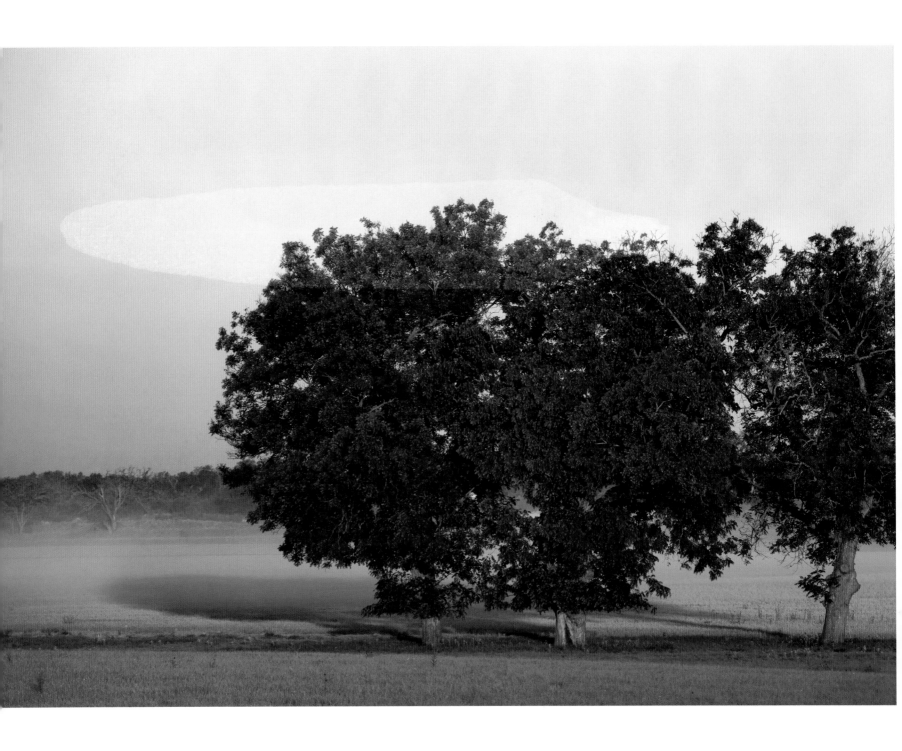

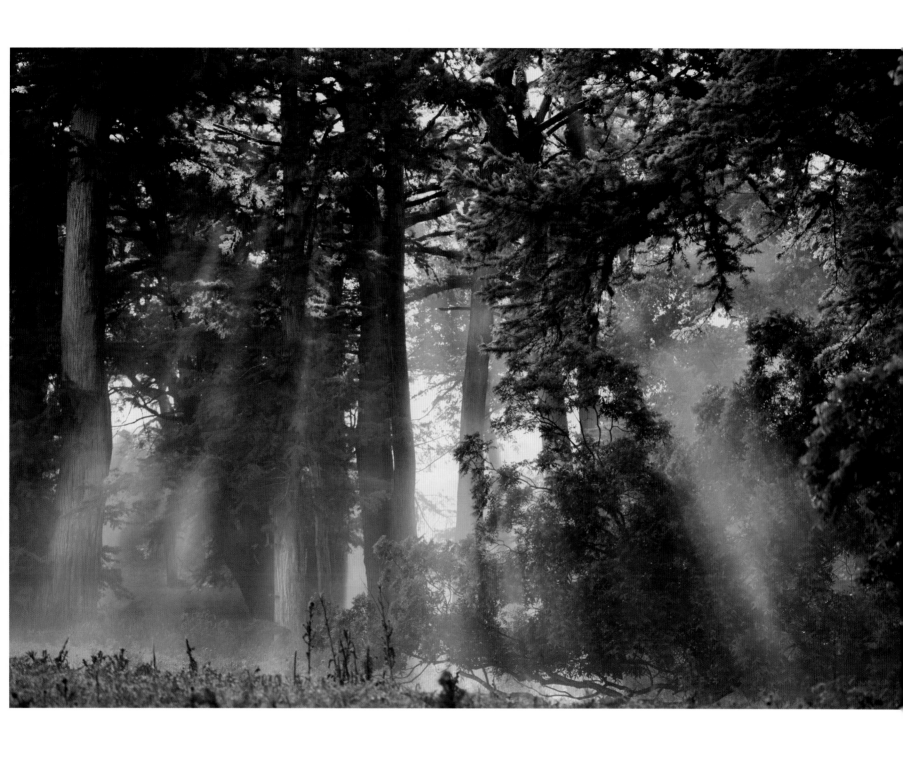

*The trees lock arms
And lean into each other like
Relatives at a family reunion.*

—Robert Kinsley, "Reunion"

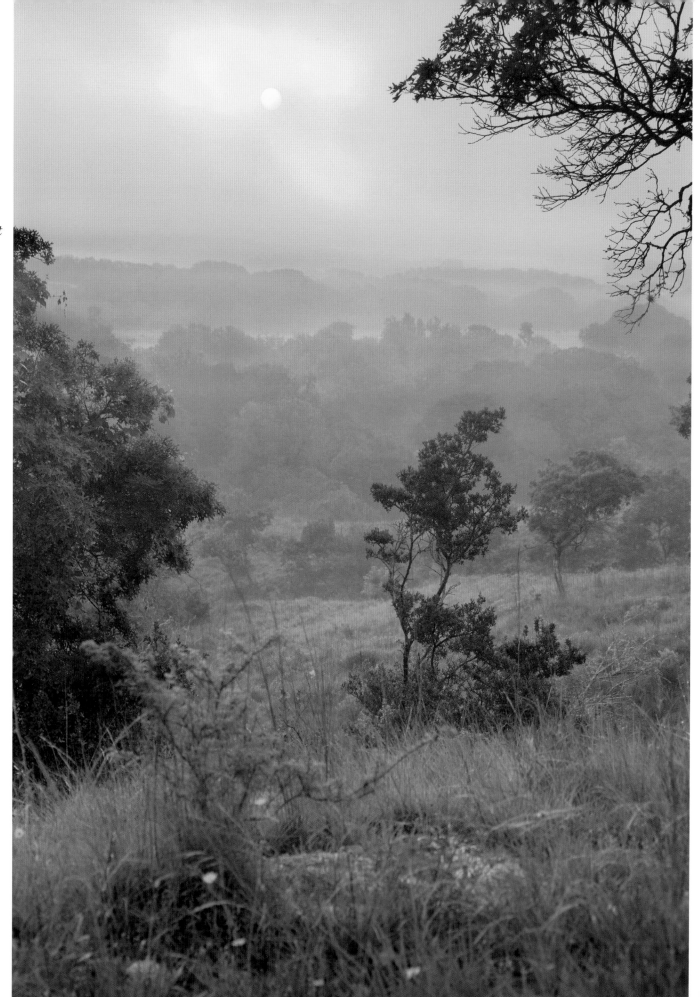

The sunlight needs
no praise piercing the
raincloud,
Painting the rocks and
leaves with light, then
dissolving
Each lucent droplet
back into the clouds that
engendered it.

—Dana Gioia, "Words"

66

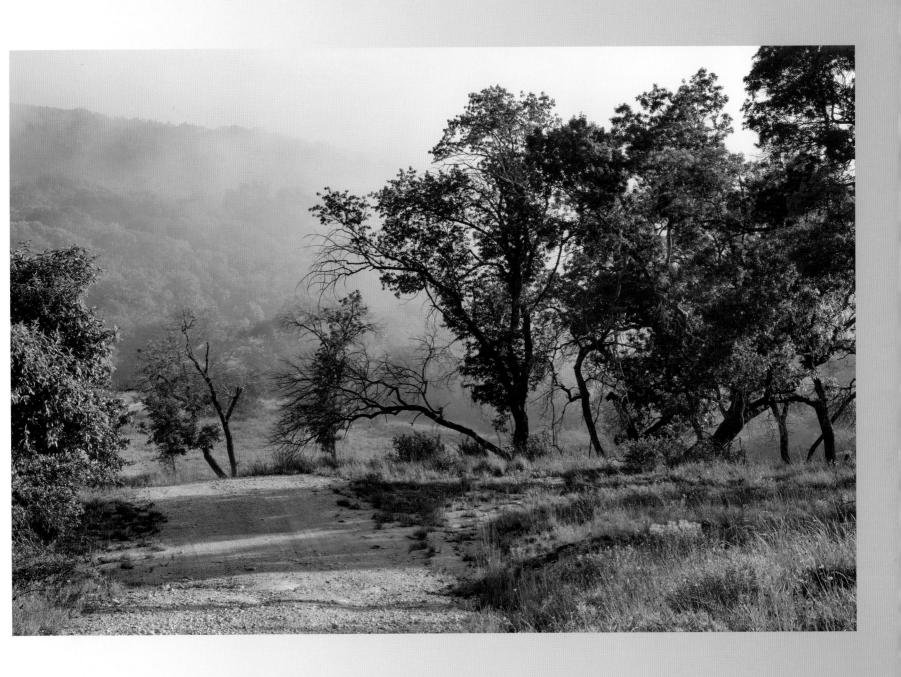

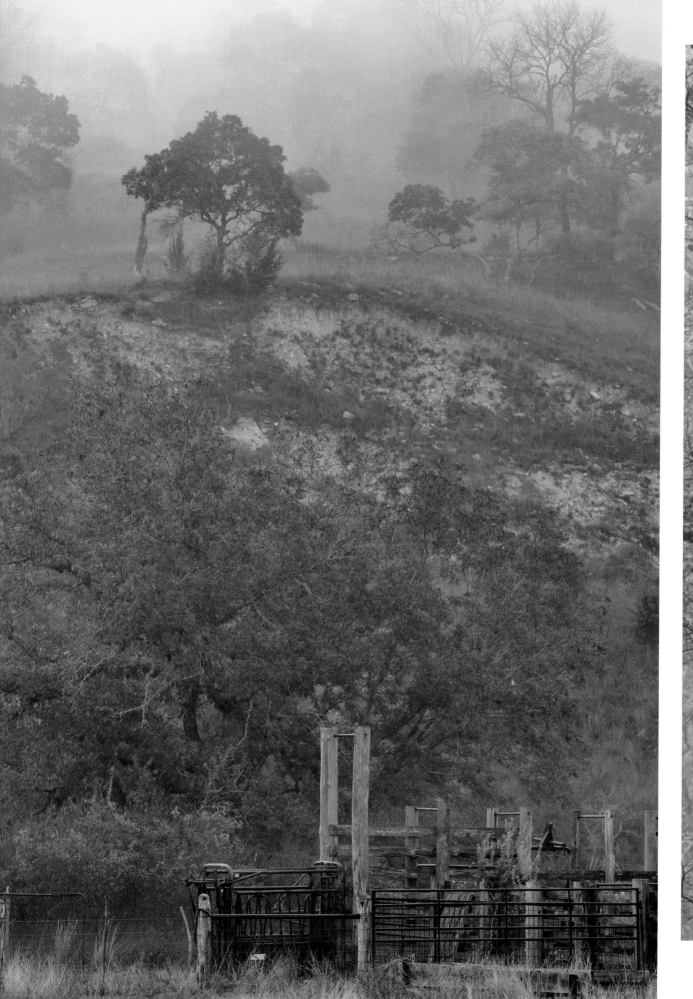
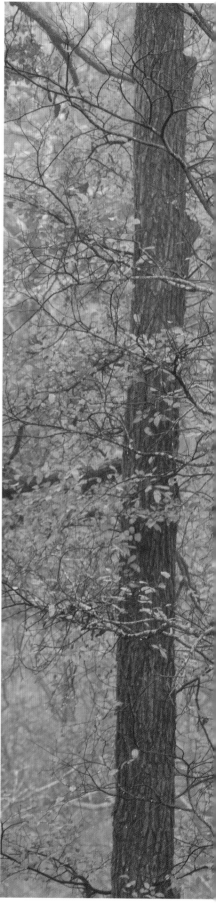

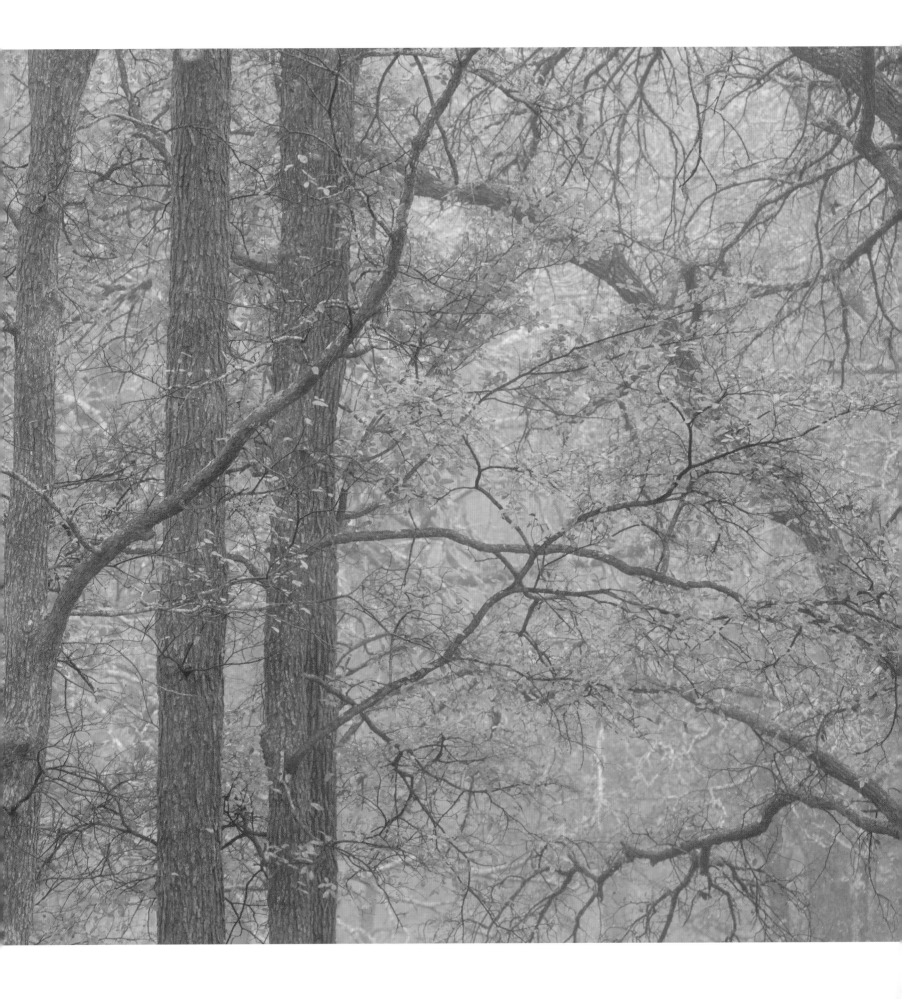

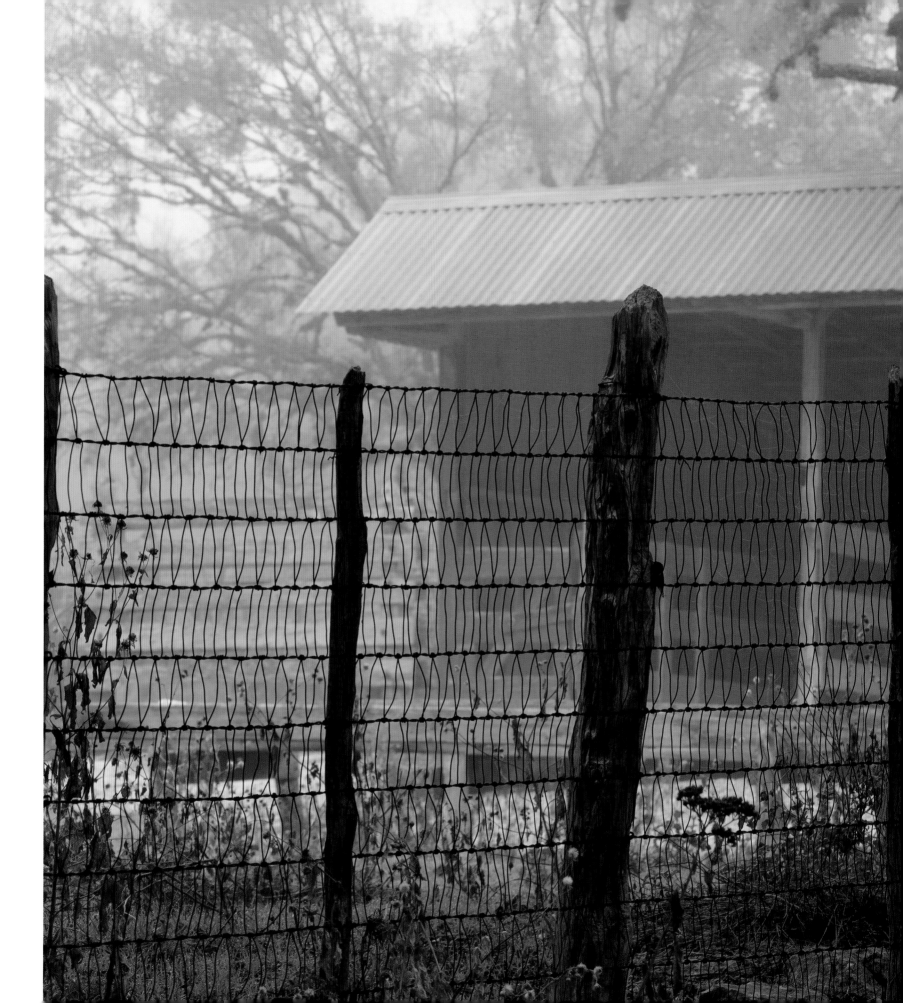

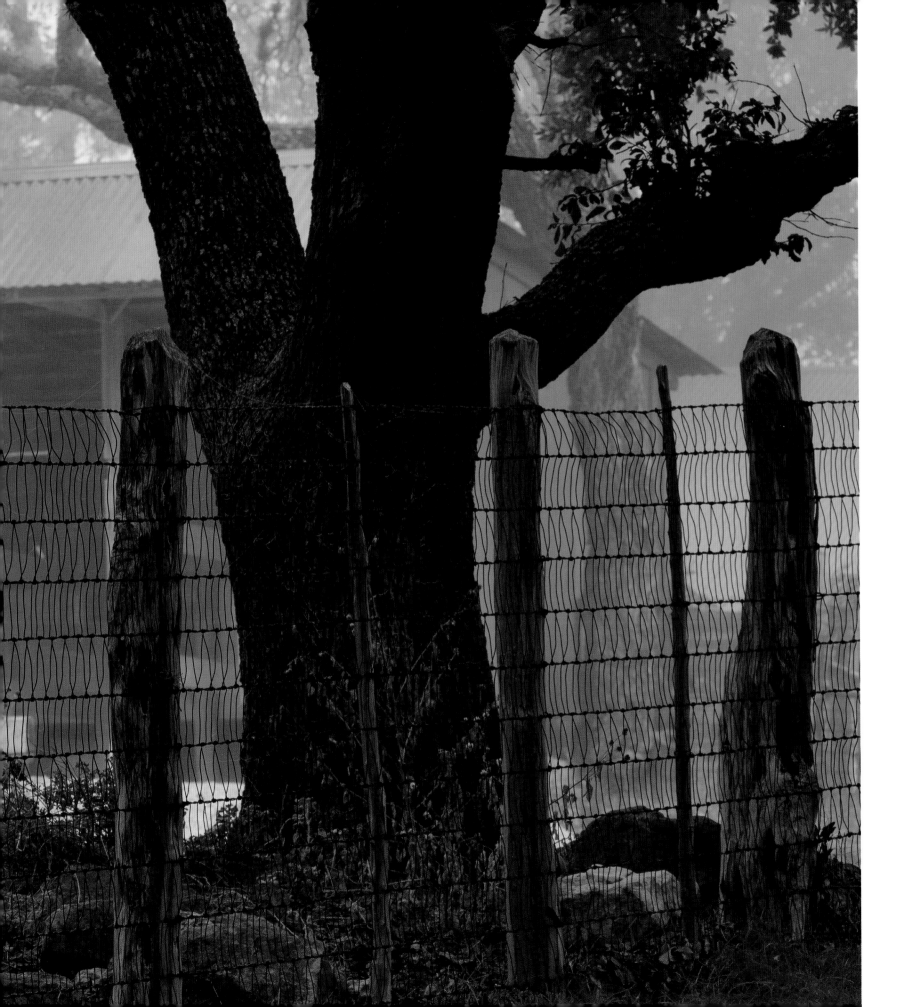

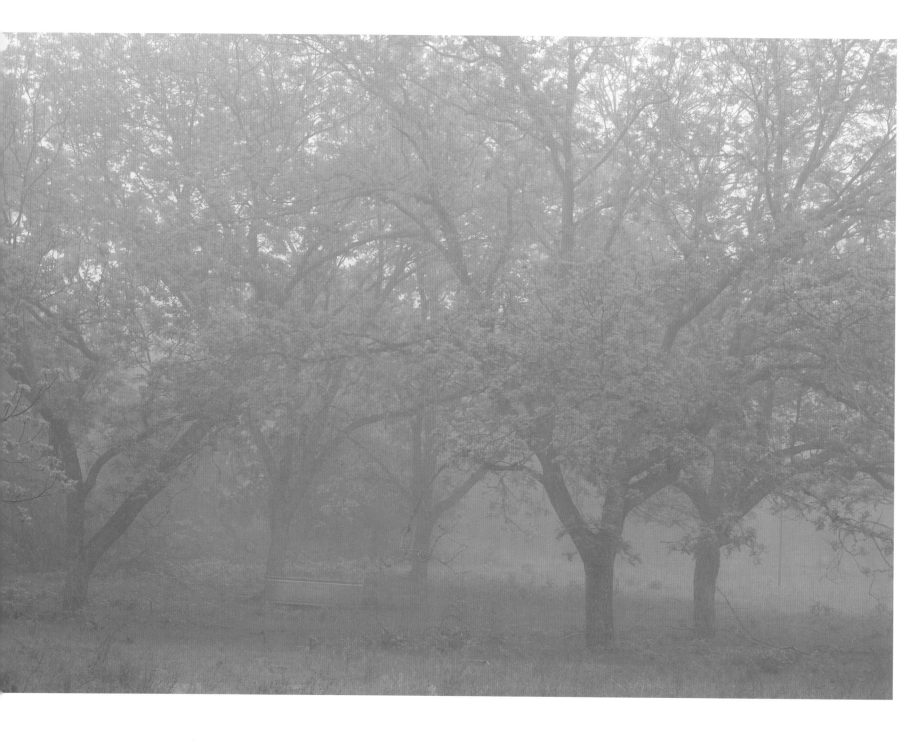

The nuts were a favorite food of the Indians and are an important food source for many wildlife species.

—Paul W. Cox and Patty Leslie, "Pecan" in *Texas Trees: A Friendly Guide*

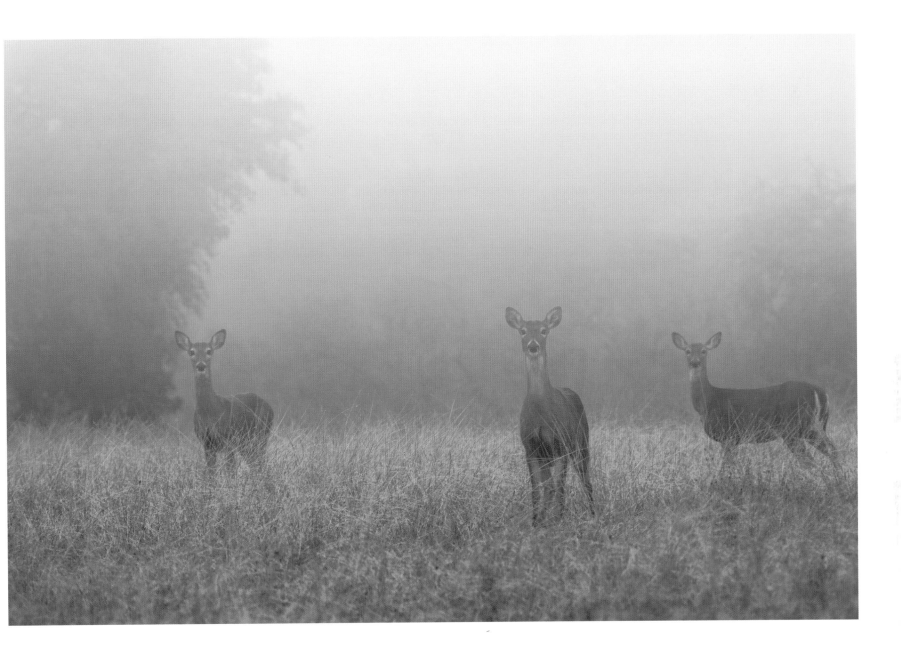

The white-tail deer have survived . . . by becoming the furtive shadows in the thickets, but they were not always these timid creatures hiding all day in the solitude of the deepest brush. Our explorers found them ranging all day in the "immense herds" throughout the prairies. They were numerous and bold enough to at least share that court as lords of the prairies.

—Del Weniger, *The Explorers' Texas: The Animals They Found*

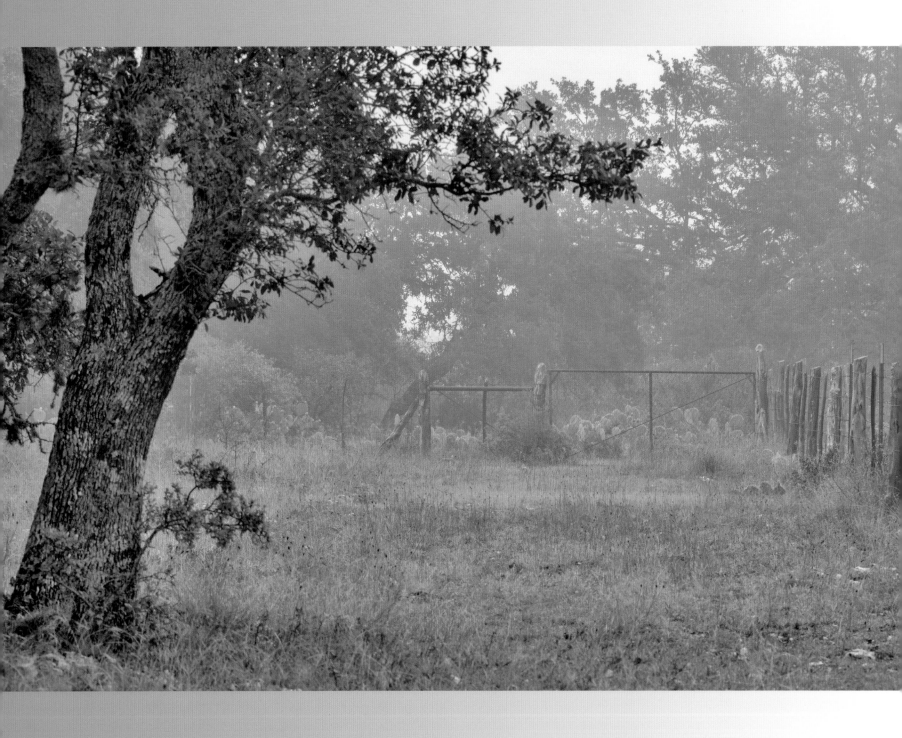

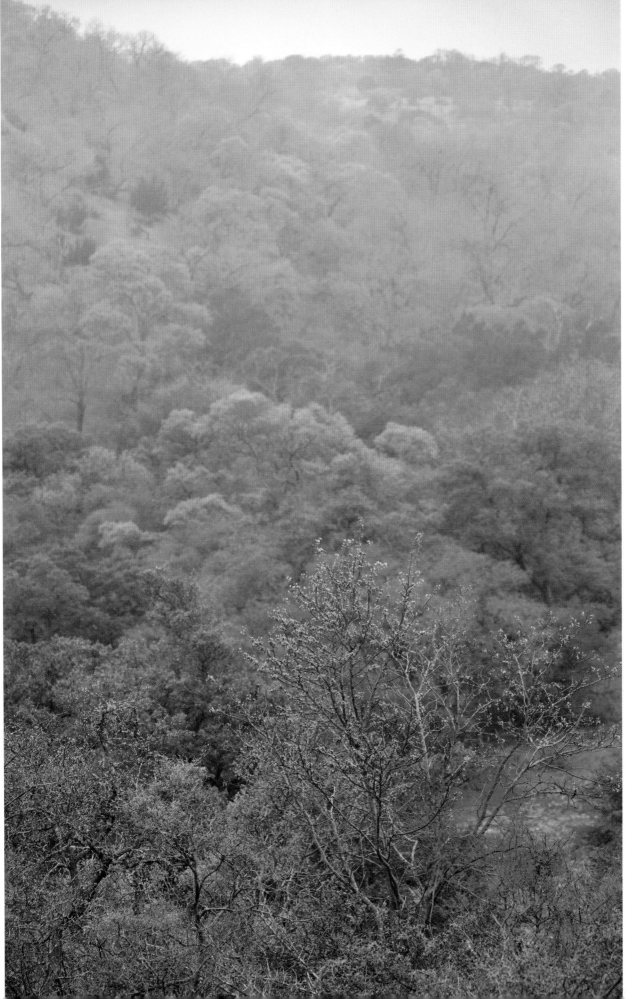

Conspicuous early spring flowers make this one of the most attractive and popular native plants.

—Paul W. Cox and Patty Leslie, "Texas Redbud" in *Texas Trees: A Friendly Guide*

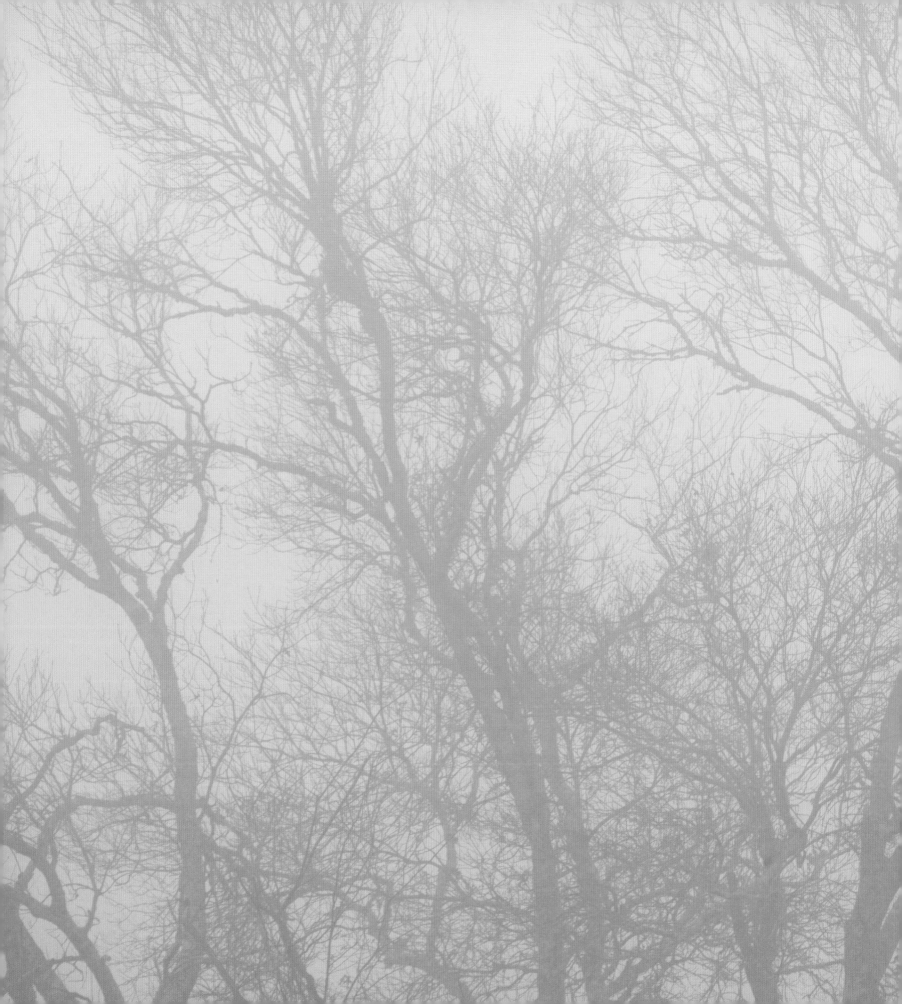

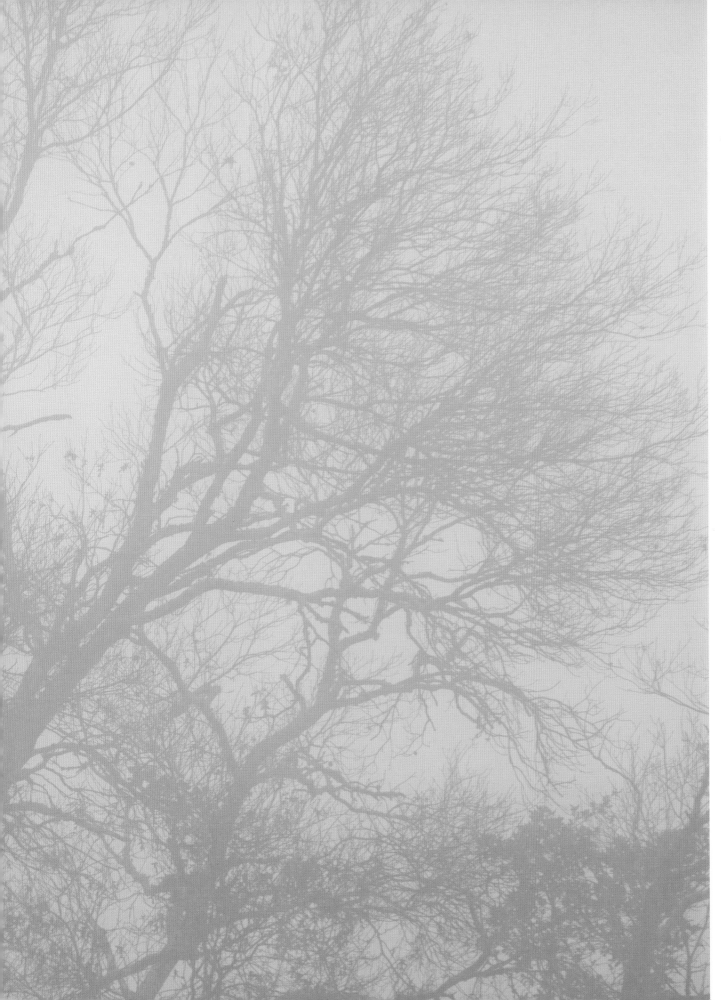

The whisper of color
at brink of day—
I sometimes think
That peace is grey

—Noel McNeel
Gordon, "Grey," an
unpublished poem

77

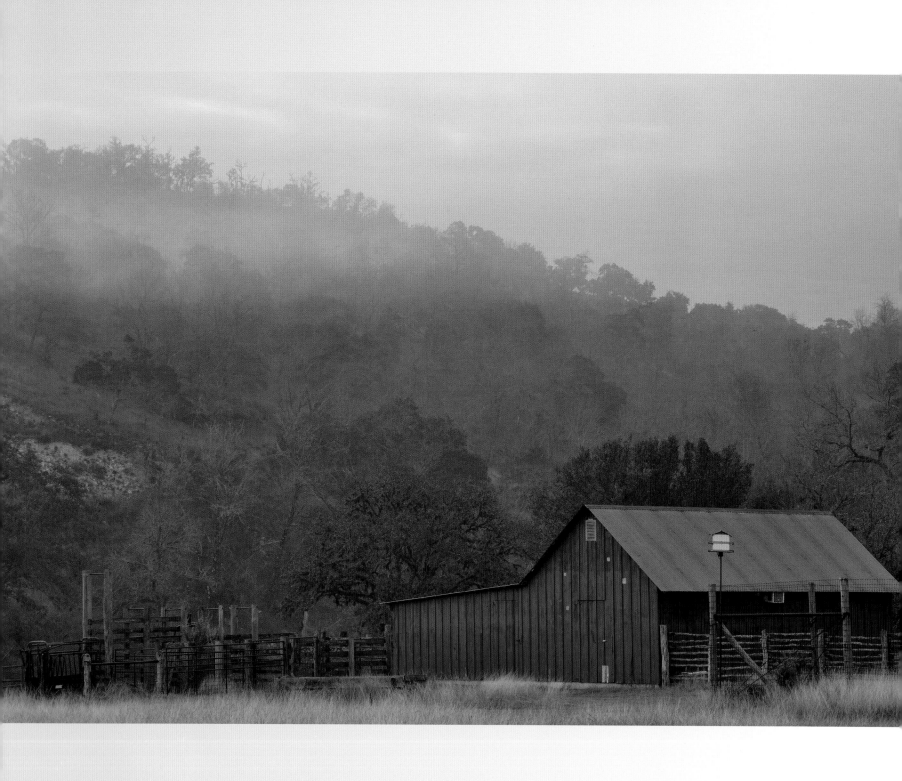

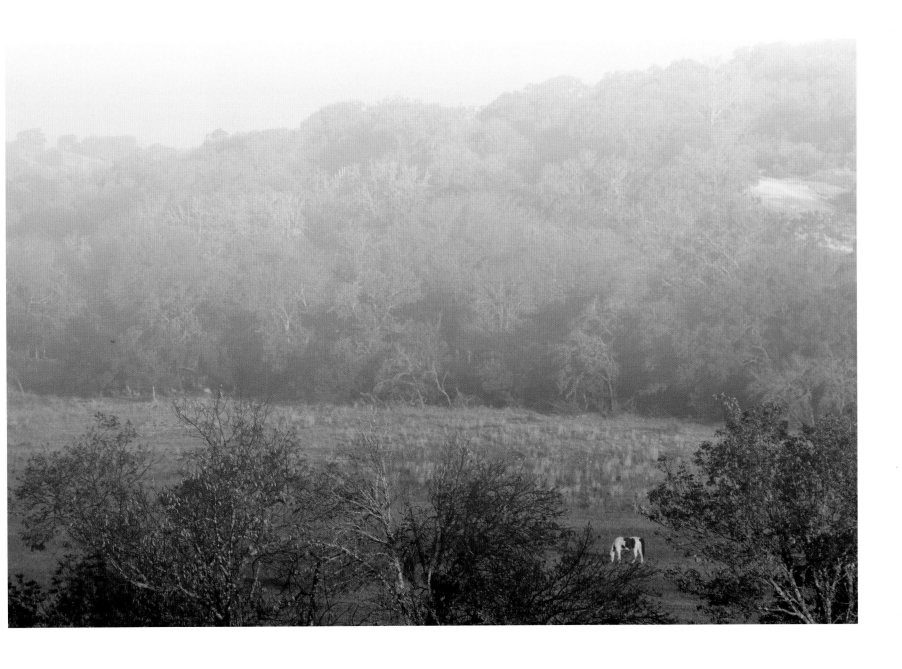

All the old-time range men of validity whom I have known remembered horses with affection and respect as a part of the best of themselves.

—J. Frank Dobie, *I'll Tell You a Tale*

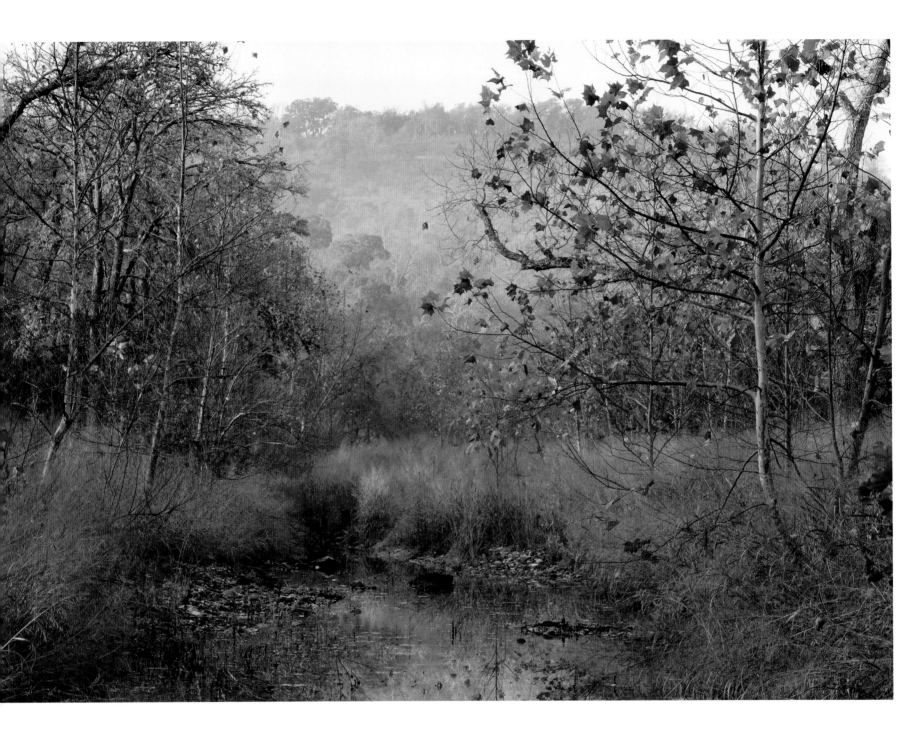

Each bend, each pool, each riffle, each sunken log, each sandbar, each backwater slough, each cut-bank, each boulder, each tree, each clump of grass, are parts of the whole, just like the parts of the body.

—Steve Nelle, *Texas Riparian Areas*

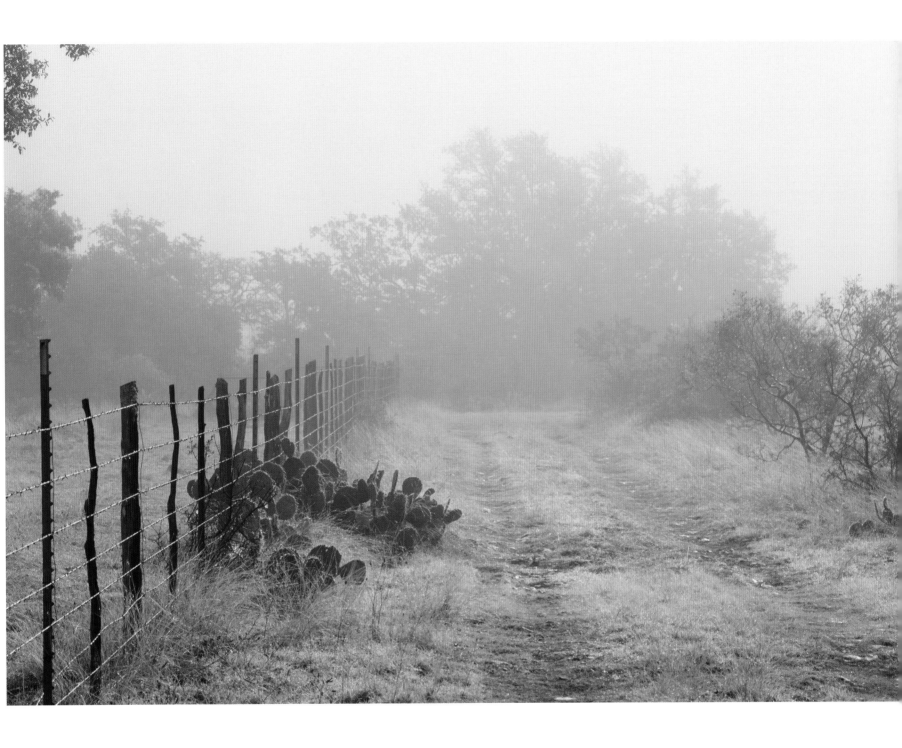

Paths are consensual because without common care and common practice, they disappear.

—Robert Macfarlane, *The Old Ways: A Journey on Foot*

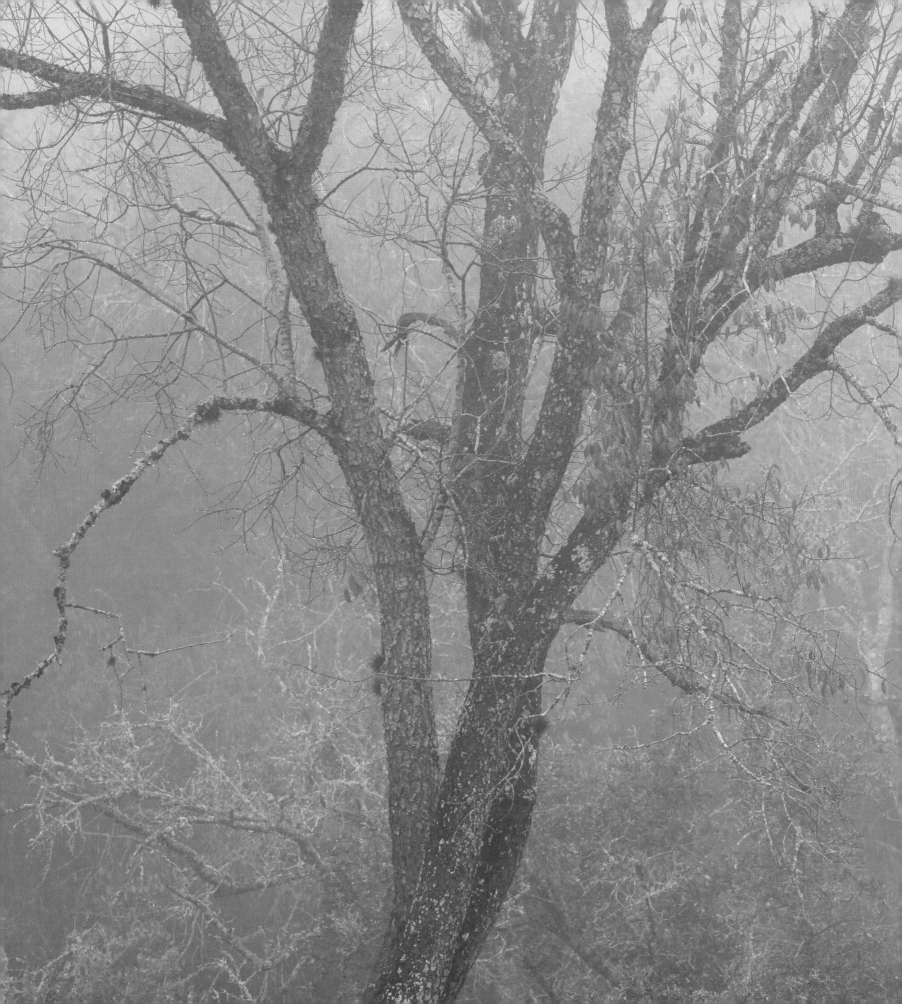

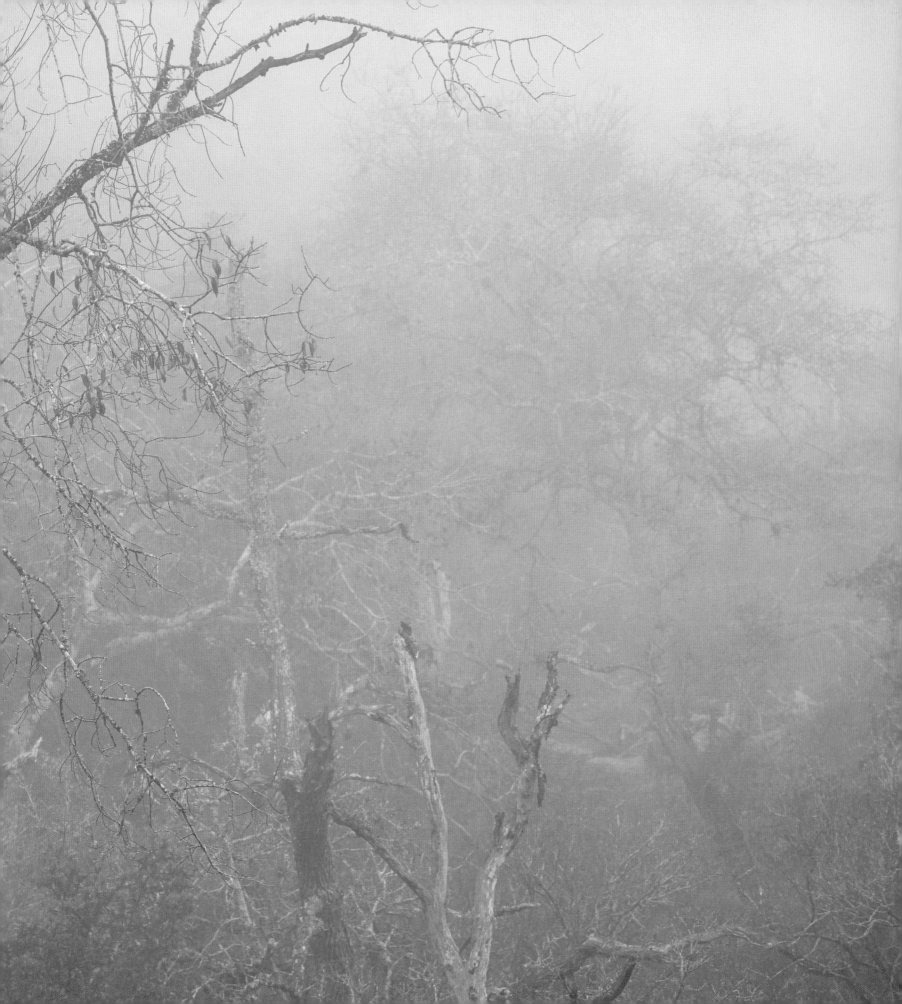

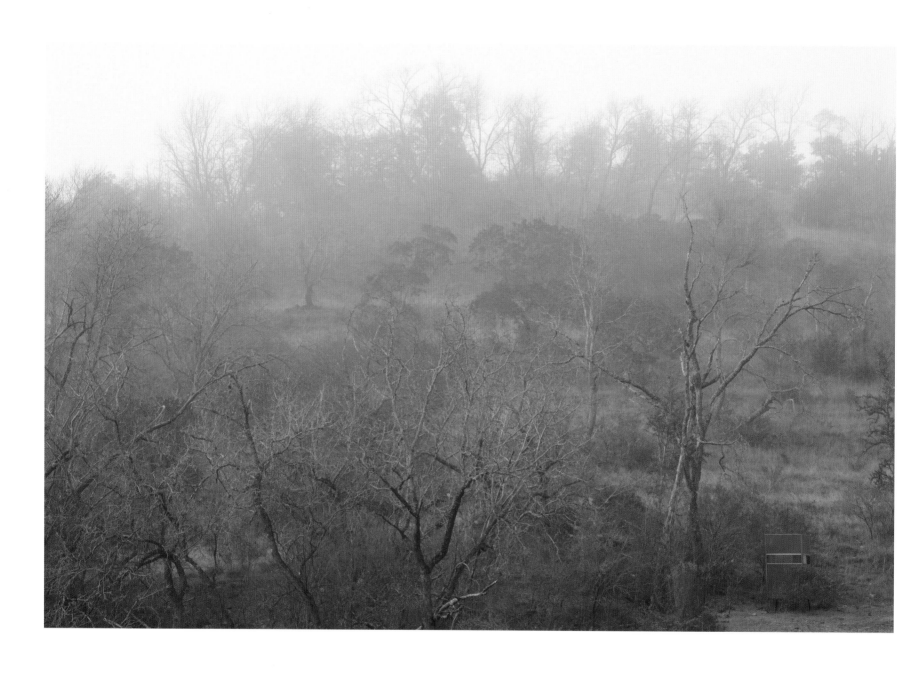

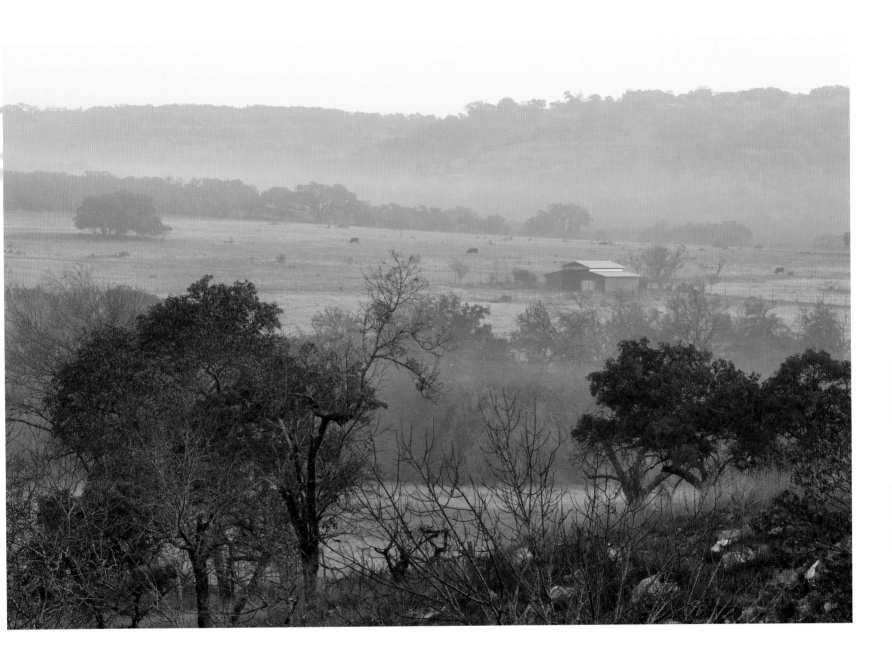

The old barn embodied practices which had suffered no mutilation at the hands of time. Here at least the spirit of the ancient builders was at one with the spirit of the modern beholder.

—Thomas Hardy, *Far From the Madding Crowd*

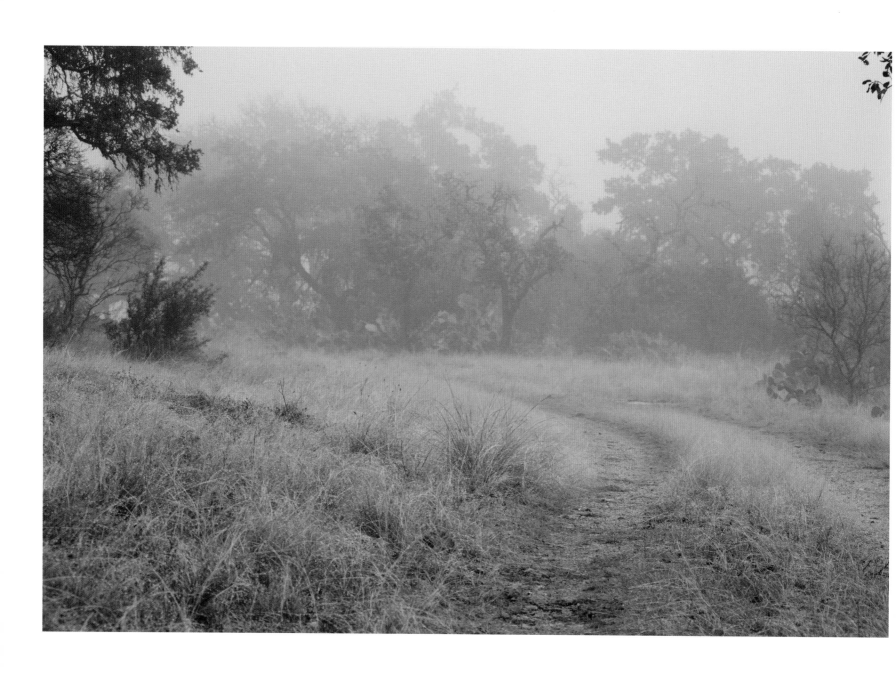

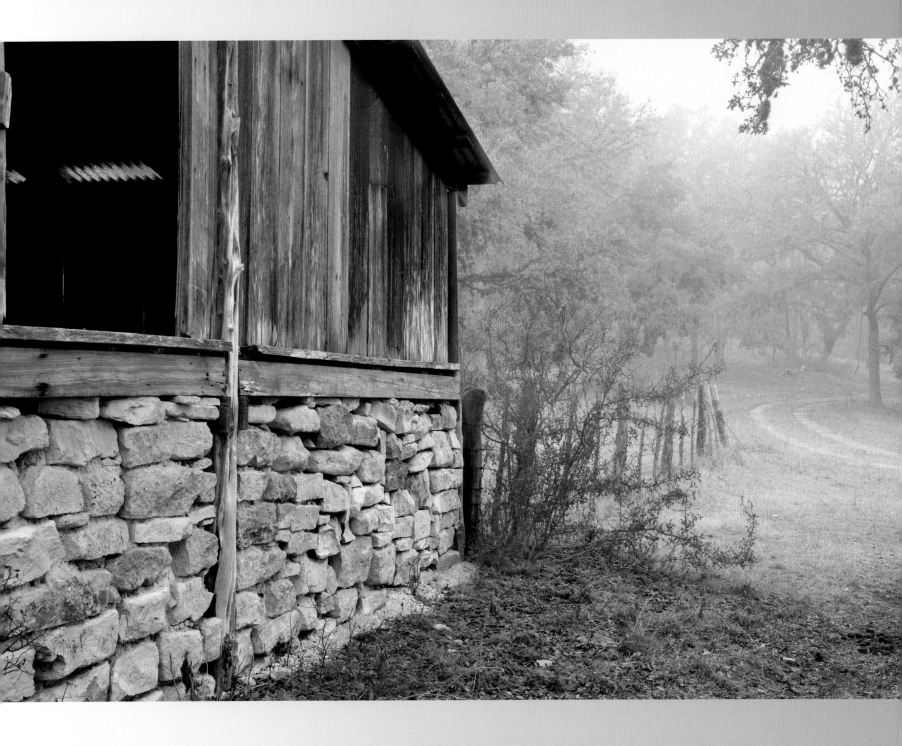

We come and go but the land is always here. And the people who love it and understand it are the people who own it—for a little while.

—Willa Cather, *O Pioneers!*

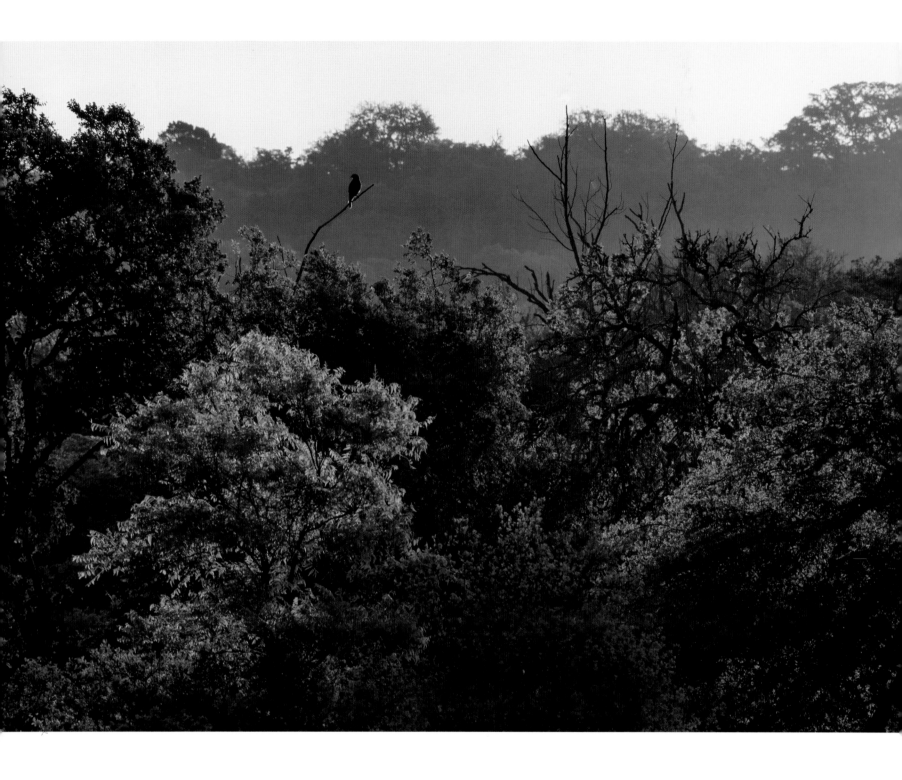

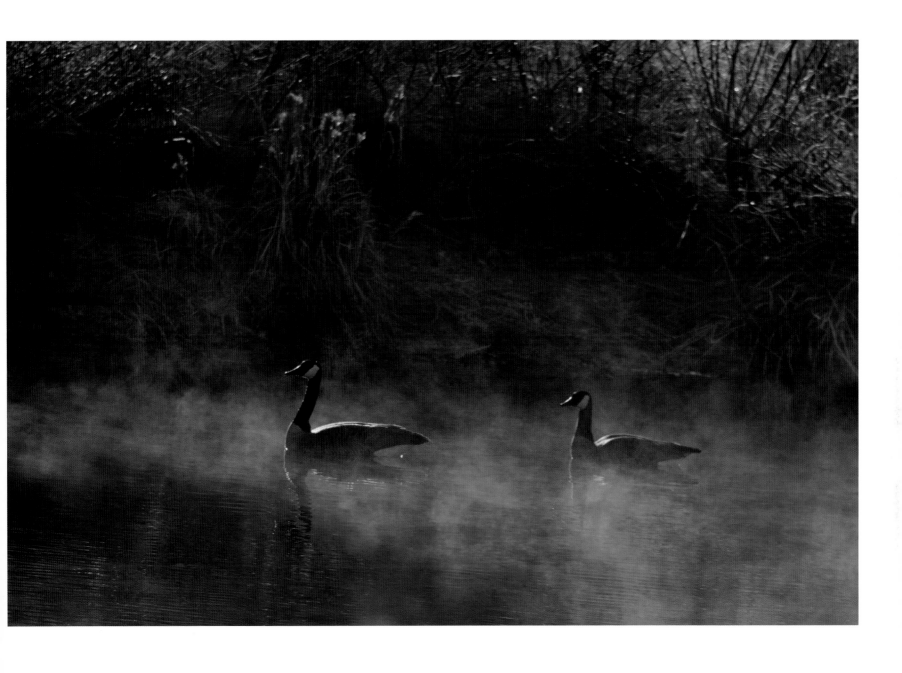

the world offers itself to your imagination,
calls to you like the wild geese, harsh and exciting

—Mary Oliver, "Wild Geese"

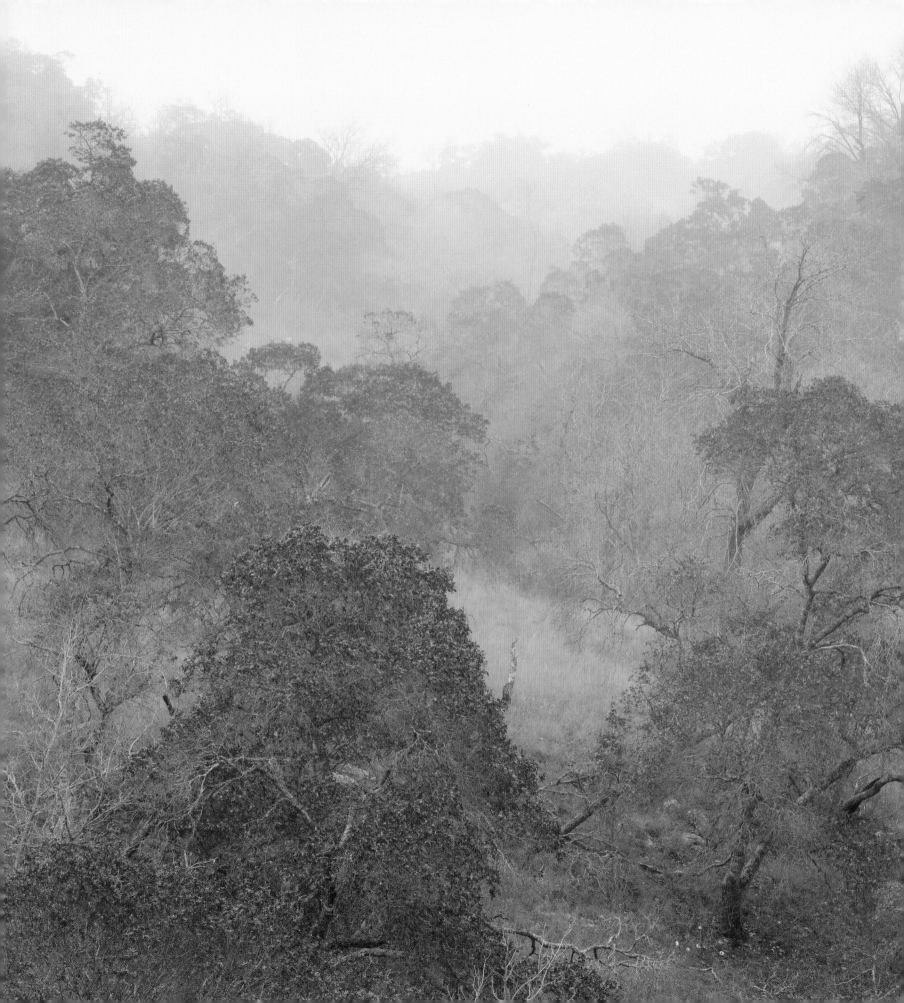

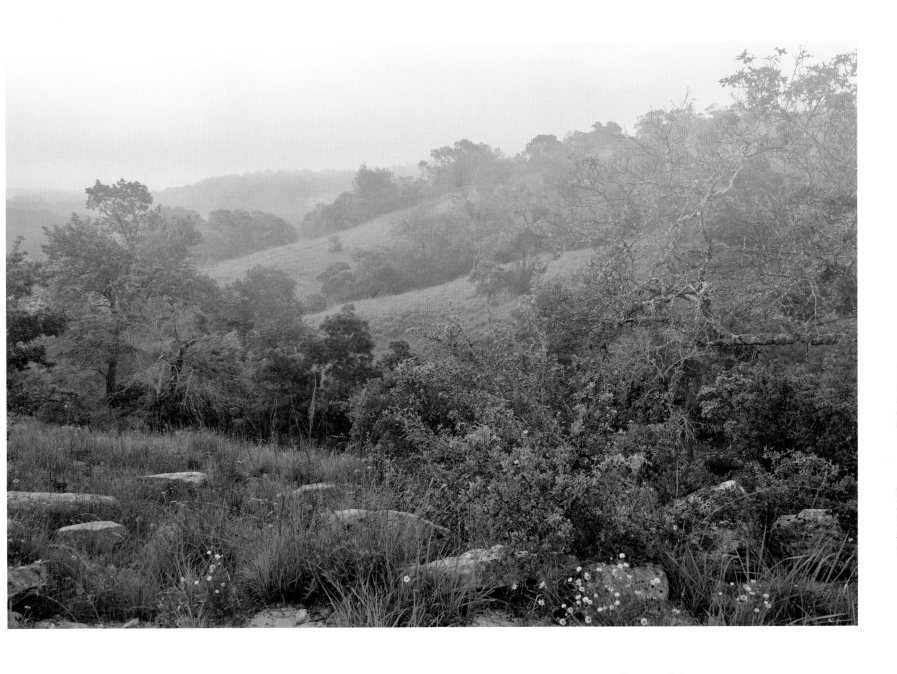

Aug. 31, 1887. The weather is perfectly beautiful, so cool and pleasant. I sit on the gallery and feast my eyes on the hills and sky. Dame Nature has already since the rain, spread her carpet of green.

—Annie Laura James Giles, author's great-grandmother, Diary at Hillingdon Ranch

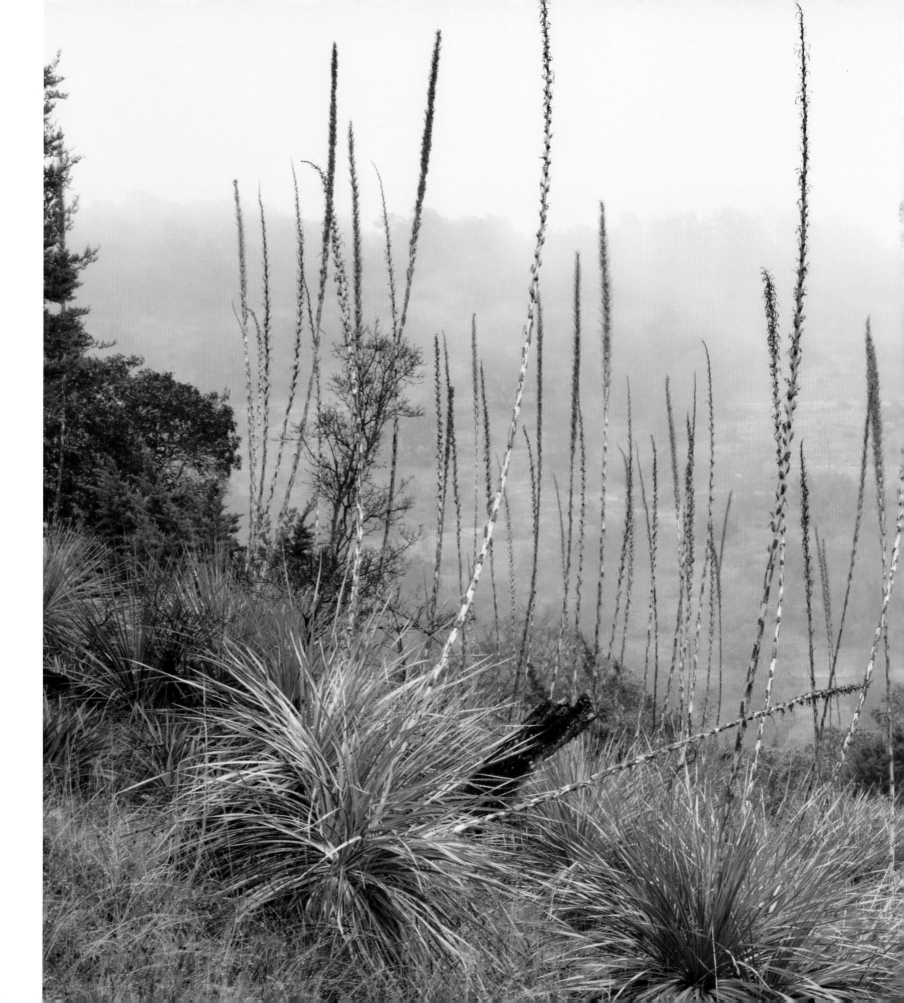

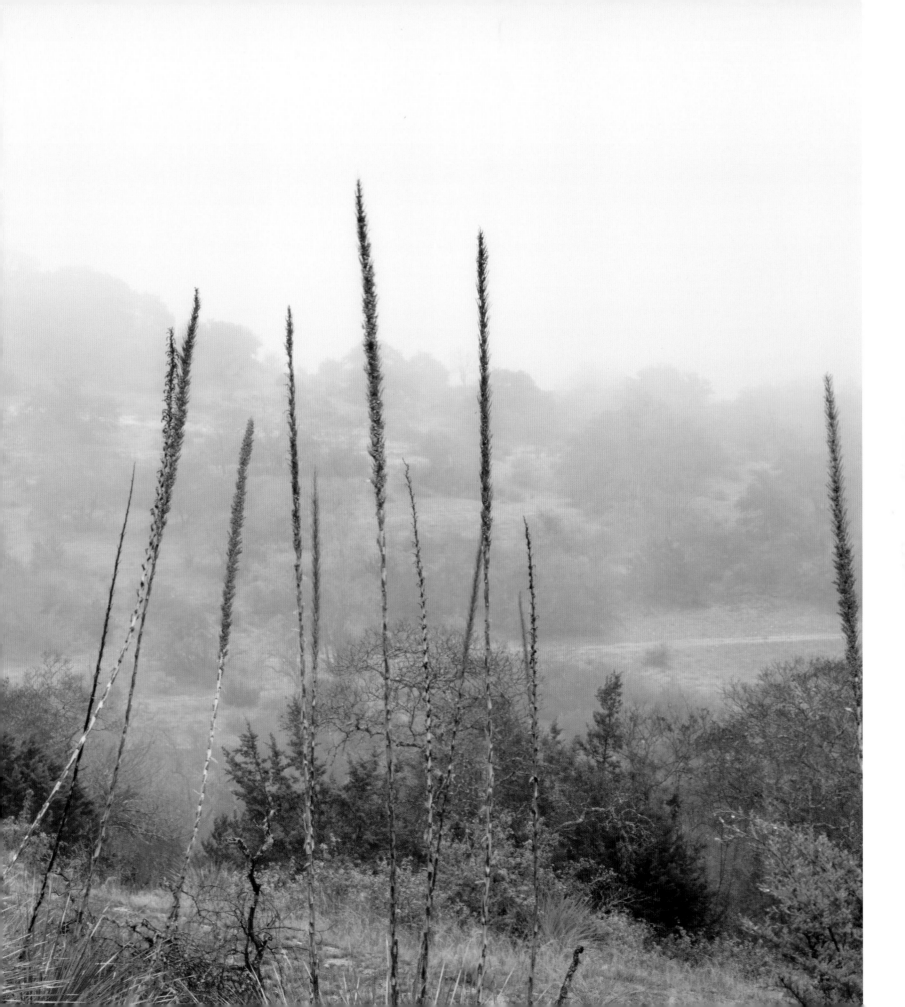

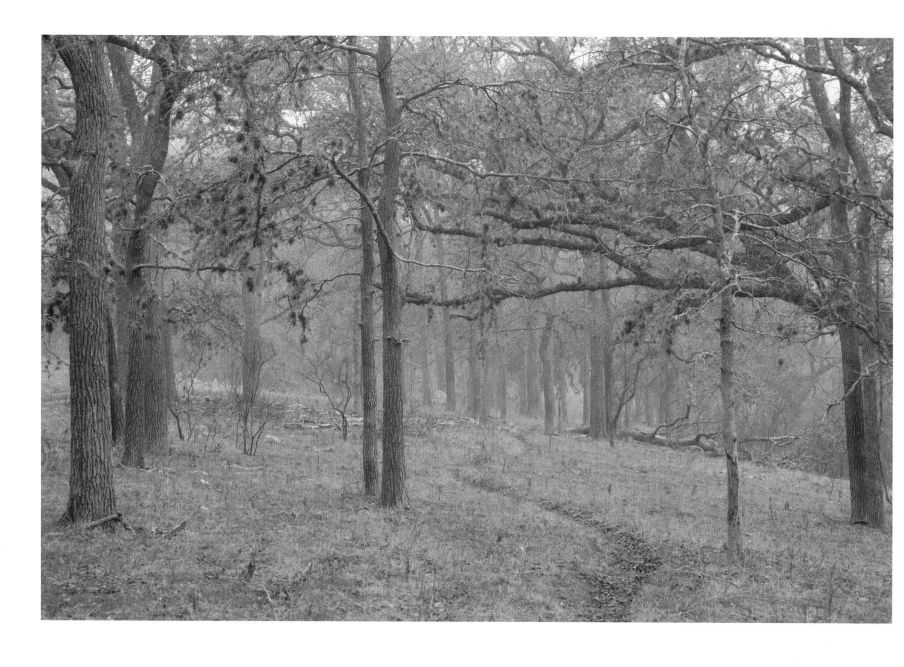

I only went out for a walk, and finally concluded to stay out till sundown, for going out, I found, was really going in.

—John Muir, *John of the Mountains: The Unpublished Journals of John Muir*

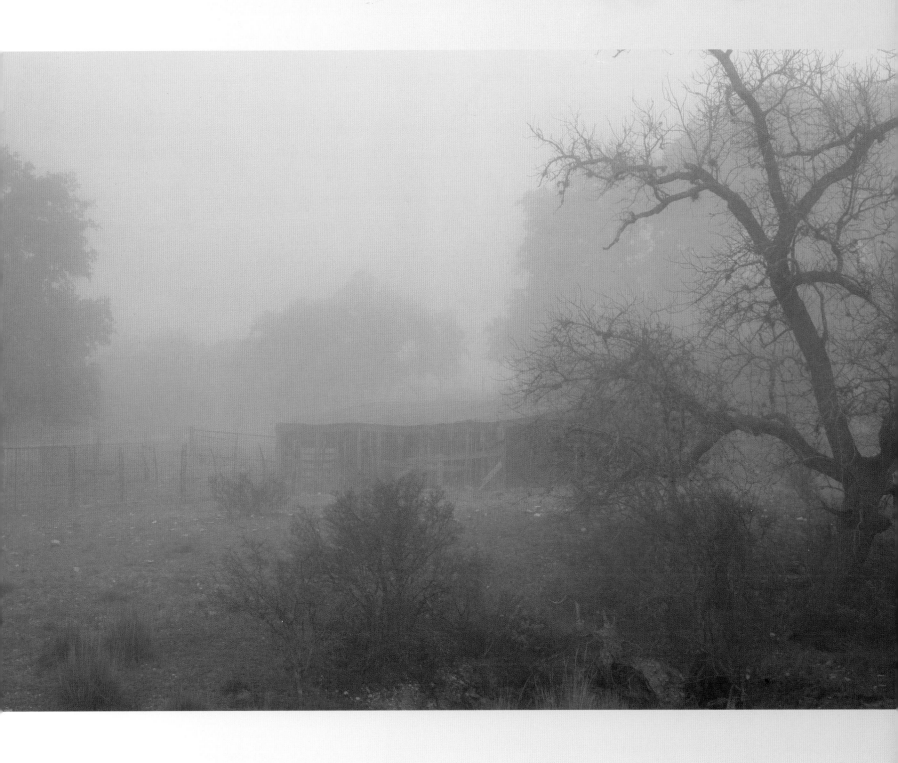

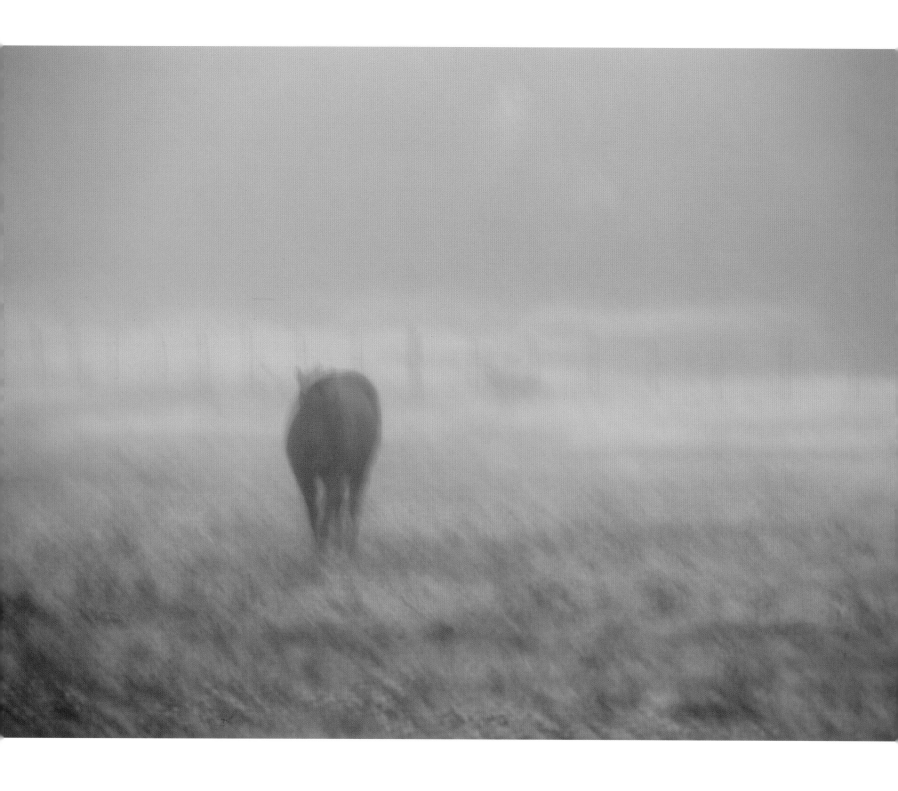

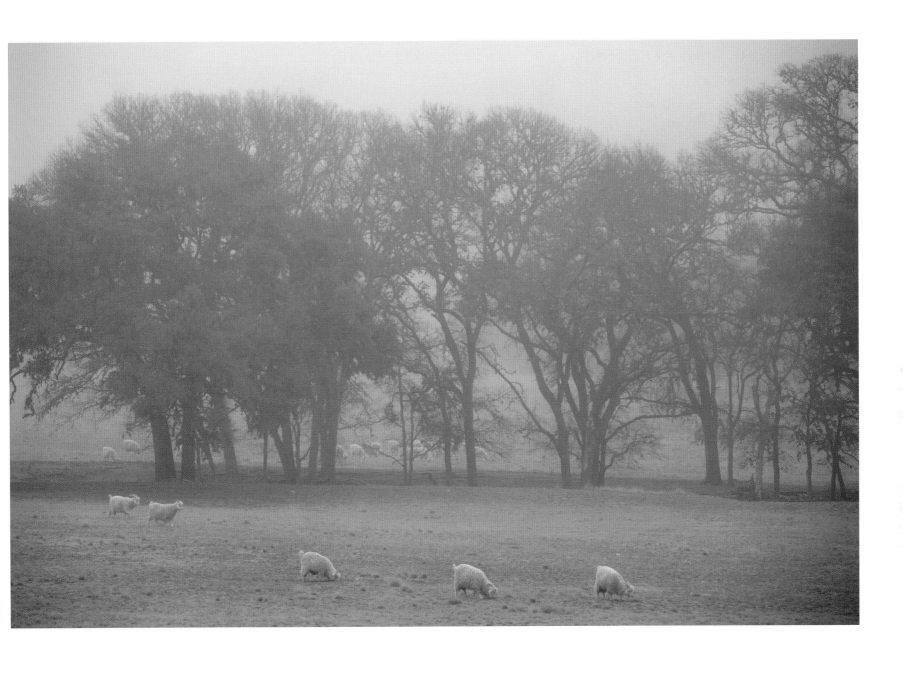

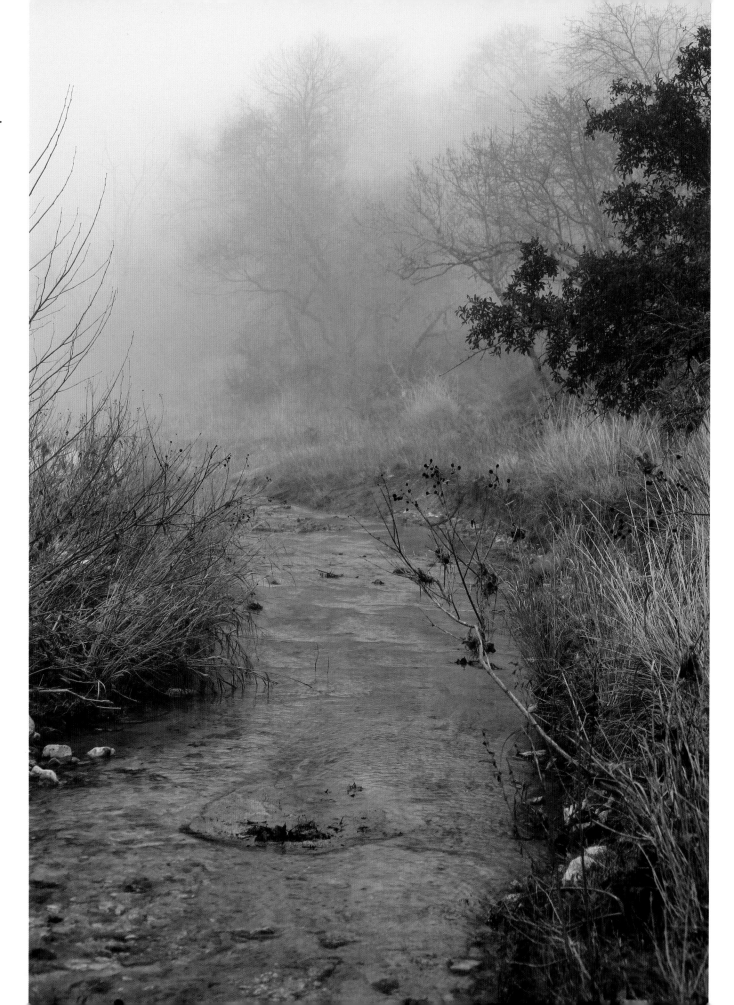

*Lately I been goin'
home on bridges over
low water slow
It seems to lay at the
valley of a crown in
the bottom of a bell
upside down.*

—Kevin "Shinyribs"
Russell, author's
son-in-law, "Dead
Batteries"

98

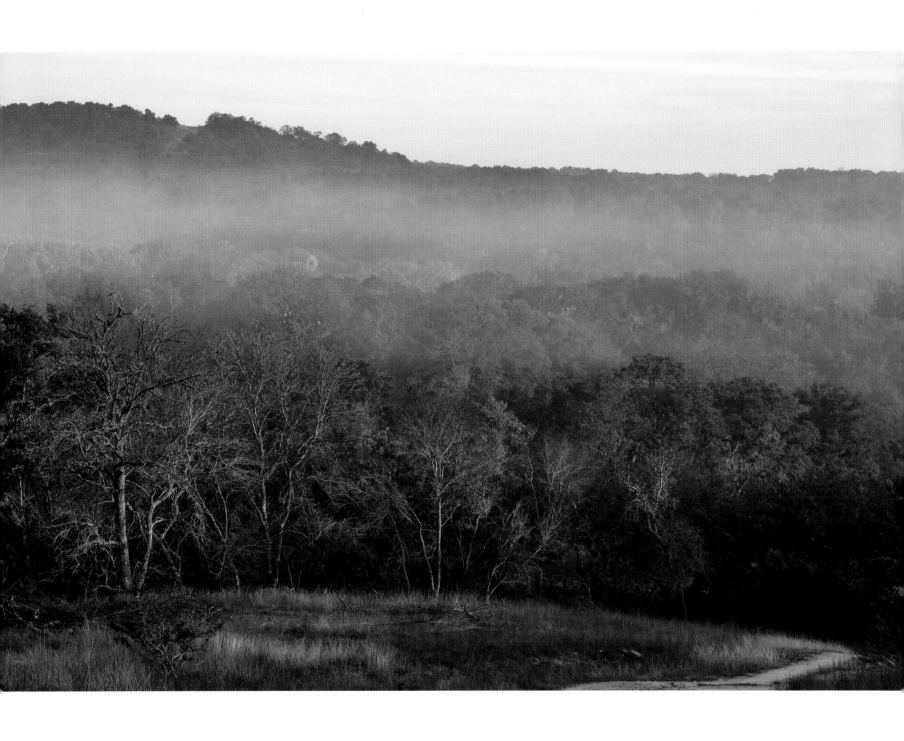

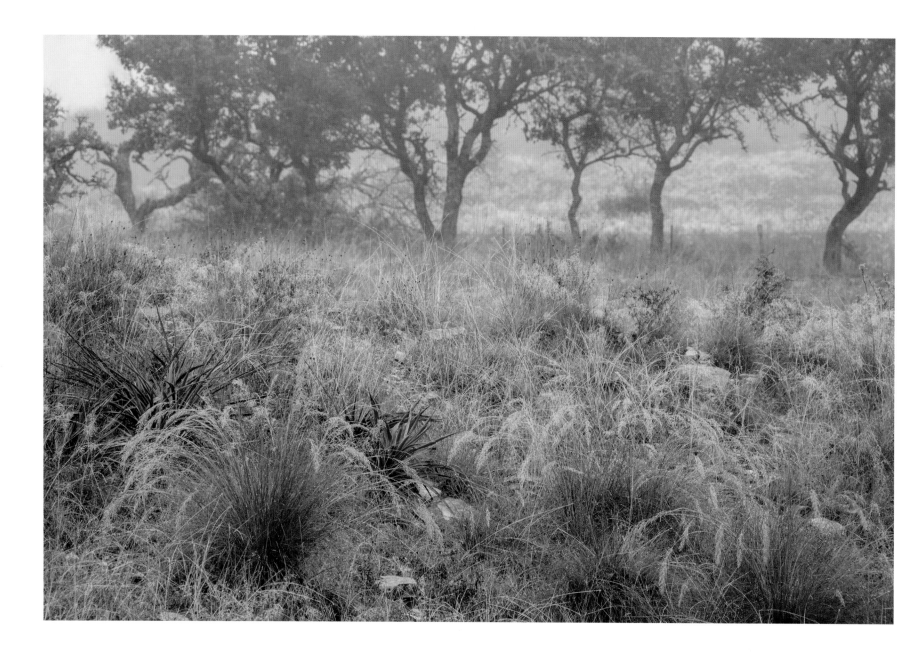

To the attentive eye, each moment of the year has its own beauty, and in the same field, it beholds, every hour, a picture which was never seen before, and which shall never be seen again.

—Ralph Waldo Emerson, *Nature, Addresses and Lectures*

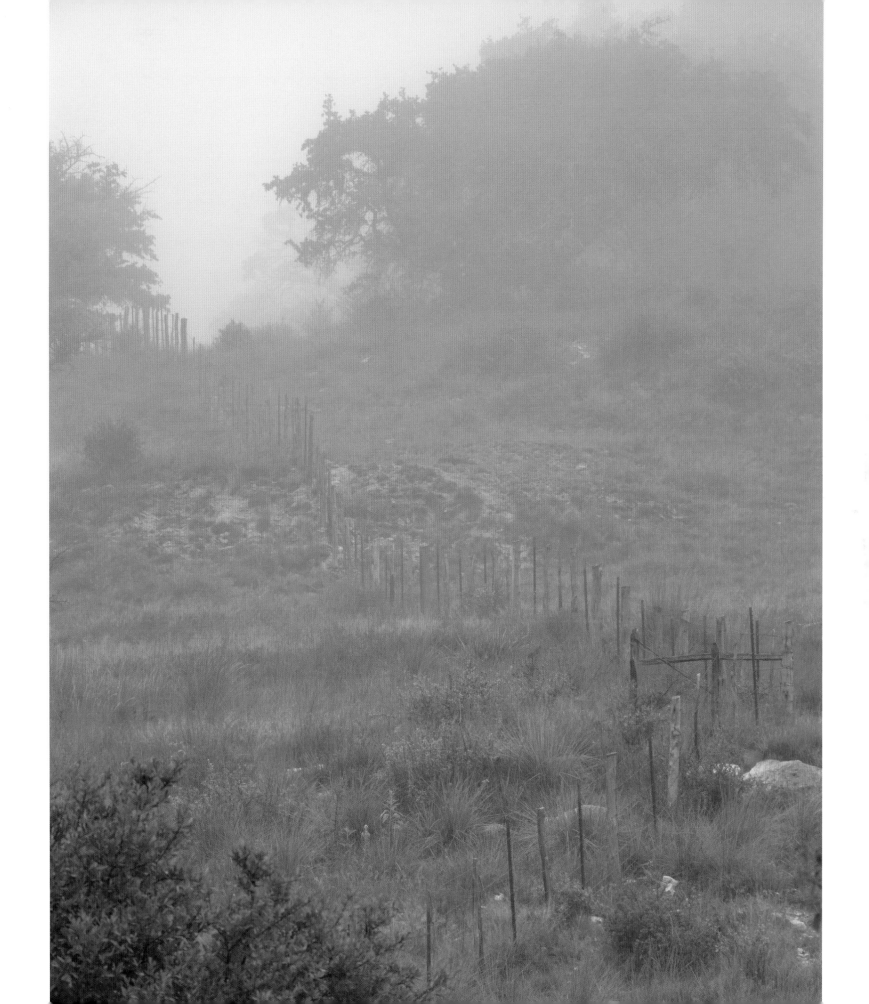

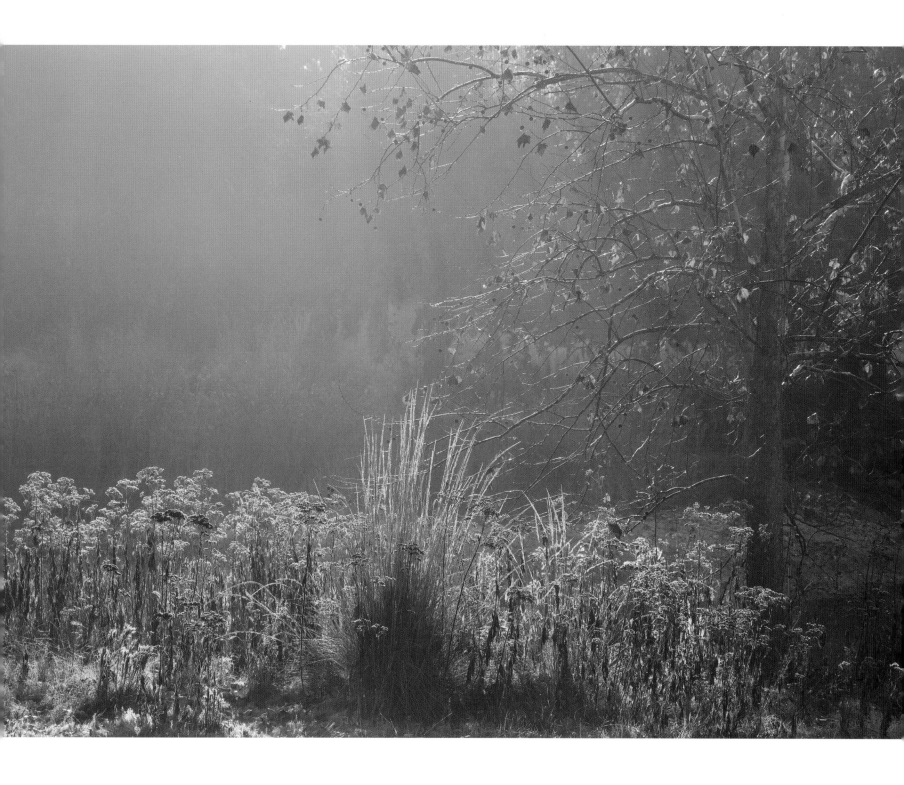

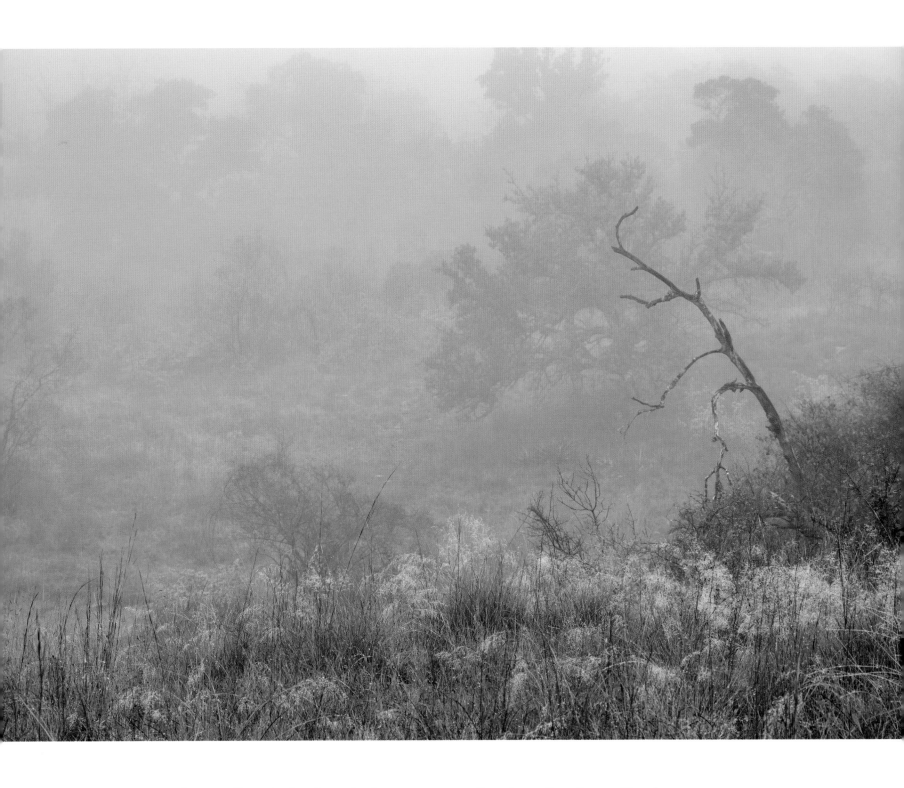

No matter where we live—in the city or in the country—our lives depend on the quality of our native lands.

—Mrs. Laura Bush, Former First Lady of Texas and the United States, in Colleen Schreiber,
"Former First Lady Rolls out New Conservation Effort for Texas"

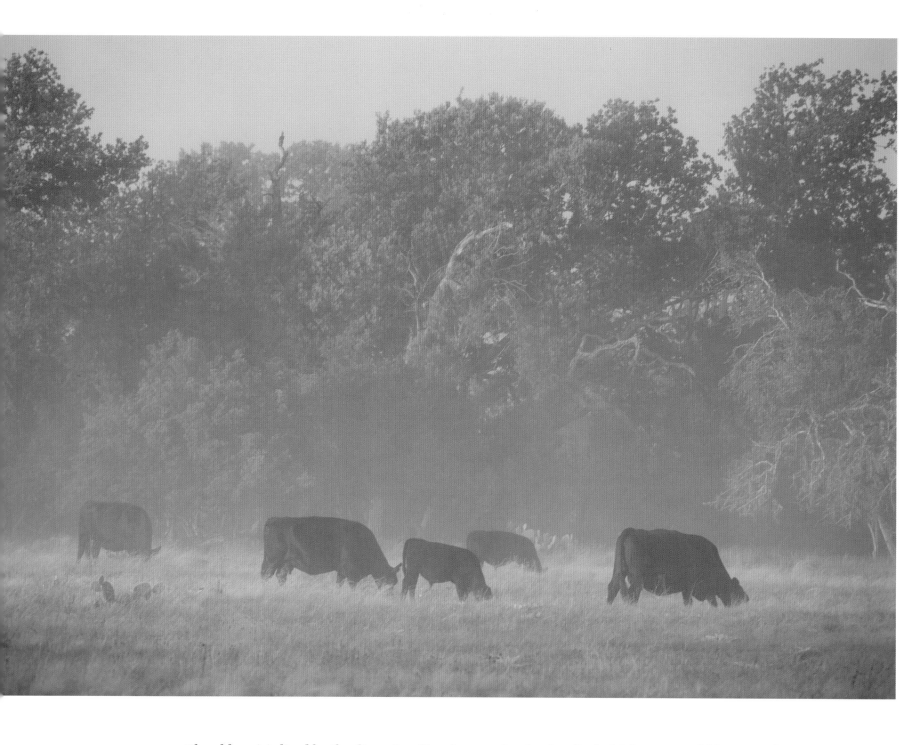

The old prairie lived by the diversity of its plants and animals, all of which were useful because the sum total of their co-operations and competitions achieved continuity.

—Aldo Leopold, *A Sand County Almanac: And Sketches Here and There*

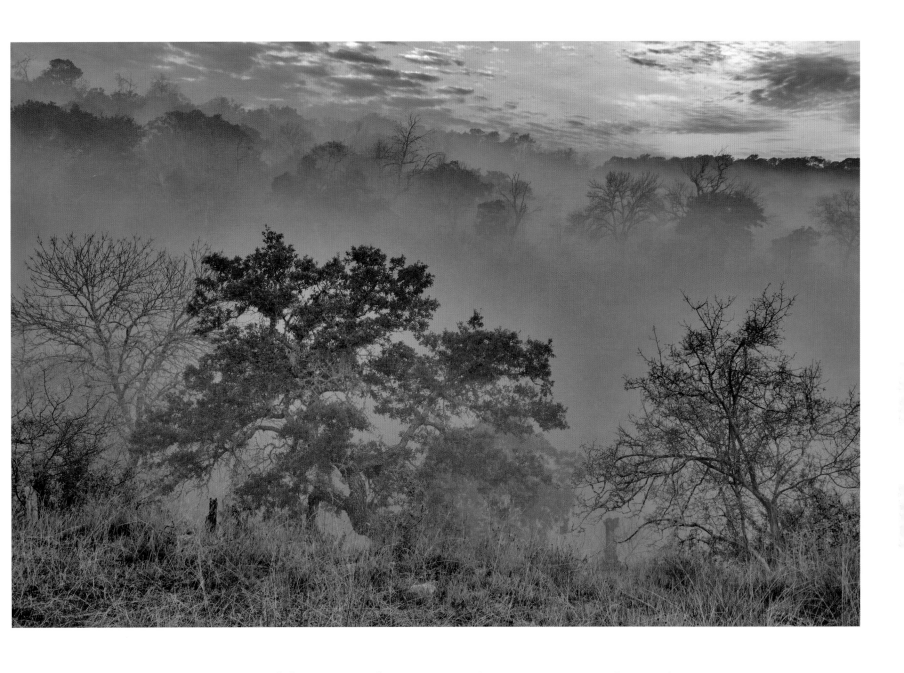

Knowing trees, I understand the meaning of patience. Knowing grass, I can appreciate persistence.

—Hal Borland, *Countryman: A Summary of Belief*

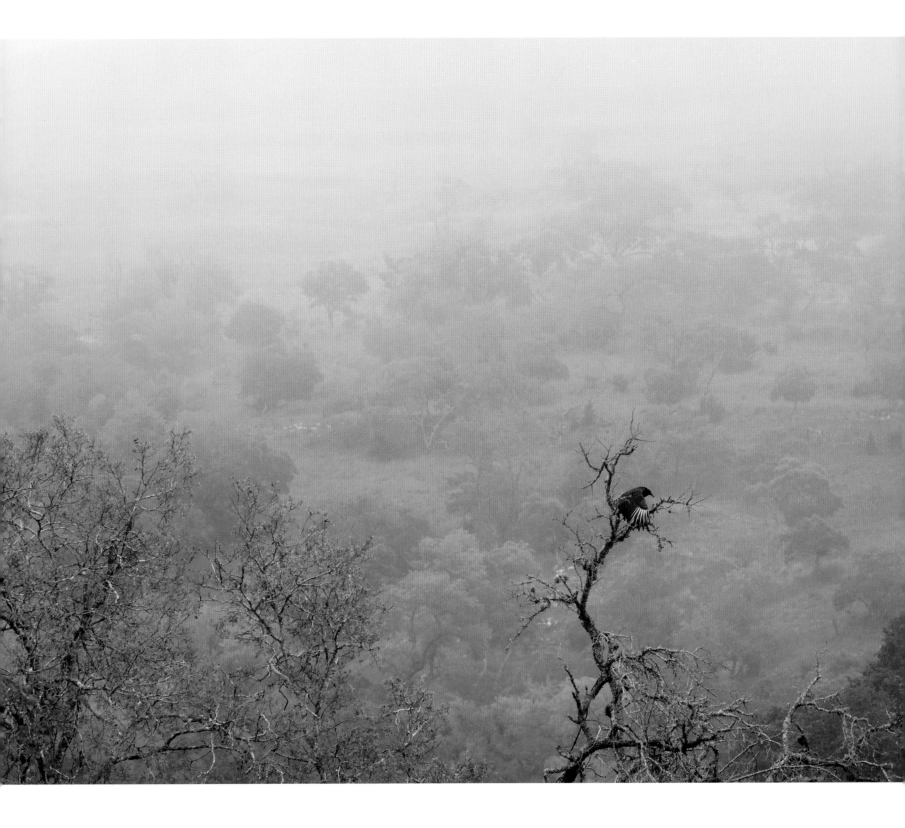

Blessedly, parts and pieces of the old magnificence do now remain reasonably intact, and all of us who have had the privilege of touching and seeing and feeling them need to be grateful for that.

—John Graves, "State of Nature, a 50th Anniversary Celebration"

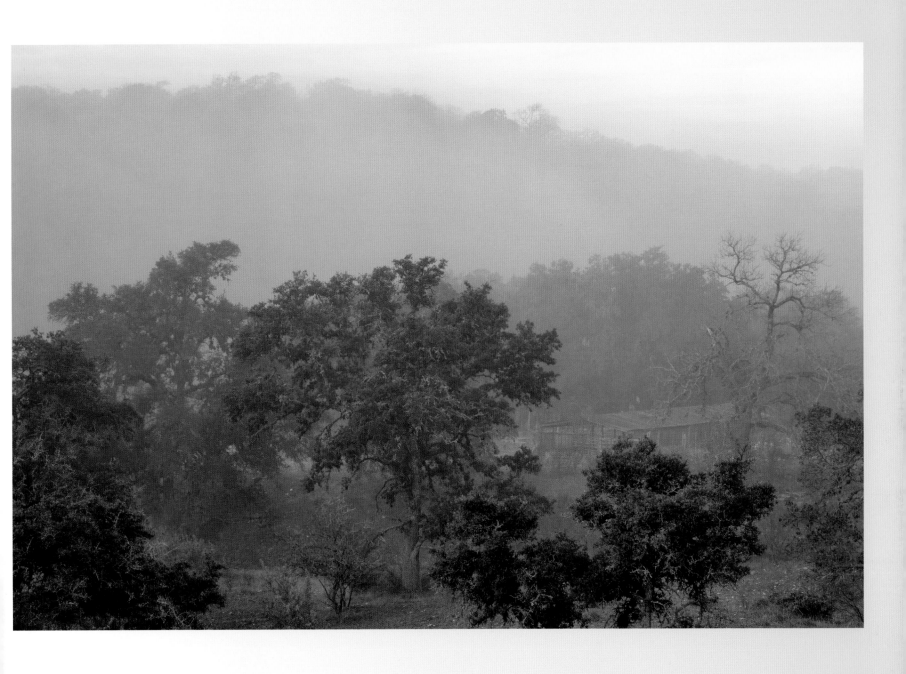

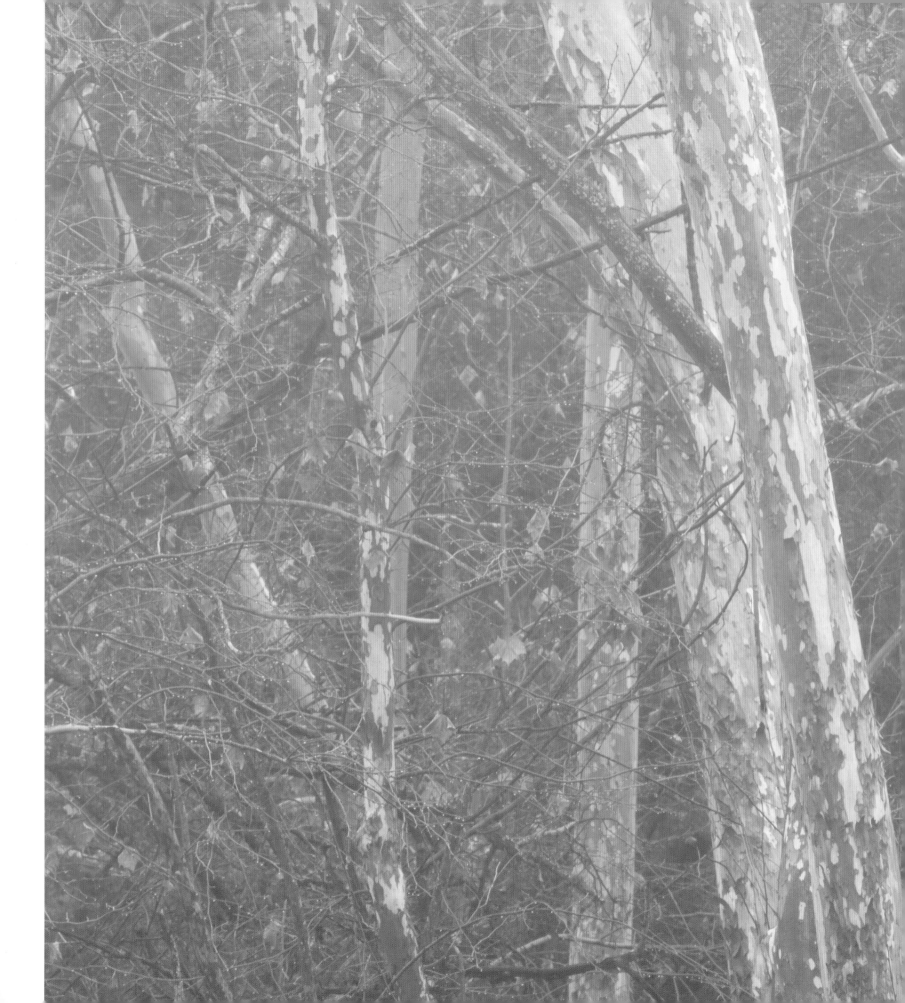

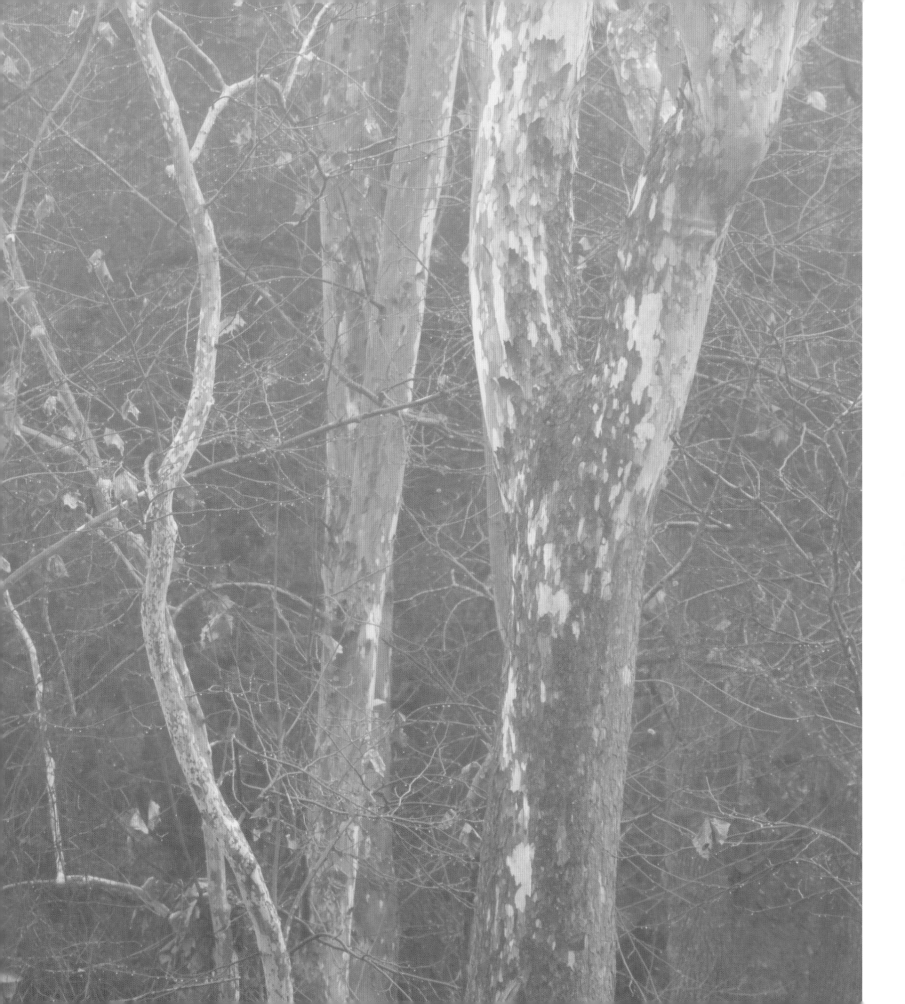

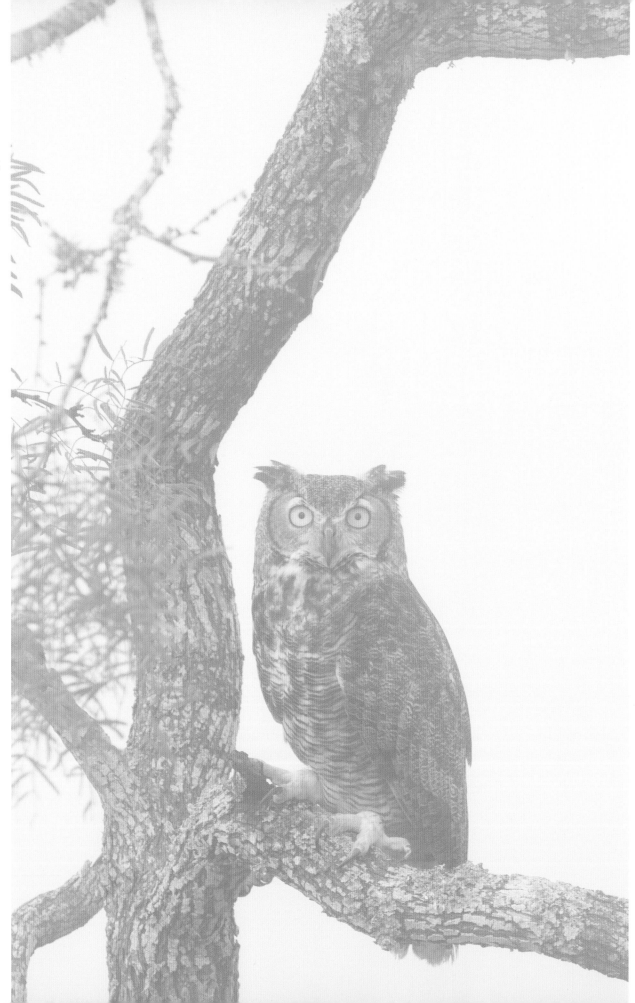

A perfectly camouflaged, silent flyer who can hunt by sound alone, the Great Horned Owl finds the fog an ally.

—Rick Pratt, conservationist

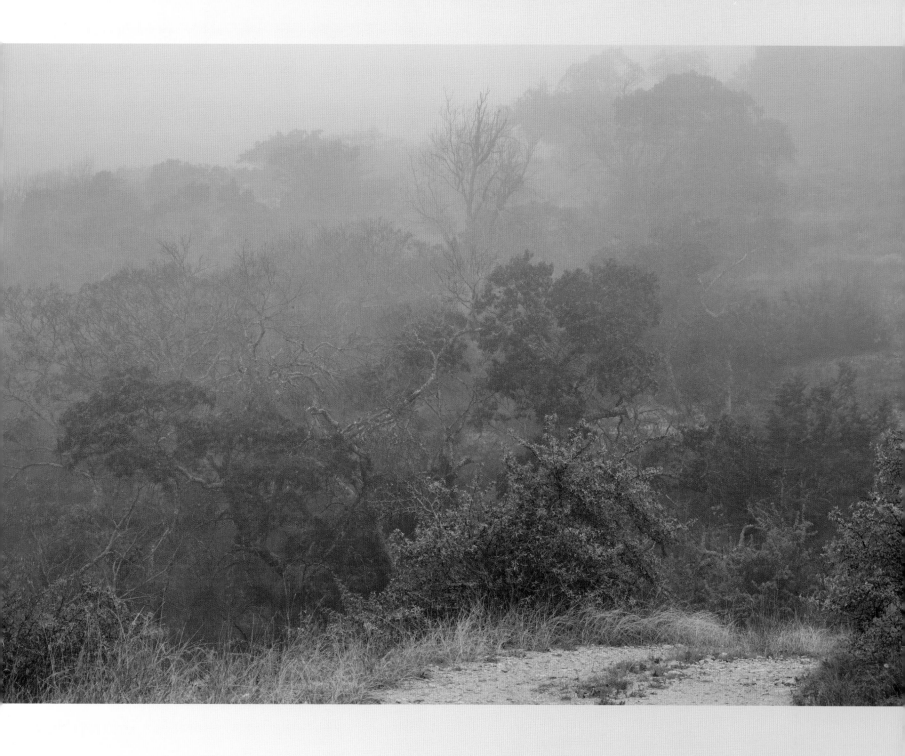

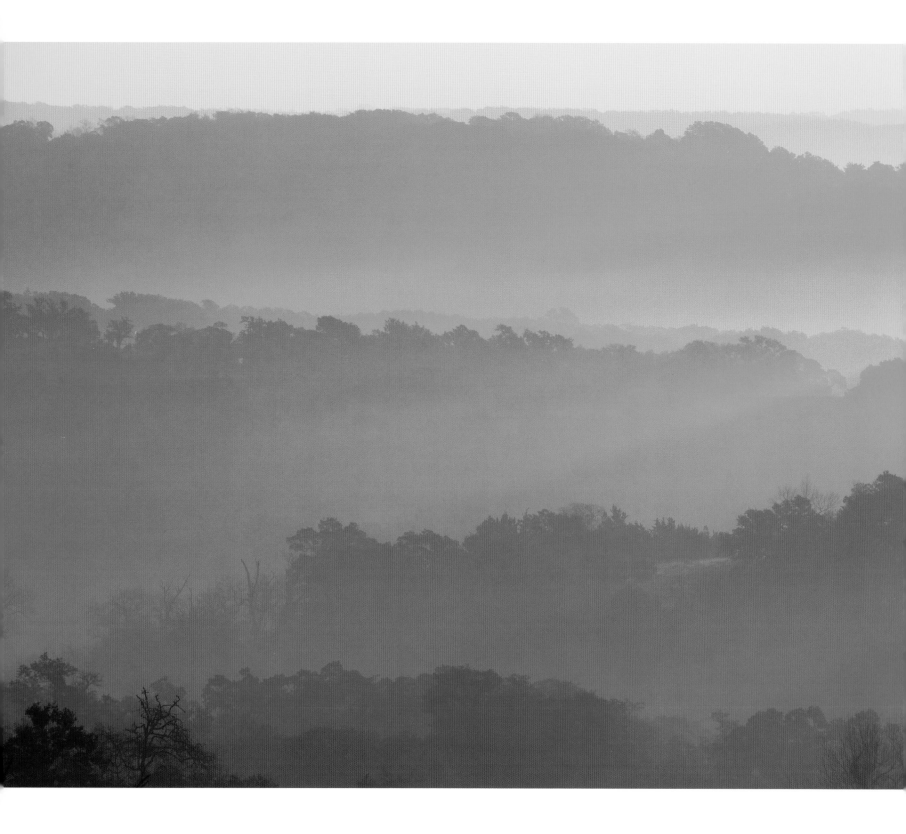

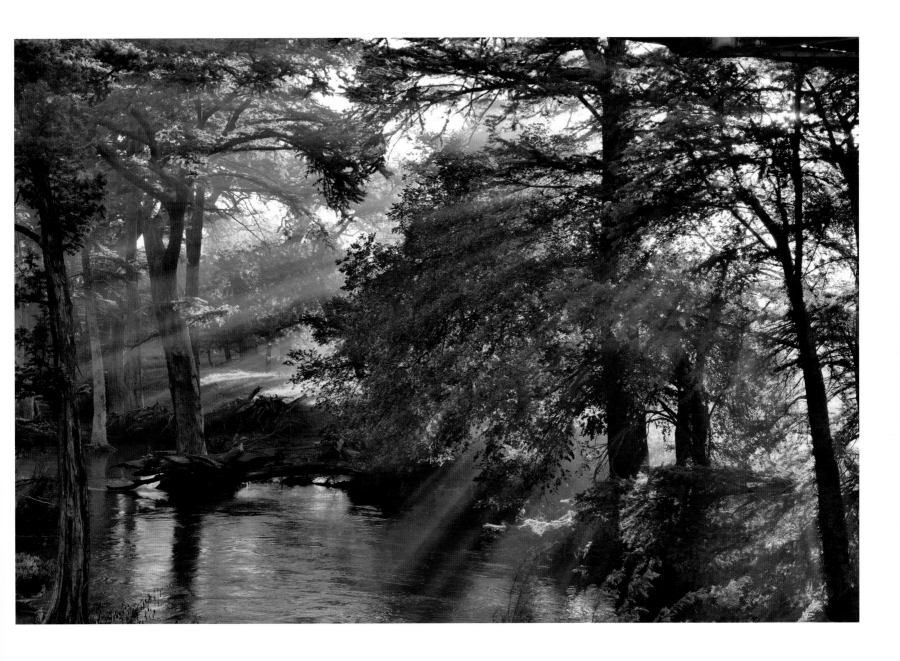

I have rarely seen any resort of wood-nymphs more perfect than the bower of cypress branches and vines. . . . The water of both streams has a delicate, cool, blue-green color; the rocky banks are clean and inviting; the cypresses rise superbly from the very edge, like ornamental columns.

—Frederick Law Olmsted, 1857, *A Journey through Texas; Or, a Saddle-Trip on the Southwestern Frontier*

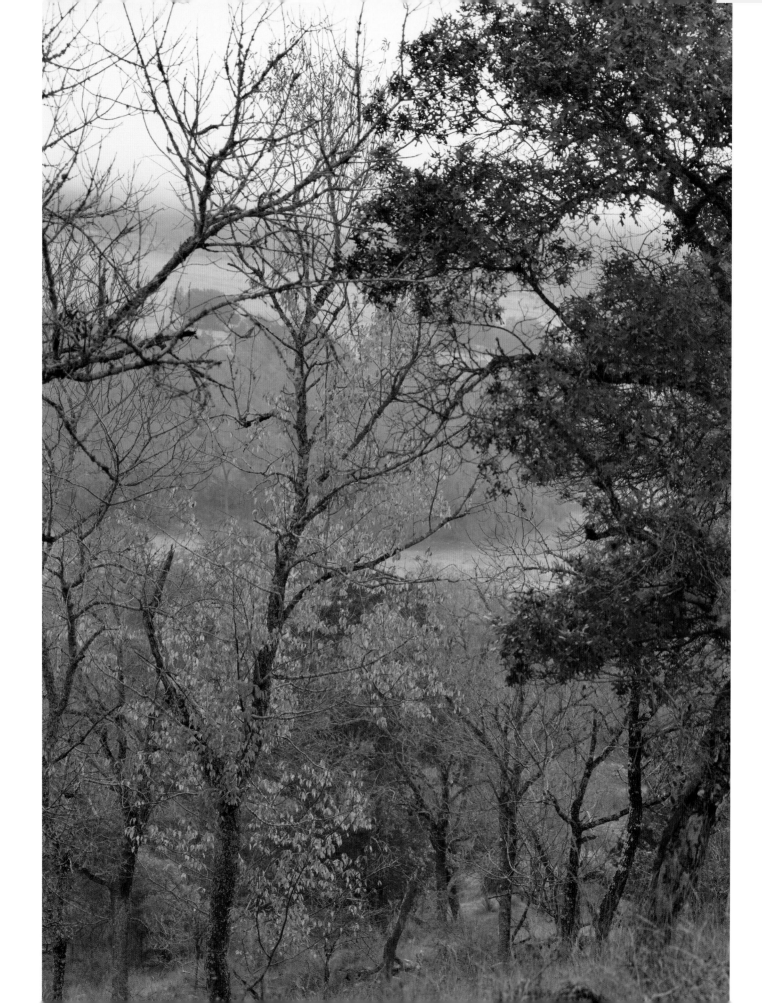

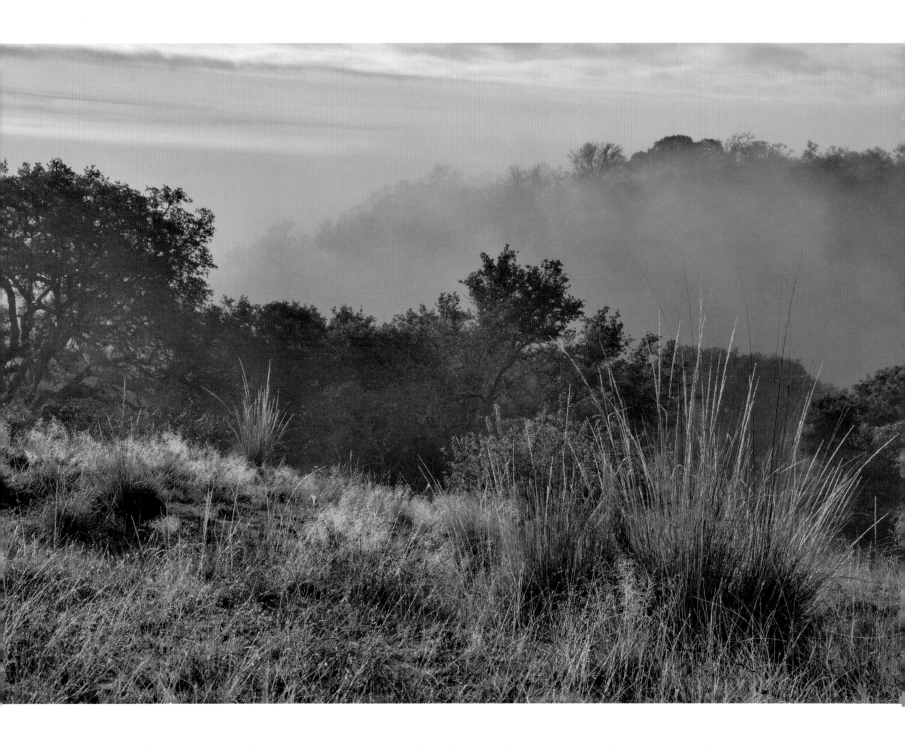

"Goodbye pretty ranch." That's what my grandmother always said each time we left the countryside, and headed back to the city in her old Wagoneer. Now we say this to our son, Huck. Simple words, capturing the soul-restoration and contentment we feel in open spaces.

—Keith Beckmann Langford, author's son

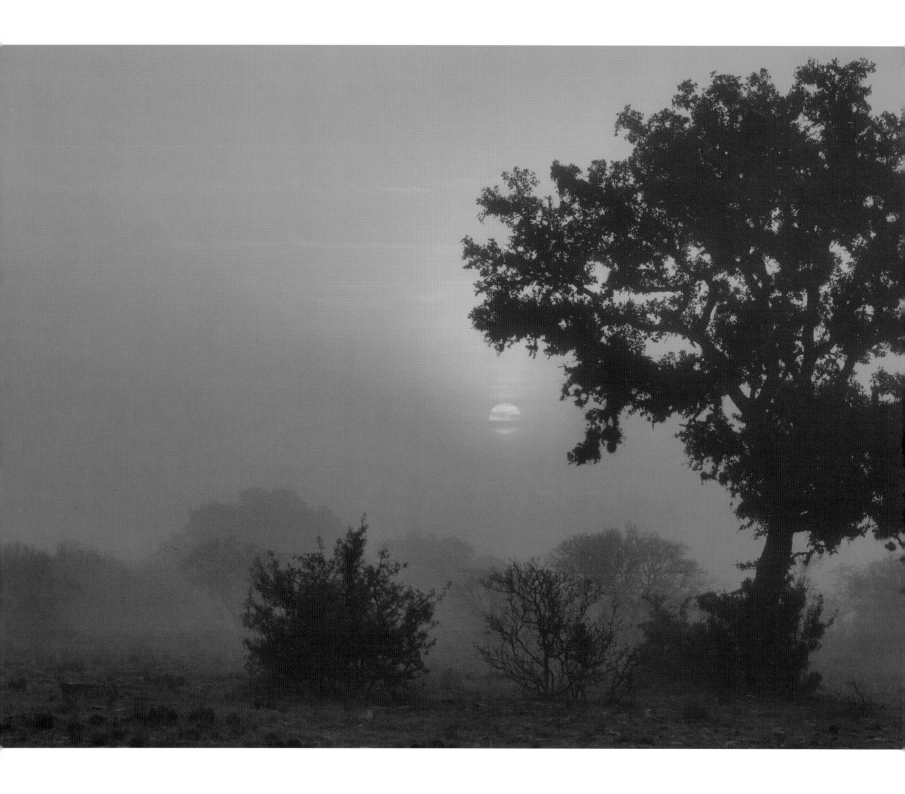

Perhaps nature is our best assurance of immortality.

—Eleanor Roosevelt, "My Day"

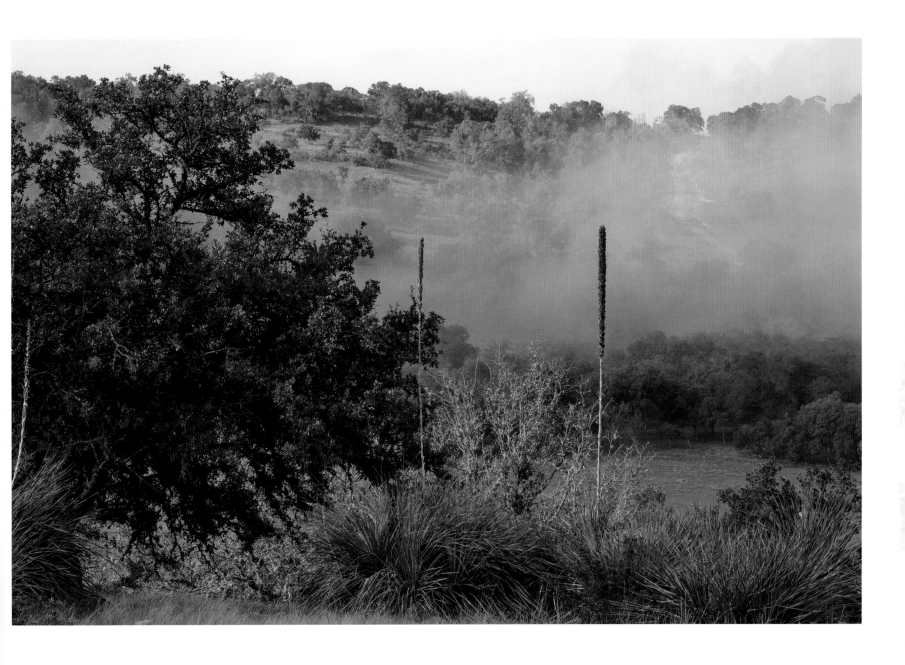

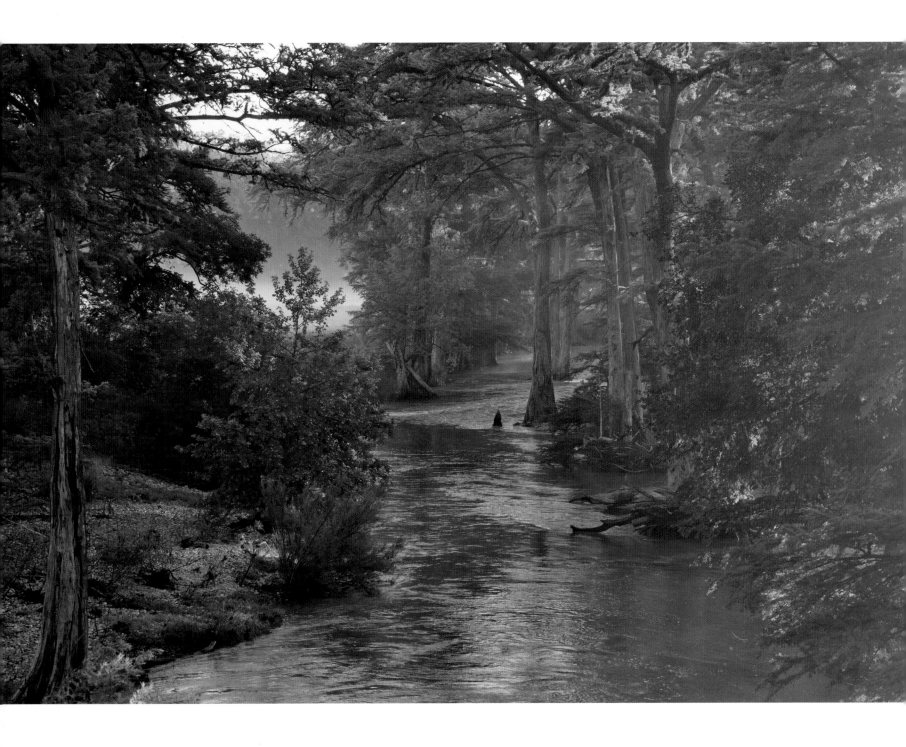

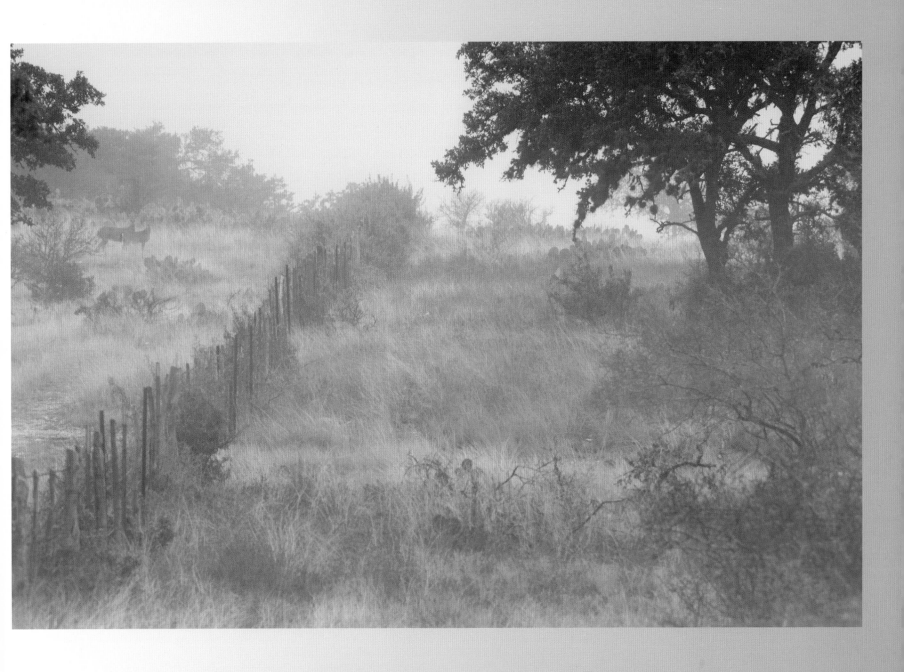

You've got to sustain the relationship between you and the land, you've got to recognize the relationships between all natural resources, and you've got to balance the successes of the past with the challenges of the future.

—Robin Giles in David K. Langford and Lorie Woodward Cantu,
Hillingdon Ranch: Four Seasons, Six Generations

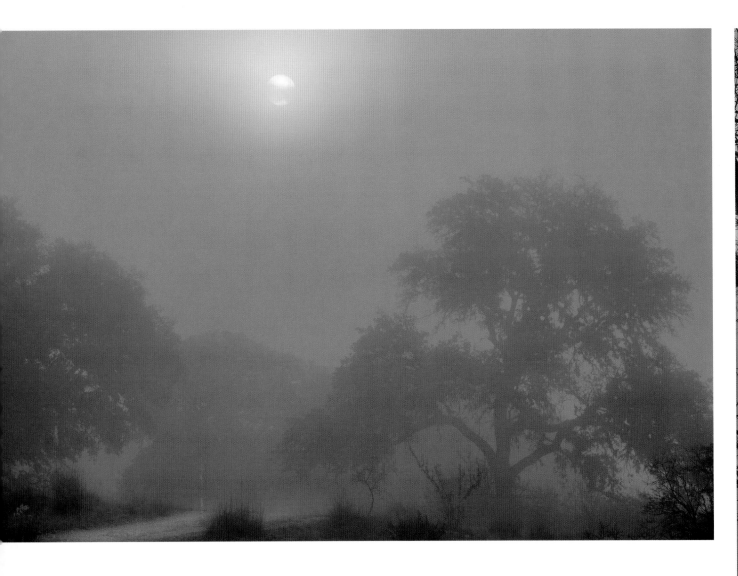

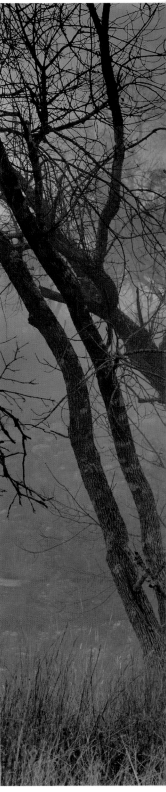

A sense of peace envelops me as I contemplate the land. God's hands surround me.

—Laura Giles Mullen, author's cousin

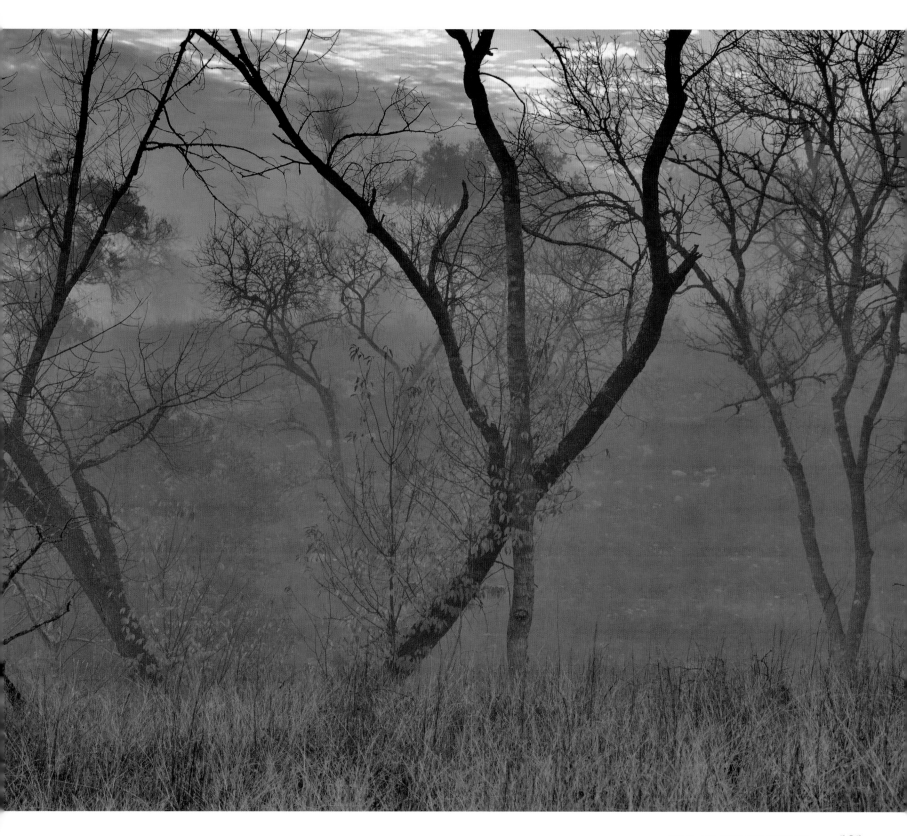

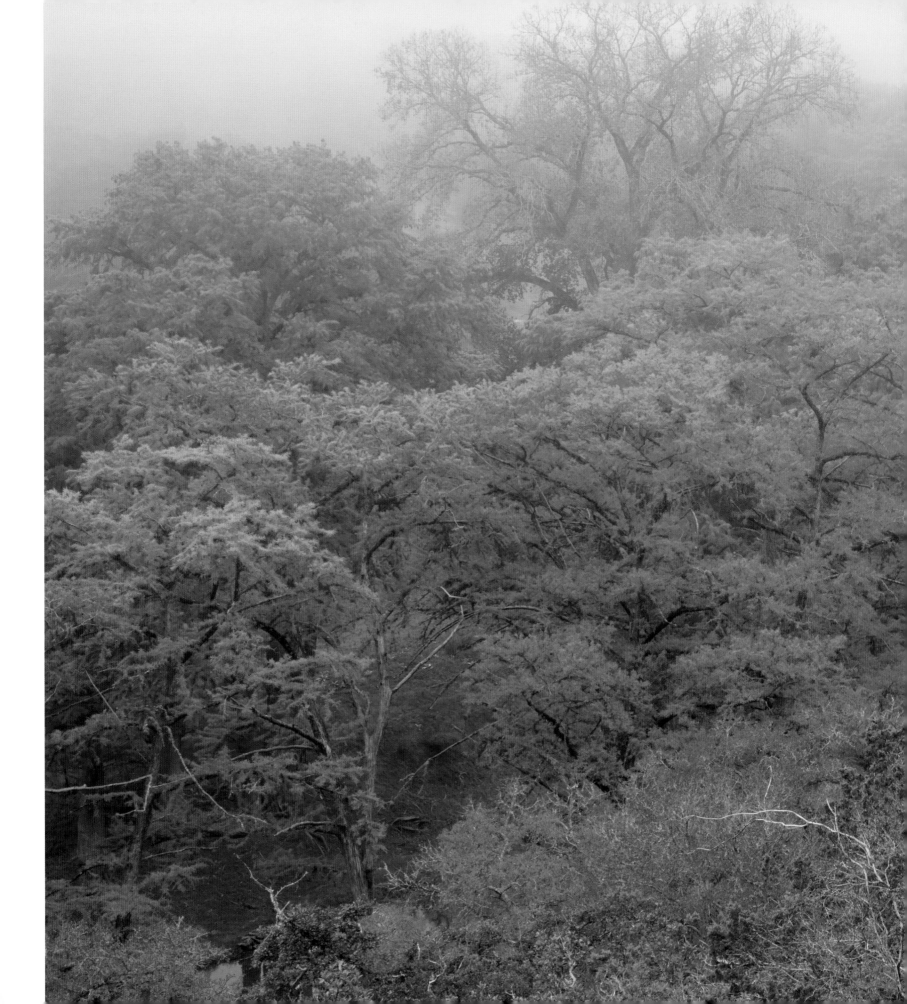

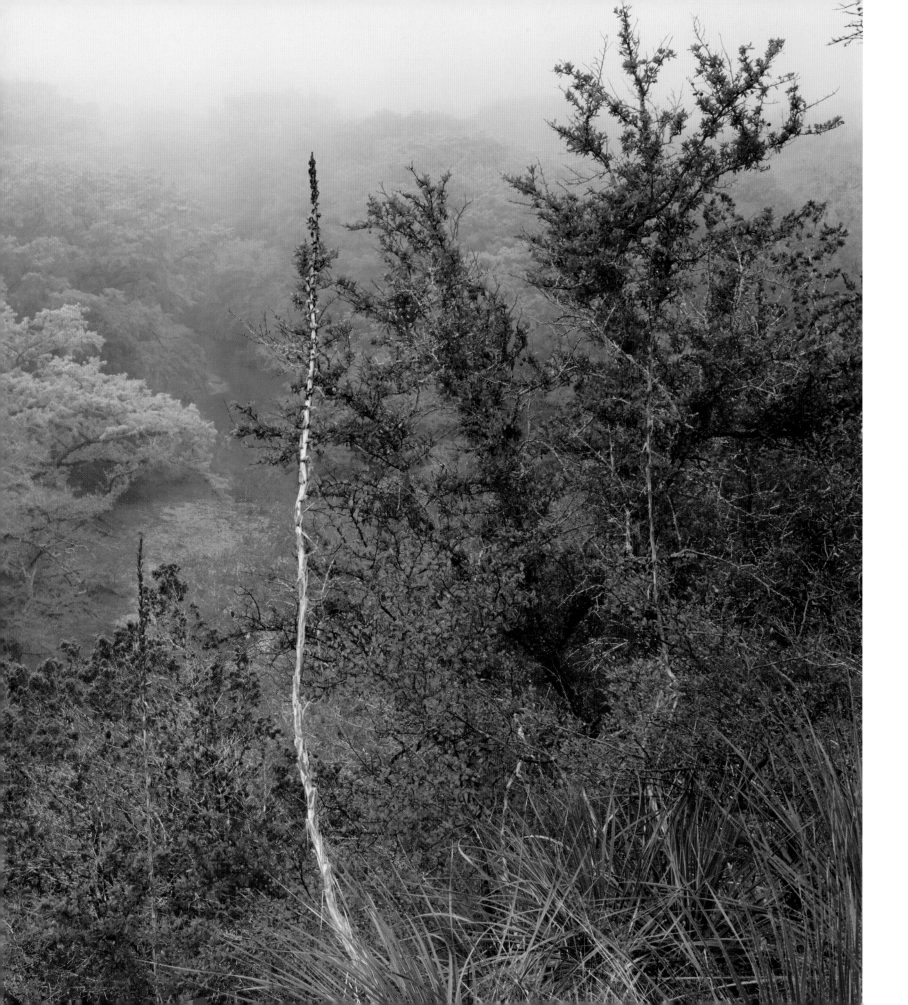

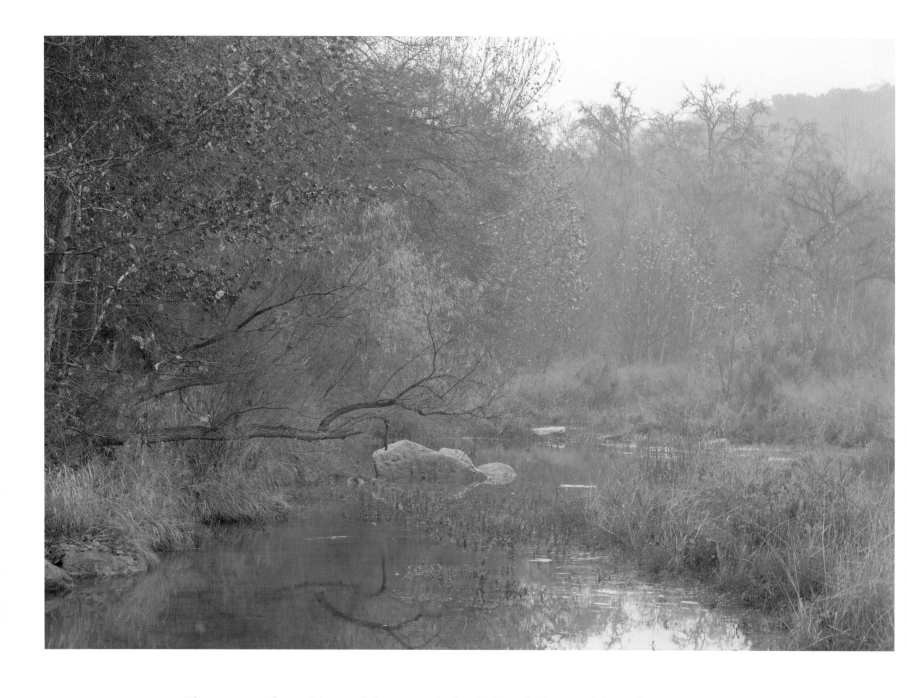

These towns, these cities, and these people drank from the heart of the Hill Country, the water in their bodies is water that has come from beneath the hills.

—Rick Bass, *A Thousand Deer: Four Generations of Hunting and the Hill Country*

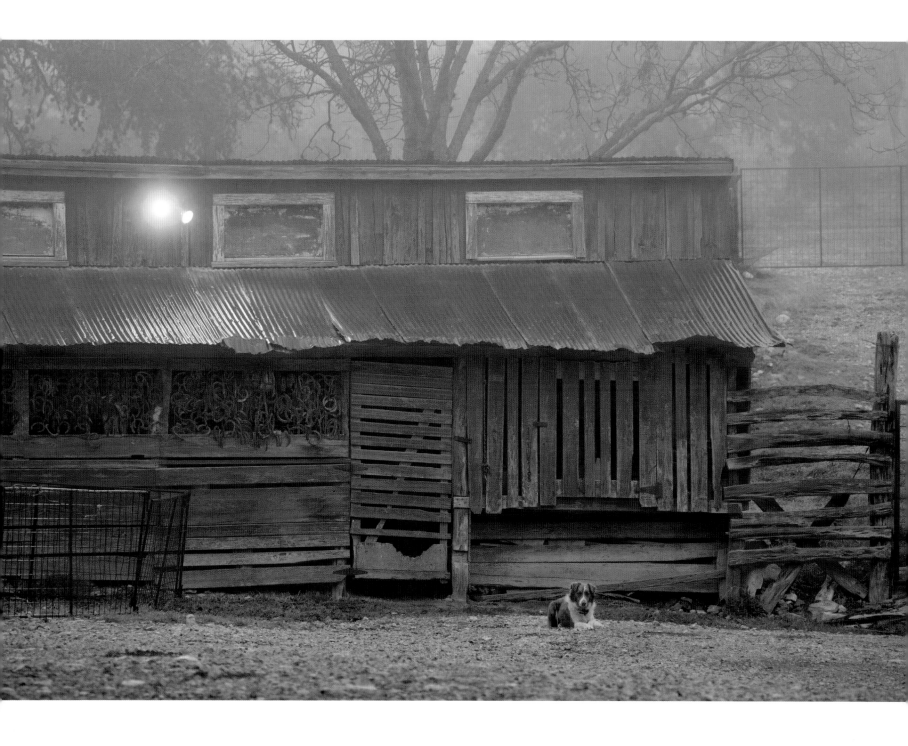

When the uniqueness of a place sings to us like a melody, then we will know, at last, what it means to be at home.

—Paul Gruchow, *The Necessity of Empty Places*

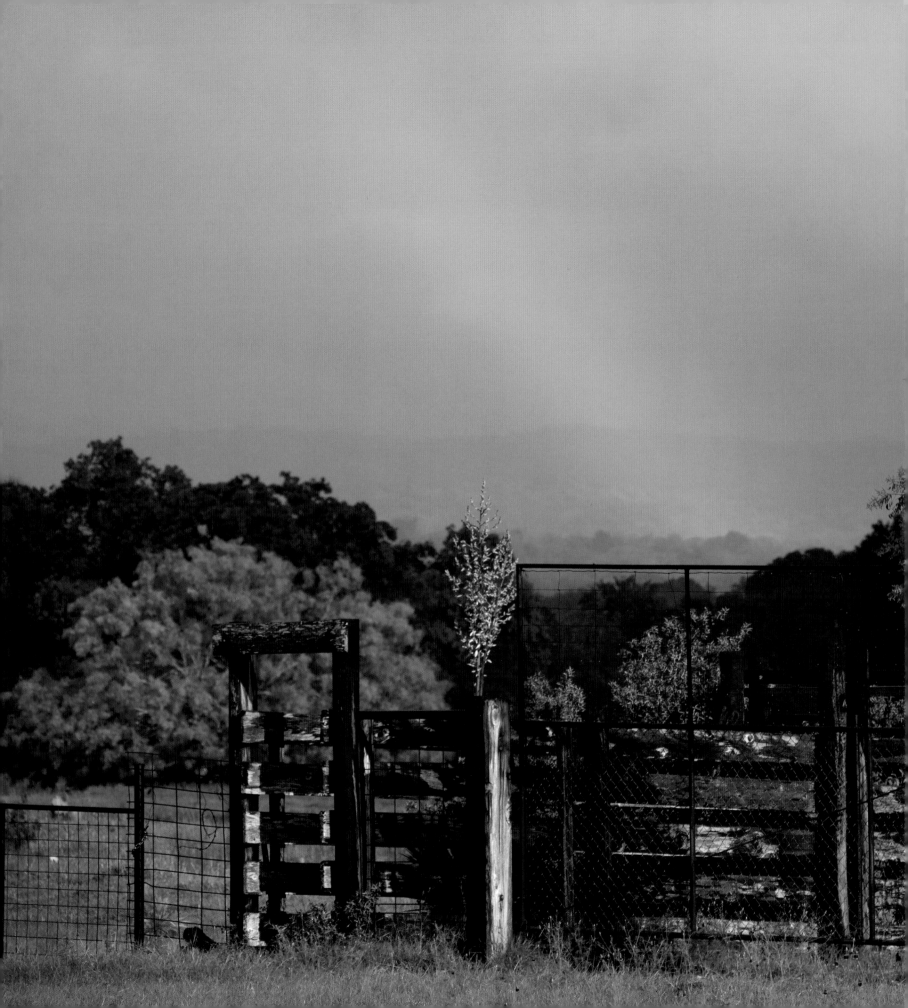

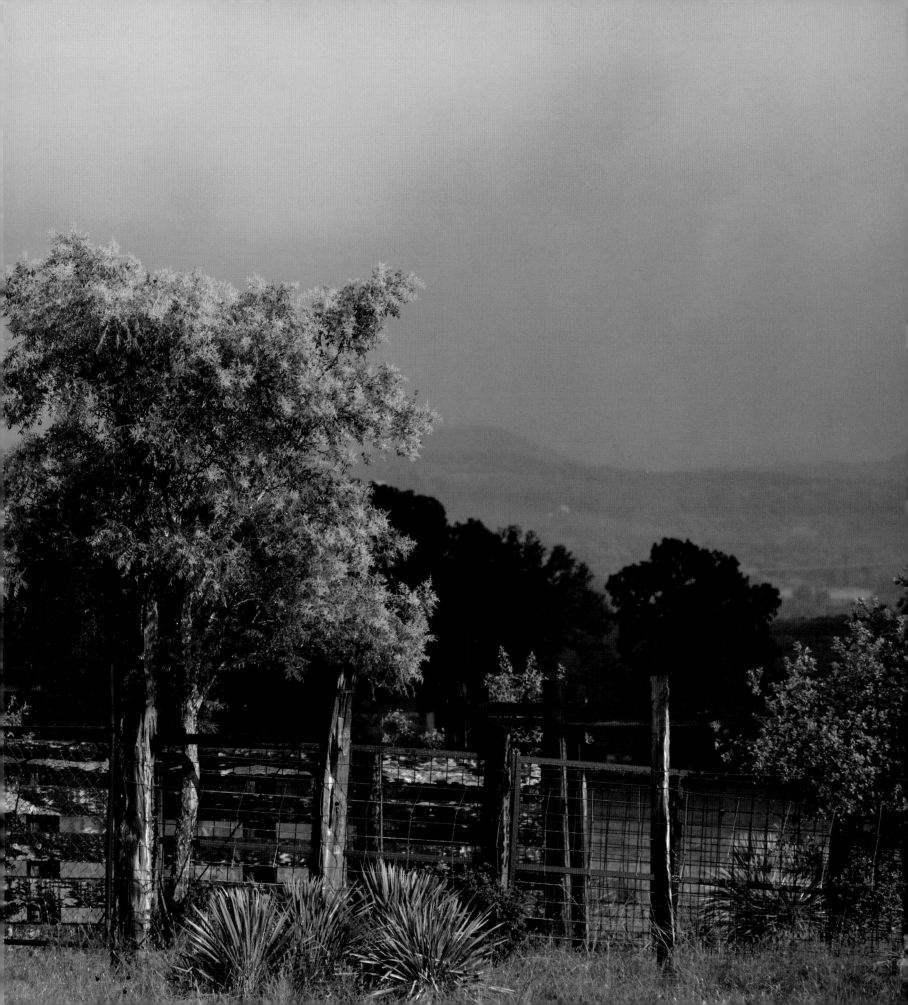

Bibliography

Bartlett, Richard C. *Saving the Best of Texas: A Partnership Approach to Conservation.* Austin: University of Texas Press, 1995.

Bass, Rick. *A Thousand Deer: Four Generations of Hunting and the Hill Country.* Austin: University of Texas Press, 2012.

Berry, Wendell. "The Peace of Wild Things." In *Collected Poems, 1957–1982.* Berkeley: Counterpoint Press, 1985.

Borland, Hal. *An American Year.* New York: Simon & Schuster, 1946.

———. *Countryman: A Summary of Belief.* Philadelphia: J. B. Lippincott, 1965.

———. *Hill Country Harvest.* Philadelphia: J. B. Lippincott, 1967.

Bush, Mrs. Laura, Former First Lady of Texas and the United States. Quoted in Colleen Schreiber, "Former First Lady Rolls out New Conservation Effort for Texas." *San Angelo (TX) Livestock Weekly,* July 21, 2011.

Cather, Willa. *O Pioneers!.* Boston: Houghton Mifflin, 1913.

Chesnut, Jim. "The Music of a Windmill," on *J. W. Chesnut's Sippin' Whiskey.* Lyrics and music by Jim Chesnut Music. Produced by Chesnut Productions, 2012, compact disc.

Cox, Paul W., and Patty Leslie. *Texas Trees: A Friendly Guide.* San Antonio: Corona, 1988.

Davis, Richard Harding. *The West from a Car Window.* New York and London, 1899.

Dobie, J. Frank. *I'll Tell You a Tale.* Boston: Little Brown, 1931.

Emerson, Ralph Waldo. *Nature, Addresses and Lectures.* Boston: Houghton Mifflin, 1917.

Frost, Robert. "Storm Fear." In *The New Poetry: An Anthology.* Edited by Harriet Monroe and Alice Corbin Henderson. New York: Macmillan, 1917.

Giles, Robin. Quoted in David K. Langford and Lorie Woodward Cantu, *Hillingdon Ranch: Four Seasons, Six Generations.* College Station: Texas A&M University Press, 2013.

Gioia, Dana. "Words." In *Interrogations at Noon.* Port Townsend: Graywolf Press, 2001.

Graves, John. *Hard Scrabble.* New York: Alfred A. Knopf, 1980.

———. "State of Nature, A 50th Anniversary Celebration: An Essay by John Graves." *Texas Parks and Wildlife,* December 1992.

Grayson, David. *The Countryman's Year.* Garden City: Doubleday, Doran, 1935.

Gruchow, Paul. *The Necessity of Empty Places.* New York: St. Martin's Press, 1988.

Hardy, Thomas. *Far From the Madding Crowd.* New York, 1874.

Hennen, Tom. "From a Country Overlooked." *Darkness Sticks to Everything.* Port Townsend: Copper Canyon Press, 2013.

Hess, Myron J. "Hooked on Rivers." In *Living Waters of Texas.* Edited by Ken Kramer, 33–43. College Station: Texas A&M University Press, 2010.

James, Will. *Will James' Book of Cowboy Stories.* New York: Charles Scribner's Sons, 1951.

Johnson, Lyndon Baines. "A Program for all the People in the Colorado River Valley to be Undertaken by their Servant the Lower Colorado River Authority," Presentation, 1948. As Interpreted by Bill Eikenhorst, DVM.

Kapp, Ida. "Letter." Translated and edited by Oscar Haas. New Braunfels: *New Braunfels Herald and Zeitung,* August 3-October 19, 1972. Reprinted by Crystal Sasse Ragsdale. *The Golden Free*

Land: The Reminiscences and Letters of Women on an American Frontier. Austin: Landmark Press, 1976.

Kinsley, Robert. "Reunion." In *Endangered Species*. Alexandria: Orchises Press, 1989.

Karger, John. Quoted in Ralph Winningham, "Last Chance Forever." *Texas Parks and Wildlife*, April 2003.

Leopold, Aldo. *A Sand County Almanac: And, Sketches Here and There*. New York: Oxford University Press, 1949.

Lincoln, Abraham. "Second Annual Message to Congress, Dec. 1, 1862." As summarized by Carl Sandburg, *Abraham Lincoln: The War Years*. New York: Harcourt Brace, 1939.

Lopez, Barry. "Blind Creek." In *Home Ground: A Guide to the American Landscape*. Edited by Barry Lopez and Debra Gwartney. San Antonio: Trinity University Press, 2006, 2013.

Macfarlane, Robert. *The Old Ways: A Journey on Foot*. New York: Penguin Press, 2013.

Momaday, N. Scott. *Man Made of Words: Essays, Stories, Passages*. New York: St. Martin's Press, 1997.

Muir, John. *John of the Mountains: The Unpublished Journals of John Muir*. Edited by Linnie Marsh Wolfe. Madison: University of Wisconsin Press, 1938, republished 1979.

———. *Steep Trails*. Boston: Houghton Mifflin Press, 1918. Reprinted and edited by William Frederick Bade. Dunwoody: Norman S. Berg, 1970.

Nelle, Steve. "Cows and Creeks." *Texas Wildlife*, 28, no. 2 (May 2012): 44–7.

———. *Texas Riparian Areas*. Edited by Thomas B. Hardy and Nicole A. Davis. College Station: Texas A&M University Press, forthcoming.

Oberhauser, Karen S. "Overview of Monarch Breeding Biology." In *The Monarch Butterfly: Biology and Conservation*. Edited by Karen S. Oberhauser and Michelle J. Solensky. Ithaca: Cornell University Press, 2004.

Oliver, Mary. "Wild Geese." In *Dream Work*. New York: Atlantic Monthly Press, 1986.

Olmsted, Frederick Law. *A Journey through Texas; or, A Saddle-Trip on the Southwestern Frontier*. New York, 1857. Reprint with foreword by Larry McMurtry. Austin: University of Texas Press, 1978.

Roe, Margie McCreless. "Live Oak Spring," "Wild Turkeys," and "Limestone Country." In *Flight Patterns*. San Antonio: River Lily Press, 2003.

Roosevelt, Eleanor. "My Day." Syndicated newspaper column, April 26, 1945.

Rowell, Galen. *Mountain Light*. Covela: Yolla Bolly Press, 1986.

Russell, Kevin "Shinyribs." "Dead Batteries," on *Okra Candy*. Music and lyrics by Kevin "Shinyribs" Russell, published by Krakatowa McDinglefurry, 2015, compact disc.

Steichen, Edward. *A Life in Photography*. Garden City: Doubleday, 1963.

Shakespeare, William. *Troilus and Cressida*, 1609.

Thoreau, Henry D. *Faith in a Seed: The Dispersion of Seeds and Other Late Natural History Writings*. Edited by Bradley P. Dean. Washington, DC: Island Press, 1993.

Weniger, Del. *The Explorers' Texas: The Animals They Found*. Austin: Eakin Press, 1997.

Wordsworth, William. "The Tables Turned." In *William Wordsworth—the Major Works*. New York: Oxford University Press, 1984, reissued 2008.

Young, Dean. "Son of Fog." *Poetry*, April 2005.

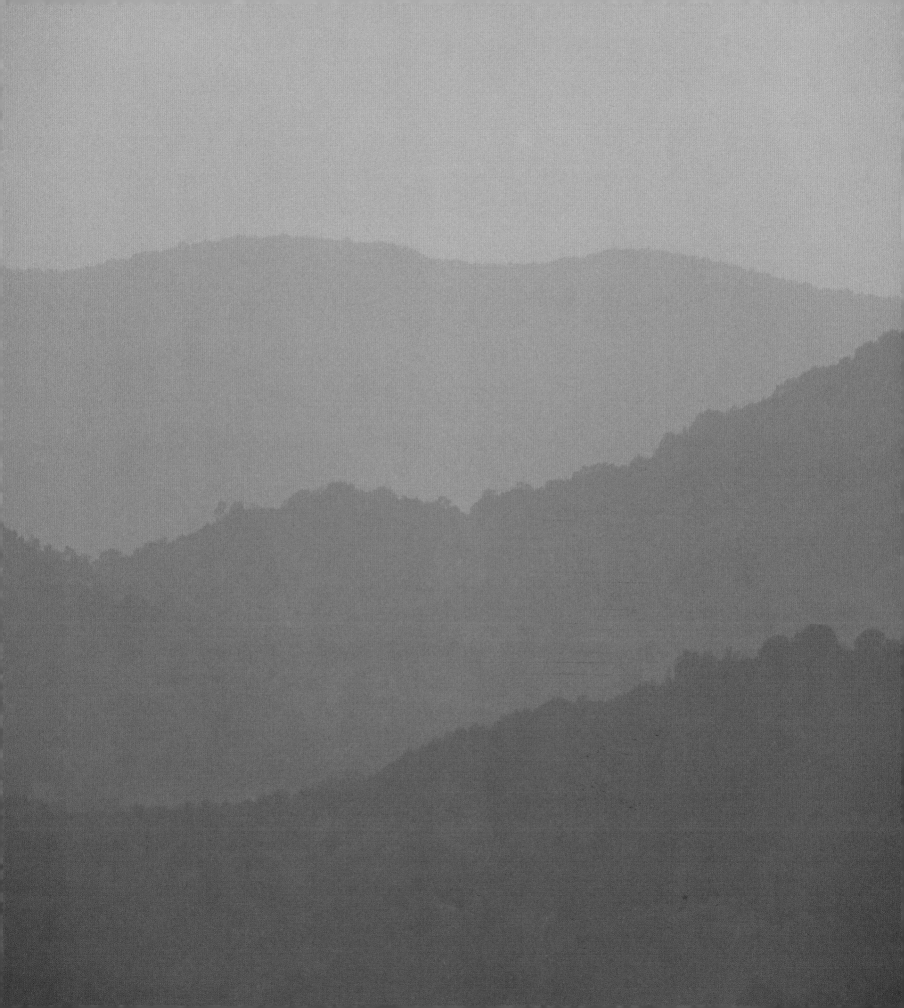

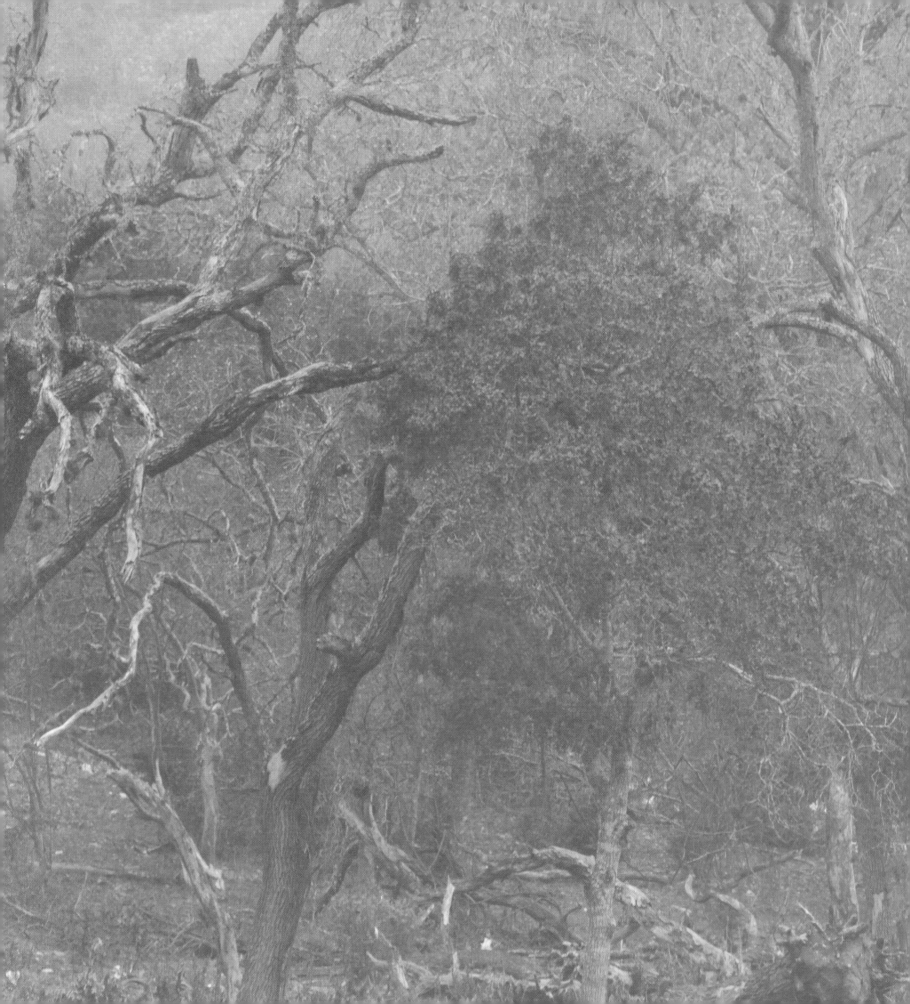